Salvador Dalí

Author:
Eric Shanes

Layout:
Baseline Co. Ltd
61A-63A Vo Van Tan Street
4th Floor
District 3, Ho Chi Minh City
Vietnam

Library of Congress Control Number: 2014936060

ISBN: 978-1-78310-124-5

Printed in China

Eric Shanes

Salvador Dalí

PARKSTONE®
INTERNATIONAL

Contents

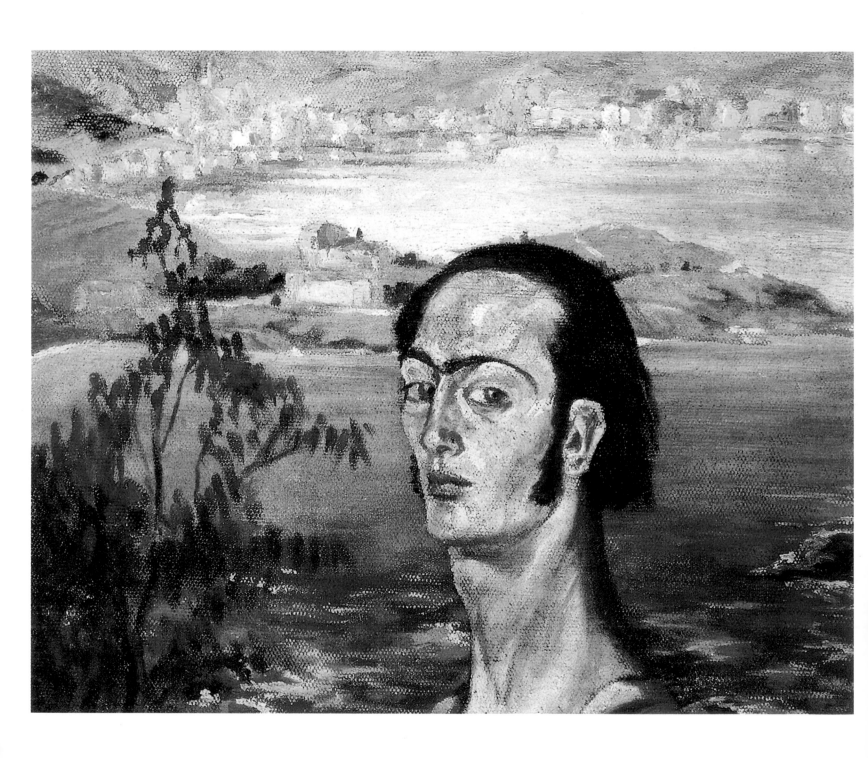

Self-Portrait with the Neck of Raphael, 1921.
Oil on canvas, 41.5 x 53 cm. Teatre-Museu Dalí, Figueres.

Introduction

It is perhaps unsurprising that Salvador Dalí has proven to be one of the most popular artists of the 20th century, for his finest works explore universal and timeless states of mind, and most of his pictures were painted with a mastery of traditional representation that has proven rare in our time. For many people, that acute realism alone would have sufficed to attract them to Dalí's work, and it has certainly served to mask any gradual lessening of quality in his art. Moreover, Dalí was also probably the greatest artistic self-publicist in a century in which (as Igor Stravinsky commented in 1970) publicity gradually became "about all that is left of the arts". In this respect he was in a class of his own for much of his lifetime, as was his brilliant wife and co-publicist, Gala.

Yet Dalí's immense popularity is also rather ironic, for his work – in its finest phase, at least – constitutes an attack on the social, sexual, and cultural mores of the very society that feted him. The notion that an artist should be culturally subversive has proven central to modernist art practice, and it was certainly essential to Surrealism, which aimed to subvert the supposedly rational basis of society itself. In time, Dalí's subversiveness softened, and by the mid-1940s André Breton, the leading spokesman for Surrealism, was perhaps justifiably dismissing the painter as a mere showman and betrayer of Surrealist intentions. But although there was a sea change in Dalí's art after about 1940, his earlier work certainly retains its ability to bewilder, shock, and intrigue, whilst also dealing inventively with the nature of reality and appearances. Similarly, Dalí's behaviour as an artist after about 1940 throws light on the basically superficial culture that sustained him, and this too seems worth touching upon, if only for that which it can tell us about the man behind the myths that Salvador Dalí projected about himself.

Salvador Domingo Felipe Jacinto Dalí i Domènech was born on 11 May 1904 in Figueres, a small town in the Catalan province of Gerona in northern Spain, the son of Salvador Dalí i Cusi and Felipa Domènech. Dalí senior was the public notary of Figueres and, as such, an important and widely respected local official. He was a very forceful man, and it was rumoured that he had been responsible for the death of Dalí's elder brother, also named Salvador, who had been born in 1901 and who died in 1903; officially the death was caused by catarrh and gastroenteritis but according to Dalí, his older brother died of meningitis that had possibly been brought on by a blow to the head. Certainly that death left Dalí's parents with an inescapable sense of anguish, and the young Dalí was always aware of the demise because both parents constantly projected his lost brother onto him, every day making comparisons between the two boys, dressing the younger Salvador in his deceased brother's clothes, giving him the same toys to play with, and generally treating him as the reincarnation of his departed brother, rather than as a person in his own right.

Faced with such a denial of self, Dalí understandably mutinied in an assertion of his own identity, whilst equally rebelling against the perfected image of the dead brother which his parents attempted to impose upon him. Thus the painter later recounted that, "Each day I looked for a new way of bringing my father to a paroxysm of rage or fear or humiliation and forcing him to consider me, his son, me Salvador, as an object of dislike and shame. I threw him off, I amazed him, I provoked him, defied him more and more." If Dalí's later claims are to be taken seriously, among other things his rebelliousness involved him in deliberate bed-wetting, simulated convulsions, prolonged screaming, feigned muteness, jumping from heights, and acts of random aggressiveness such as flinging another little boy off a suspension bridge or kicking his younger sister in the head for no apparent reason. Supposedly Dalí also frequently overcompensated for the suppression of his identity by indulging in exhibitionist

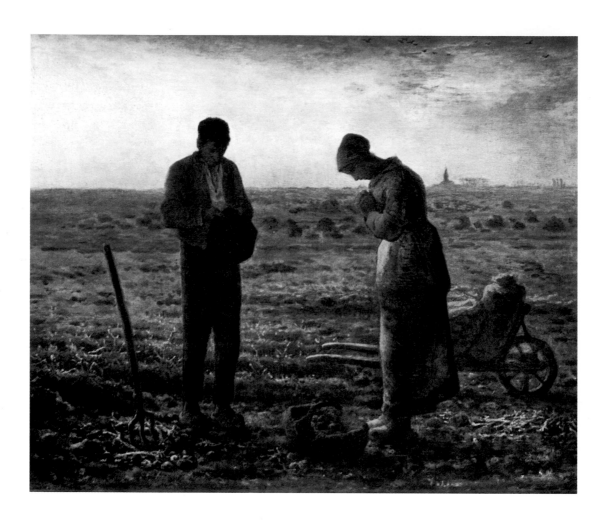

behaviour, as when he placed a dying, ant-covered bat in his mouth and bit it almost in half. There is probably only a very limited amount of truth in these assertions, but eventually both Dalí's innate rebelliousness and his exhibitionism would serve him in good stead artistically.

Dalí received his primary and secondary education in Figueres, first at a state school where he learned nothing, and then at a private school run by French Marist friars, where he gained a good working knowledge of spoken French and some helpful instruction in taking great artistic pains. The cypress trees visible from his classroom remained in his mind and later reappeared in many of his pictures, while Jean-François Millet's painting *The Angelus,* which he saw in reproduction in the school, also came back to haunt him in a very fruitful way. But the main educational input of these years clearly derived from Dalí's home life, for his father was a

relatively cultured man, with an interest in literature and music, a well-stocked library that Dalí worked through even before he was ten years old, and with decidedly liberal opinions, being both an atheist and a Republican. This political non-conformism initially rubbed off on Dalí, who as a young man regarded himself as an Anarchist and who professed a lifelong contempt for bourgeois values.

More importantly, the young Dalí also received artistic stimulation from his father, who bought the boy several of the volumes in a popular series of artistic monographs. Dalí pored over the reproductions they contained, and those images helped form his long term attraction to 19th-century academic art, with its pronounced realism; among the painters who particularly impressed him were Manuel Benedito y Vives, Eugène Carrière, Modesto Urgell and Mariano Fortuny, one of whose works, *The Battle of Tetuan,* would inspire Dalí to paint a companion picture in 1962.

Jean-François Millet (1814-1875), *The Angelus,* 1857-1859.
Oil on canvas, 55.5 x 66 cm. Musée d'Orsay, Paris.

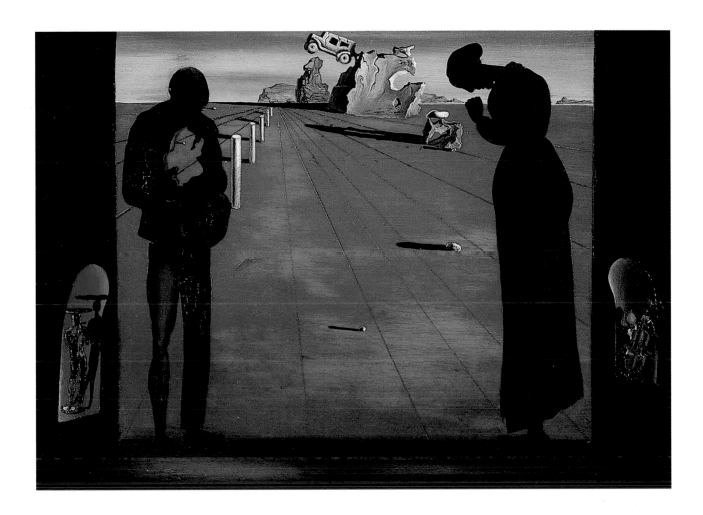

And Dalí also received artistic encouragement from a friend of his father's, the Figueres lawyer Pepito Pichot whose brother, Ramon, was a fluent impressionist painter who lived in Paris and was known to Picasso. It may have been in the Pichot summer residence in an old mill tower near Figueres that the young Dalí took his first steps as a painter, for when he was about nine years old he produced a still life of cherries on the back of an old, worm-eaten door, using merely vermilion and carmine for the fruits, and white for the highlights. (Dalí also later claimed that in this work he first blurred the dividing lines between differing realities, initially by gluing the stems of the real cherries to the bases of the painted ones, and then by transferring several worms from their holes in the door – and thus in his painted cherries – to the worm holes in the real cherries.)

Quite naturally the young Dalí was influenced by the numerous impressionistic and pointillist canvasses of Ramon Pichot that

hung in the old mill tower, and his precociousness was such that Pepito Pichot soon persuaded Dalí senior to allow his son to study drawing with Professor Juan Nuñez at the Municipal School of Drawing in Figueres, where the boy enrolled in 1917. Because Nuñez found Dalí unusually talented, he took great pains over his education. The student remained under his tuition for about two years and freely admitted that he learned much from his teacher. In December 1918 Dalí exhibited his first pictures publicly, in a show shared with two other painters that was mounted in the municipal theatre in Figueres, a building that would later become a museum devoted solely to his own works. A local art critic wrote:

The person who has inside him what the pictures at the Concerts Society reveal is already something big in the artistic sense... We have no right to talk of the boy Dalí because the said boy is already a man... We have no

Angelus, c. 1932.
Oil on wood, 16 x 21.7 cm. Private collection, courtesy of Galerie Natalie Seroussi, Paris.

right to say that he shows promise. Rather, we should say that he is already giving... We salute the novel artist and are quite certain that in the future our words... will have the value of a prophecy: Salvador Dalí will be a great painter.

This was very heady praise for a boy of fourteen, and it was true: he *was* a great painter in the making.

Over the next couple of years the little genius continued to broaden his horizons. He helped bring out a local student magazine that appeared mostly in Spanish rather than Catalan so as to reach a wider readership. To this Dalí contributed illustrations and a series of articles on great painters, taking as his subjects Michelangelo, Leonardo da Vinci, El Greco, Dürer, Velázquez, and Goya. He widened his reading and thereby assimilated advanced views on politics, culture, and society in 1921, even claiming to be a communist. Naturally he rebelled against paternal authority, but who does not? And he discovered the joys of masturbation, as well as the self-loathing that usually accompanied it in an age of anxiety about all things sexual. This was especially the case in Spain where sexual ignorance was endemic and sexual guilt was universally promulgated. In order to become aroused, the youth did not necessarily fantasise about women; towers and church belfries could just as easily help him rise to the occasion (which is surely why there are so many towers and belfries in his art). He worried intensely about the smallness of his sexual organ, and his sexual anxiety made him "the victim of inextinguishable attacks of laughter". He also realised that, "you have to have a very strong erection to be able to penetrate. And my problem is that I've always been a premature ejaculator. So much so, that sometimes it's enough for me just to look in order to have an orgasm." It appears probable that never in the history of art has such an avid masturbator and voyeur become such a great painter, and certainly no artist has ever admitted to these predilections as openly as Dalí would do in 1929 and thereafter.

In February 1921 Dalí's mother, Felipa Domènech, died suddenly of cancer of the uterus. She was just forty-seven years of age. Dalí was exceedingly pained by the loss, stating later:

With my teeth clenched with weeping, I swore to myself that I would snatch my mother from death and destiny with the swords of light that someday would savagely gleam around my glorious name.

In November 1922 Dalí's father would remarry, although he had to obtain a papal dispensation in order to do so, as his new bride, Catalina Domènech, was the sister of his dead wife.

In September 1922 Dalí was accompanied by his father and sister to Madrid in order to apply for admittance to the leading art school in Spain, the San Fernando Royal Academy of Fine Arts. The boy had long wanted to devote himself to art, and although his father harboured the usual reservations about such an uncertain career, clearly he was relieved that his unstable son had some set target in mind. The entrance examination for the Academy of Fine Arts involved spending six days drawing a cast of Jacopo Sansovino's *Bacchus*, and although Dalí failed to make his drawing to the required size, his facility was such that the dimensions of his work were ignored and he was granted a place.

Dalí was not to prove happy with the tuition he would receive at the San Fernando Academy, mainly because Impressionism was still the prevailing artistic mode there and it was a style he had already worked through and exhausted. Instead, he took an interest in more advanced visual thinking, such as Cubism, while equally being attracted to traditional artistic techniques, which unfortunately were no longer being much taught at the Academy because of the prevailing taste for the loose, painterly techniques demanded by an impressionistic approach. But if the San Fernando Academy made only a passing contribution to Dalí's artistic development, his choice of accommodation in Madrid gave him much more creative stimulation, for he stayed in the Residencia de Studia, or university hall of residence. This was not just a place to eat and sleep but was far more like a college in itself, with activities taking place on all kinds of intellectual levels. Dalí's sojourn in the Residencia coincided with that of some of the most brilliant emergent minds in contemporary Spanish culture.

Portrait of Maria Carbona, 1925.
Oil on cardboard, 53 x 40 cm. The Montreal Museum of Fine Arts, Montreal.

11

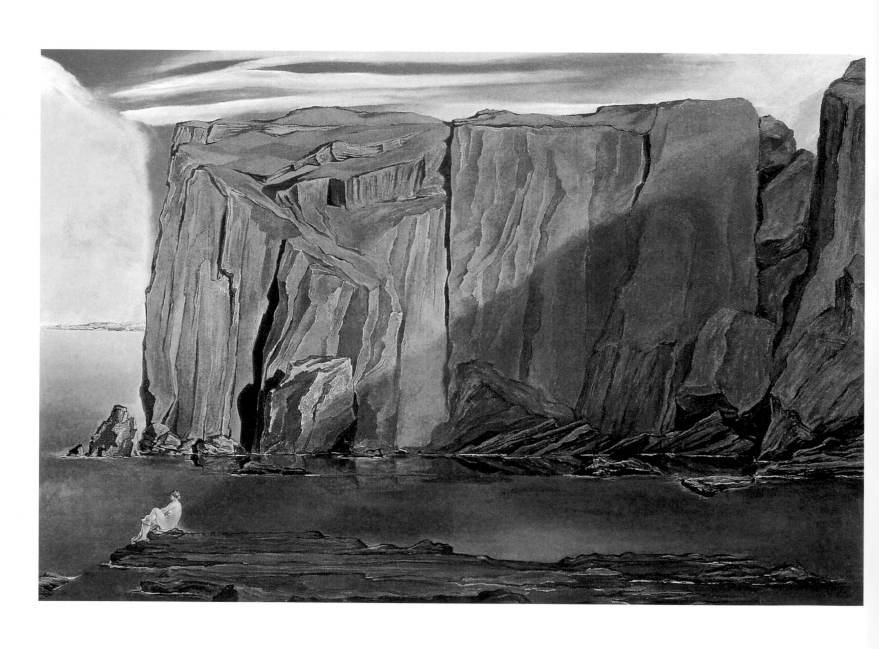

Penya-Segats (*Woman by the Cliffs*), 1926.
Oil on wood, 26 x 40 cm. Private collection.

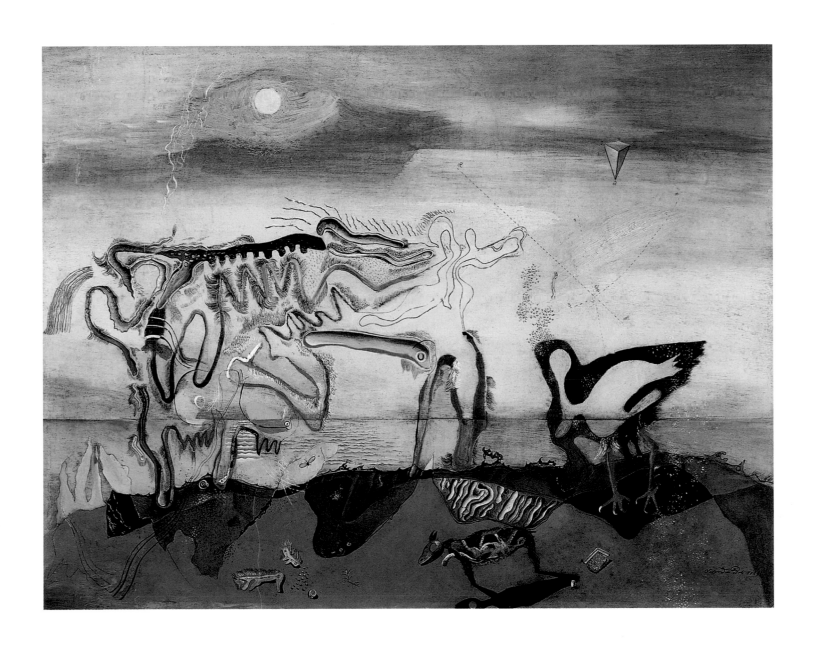

The Spectral Cow, 1928.
Oil on plywood, 50 x 64.5 cm. Musée national d'Art moderne, Centre Georges-Pompidou, Paris.

These included Luis Buñuel, then a philosophy student and later to be an outstanding film director with whom he would collaborate, in addition to the finest modern Spanish poet and playwright (and arguably the greatest poet of the 20th century), Federico García Lorca. At first Dalí was somewhat distanced from his more advanced fellow students in the Residencia by his assumed, defensive haughtiness and bohemian way of dressing, but when his modernist sympathies were discovered he was readily admitted to the circle of Buñuel and Lorca, with whom he became firm friends by early 1923.

Dalí's dissatisfaction with the San Fernando Royal Academy of Fine Arts moved onto a new plane in the autumn of 1923 when, along with five other students, he was rusticated for a year for supposed insubordination. He had supported the appointment of a progressive artist to the post of Professor of Open-Air Painting, and when his favourite failed to obtain the job, in protest he had walked out of the meeting at which the news of the failure was announced; this was followed by a vociferous student protest, for which it was assumed that Dalí's walkout had been the starting signal. Dalí thereupon returned to Figueres. Soon afterwards, in May 1924, he unwittingly found himself in further trouble with authority because of the political leanings of other members of his family; as a consequence, Dalí was imprisoned without trial in Figueres and later transferred to the provincial capital of Gerona before being released.

By this time Dalí had experimented with various artistic styles. Picasso was one influence, Derain another, while in 1923 Dalí had painted pictures of groups of nudes in the open air that were heavily indebted to pointillism and to the flowing, linear style of Matisse. By the autumn of 1924, when Dalí returned to Madrid and his formal studies, he had also begun to assimilate more recent developments in Cubism and Purism. Yet simultaneously he started exploring a highly-detailed representationalism, and here too the influence of Picasso – in the form of the latter's Neo-classicism of the late 1910s and early 1920s – is apparent. And Romantic painters of an earlier period such as Caspar David Friedrich also made their mark upon him. Clearly, the young man was searching for

a style that could express his innermost self, without yet being able to find it.

Back in Madrid, Dalí resumed his friendship with Buñuel and Lorca. On the creative level the relationship between Dalí and Lorca would prove especially important, for it would strengthen their mutual attraction for Surrealism. However, the sympathy between them also led the homosexual Lorca to fall in love with Dalí. Being perhaps bisexual but more usually asexual, Dalí could not return his affections in the same way. However, on two occasions, probably in 1926 and surely in the spirit of sexual experimentation, Dalí did passively allow Lorca to try making love to him. The experiment was unsuccessful. Apparently Dalí had no regrets and later commented that, "I felt awfully flattered vis-a-vis the prestige. Deep down, I felt that he was a great poet and that I did owe him a tiny bit of the Divine Dalí's asshole."

In early April 1925 Dalí and Lorca went to stay just outside Cadaqués, about twenty-five kilometres to the east of Figueres on the Mediterranean, where the Dalí family had use of a summer villa. There Dalí introduced his friend to the widow of a local fisherman, Lídia Noguér Sabà, who bordered on harmlessly lunacy but who had always thrilled Dalí with her freewheeling associationism, something that would soon become one of the cornerstones of not only his own art but also that of his friend. Lorca was delighted with the local landscapes, the food, the Greek and Roman ruins, and the enthusiasm with which he was received by Dalí's father and sister.

In November 1925 Dalí held his first one-man exhibition, at the Dalmau Gallery in Barcelona, showing seventeen, mostly recent paintings that ranged stylistically across the visual spectrum from Cubist semi-abstraction, as in the *Venus and Sailor*, to a low-keyed realism, as in the *Figure at a Window* (p. 68). The show was well received by the critics, although some of them were understandably puzzled by the stylistic diversity of the pictures.

In April 1926 Dalí received an overwhelming testimonial to his talents through the publication of Lorca's *Ode to Salvador Dalí*, a poem that has been called, "perhaps the finest paean to

Eggs on the Plate without the Plate, 1932.
Oil on canvas, 60.3 x 42 cm. Salvador Dalí Museum, St Petersburg (Florida).

Surrealist Horse – Woman-Horse, 1933.
Pencil and pen on paper, 52.6 x 25 cm. Salvador Dalí Museum, St Petersburg (Florida).

Gradiva, 1933.
Pen and Indian ink on sandpaper. Staatliche Graphische Sammlung, Munich.

friendship ever written in Spanish". And later that month Dalí, accompanied by his stepmother and sister, at last visited Paris for the first time. They also went on to Brussels. The trip was paid for by Dalí's father who was delighted at the success of the Dalmau Gallery exhibition the previous autumn. In Brussels, Dalí was attracted to Flemish painting, with its microscopic attention to detail, while in Paris he again met up with Buñuel. The family took an excursion to Versailles, visited the studio of Jean-François Millet in Barbizon, and explored the Grevin waxworks museum. Yet without doubt the high point of the entire trip was Dalí's visit to Picasso, which was arranged by another Spanish artist living in Paris. As Dalí later recalled:

> When I arrived at Picasso's [studio] on Rue de la Boetie I was as deeply moved and as full of respect as though I was having an audience with the Pope.
> "I have come to see you," I said, "before visiting the Louvre."
> "You're quite right," he answered.
> I brought a small painting, carefully packed, which was called *The Girl of Figueres* [p. 71]. He looked at it for at least fifteen minutes, and made no comment whatsoever. After which we went up to the next storey, where for two hours Picasso showed me quantities of his paintings. He kept going back and forth, dragging out great canvasses which he placed against the easel. Then he went to fetch others among the infinity of canvasses stacked in rows against the wall. I could see that he was going to enormous trouble. At each new canvas he cast me a glance filled with a vivacity and an intelligence so violent that it made me tremble. I left without in turn having made the slightest comment.
> At the end, on the landing on the stairs, just as I was about to leave, we exchanged a glance which meant exactly,
> "You get the idea?"
> "I get it!"

By the time Dalí visited Picasso, he had for some years been assimilating elements from the latter's art as viewed in reproduction, such as the stylisation of figures in pictures of the Blue and Rose periods, the manifold spatial dislocations and ambiguities of Cubism, and the strain of Neo-classicism that

emerged in 1919. It must have been rewarding, then, to see large numbers of original works by Picasso from all these phases of his career. And one picture in particular, if seen, would have linked to Dalí directly, for Picasso's *Three Dancers* of 1925 alludes to the recent death of Ramon Pichot, whose silhouette is discernible against the window on the right. Naturally, the influence of Picasso upon Dalí continued for some time after the 1926 visit to the Rue de la Boetie, and it derived from the elongated figures, flat shapes, crisp silhouettes, and bright colours visible in Picasso's Cubist style of the mid-1920s (all of these elements are visible in *The Three Dancers*). But simultaneously Dalí continued to develop the strain of realism that had previously emerged in his work. Clearly, he was still searching for his true self.

The welcome that Dalí had received in Paris led him to think of moving there. In order to do so he evolved a crafty, long-term strategy that involved engineering his own expulsion from the San Fernando Royal Academy of Fine Arts. As he later stated:

> The motives for my action were simple: I wanted to be done with the School of Fine Arts and with the orgiastic life of Madrid once and for all; I wanted to be forced to escape all that and come back to Figueres to work for a year, after which I would try to convince my father that my studies should be continued in Paris. Once there, with the work that I should take, I would definitely seize power!

By being "forced to escape all that", Dalí surely meant his need to overcome a seemingly insuperable obstacle, namely that if he obtained his academic degree his father would expect him to support himself by teaching for a living, rather than maintain him financially in Paris. And with his talents, how could he fail to win his degree?

Dalí found a typically outrageous way of solving the problem. In mid-June 1926, when he was summoned for the art history component of his final examination, he refused to be examined, stating that, "none of the professors of the school of San Fernando being competent to judge me, I retire". The ploy was successful, for the professors were infuriated,

Geological Destiny, 1933.
Oil on panel, 21 x 16 cm. Private collection.

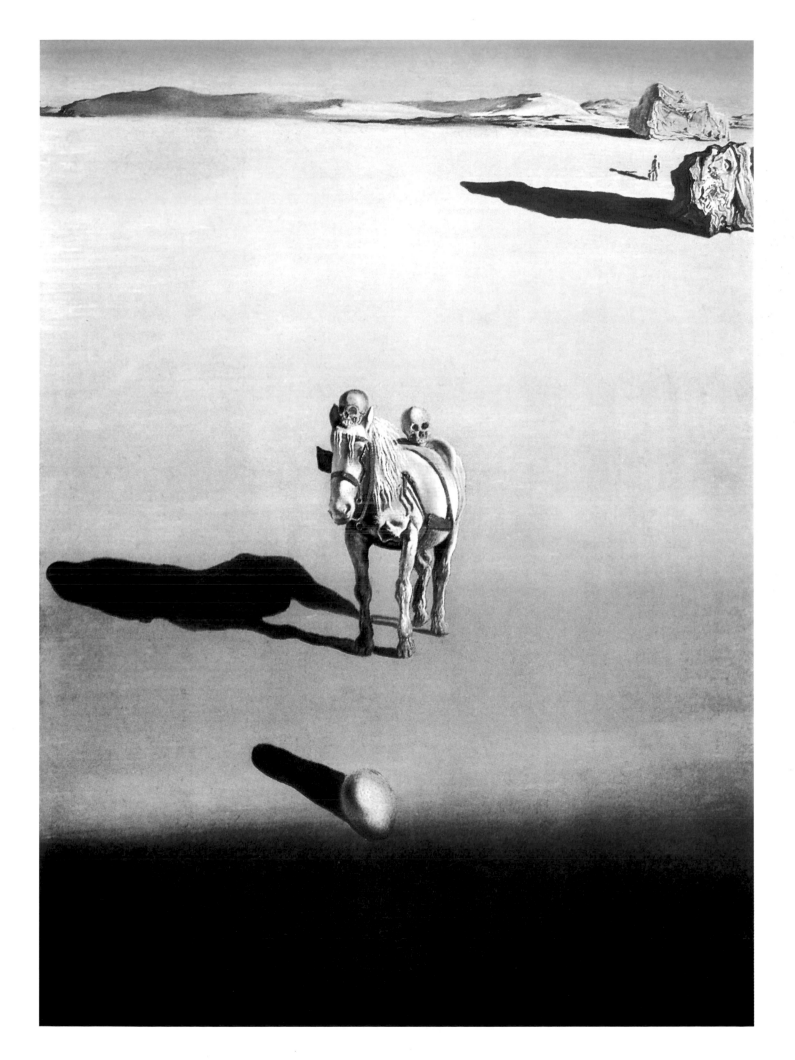

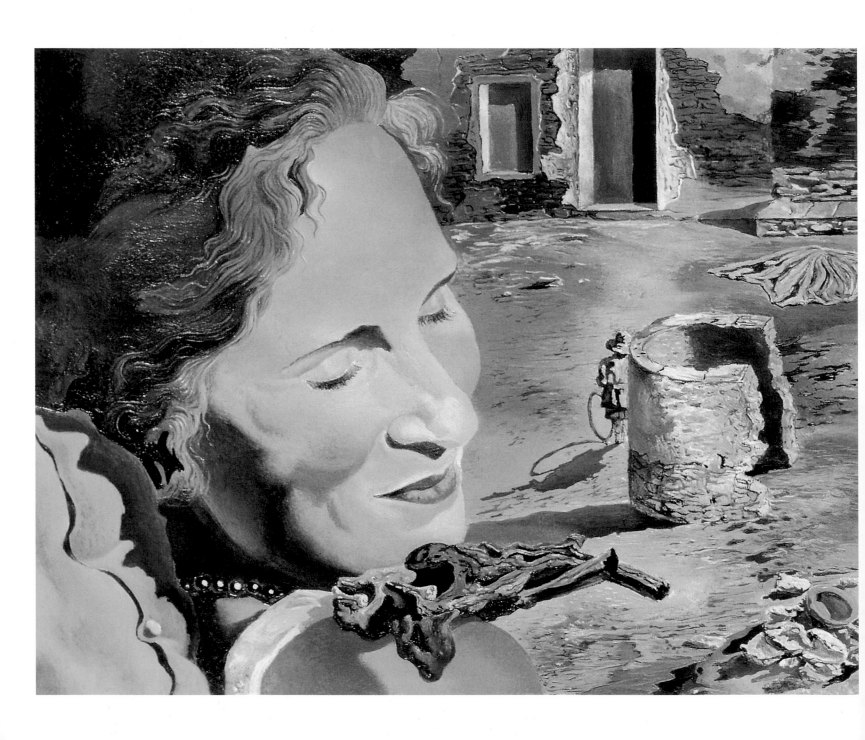

Portrait of Gala with Two Lamb Chops Balanced on Her Shoulder, 1933.
Oil on panel, 6.8 x 8.8 cm. Teatre-Museu Dalí, Figueres.

and eight days later Dalí was expelled from the institution without obtaining his degree.

Dalí's father was shattered by the expulsion, which closed an official career in Spain for his son, although he grudgingly allowed the younger Salvador to return once again to Figueres where the boy embarked on his plan to "work for a year". A show of the results was held at the Dalmau Gallery in Barcelona at the very end of 1926 when twenty paintings displayed an even wider range of styles than had been apparent in the works exhibited in the previous show. Once again Dalí was a huge success, with his pictures drawing a largely enthusiastic response from the press. But in his long-term planning to "work for a year", Dali had forgotten to take into account the Spanish army, and from February 1927 he had to spend nine months performing his compulsory military service, although the duties do not appear to have been too irksome. During that time Dalí managed to finish only a few pictures, but he did design the sets and costumes for the premiere of Lorca's *Mariana Pineda* which opened in Barcelona on 24 June, and he also contributed drawings, poetry, and prose to the highly esteemed Sitges journal *L'Amic de les Arts*. Amongst the prose pieces was his *Saint Sebastian*, in which Dalí alluded frequently to Lorca, who that summer again stayed with the painter at Cadaqués.

Dalí's professional contact with Lorca continued the following year when the painter contributed to a newly-founded journal entitled *Gallo* that was published in Lorca's hometown of Granada in Andalucia, a review in which Lorca also took an active interest. In the second issue of *Gallo* in April 1928, Dalí republished an attack on Catalan cultural complacency and anti-modernism that he had co-authored with the writers Lluis Montanyà and Sebastià Gasch. This was the *Catalan Anti-Artistic Manifesto* or *Yellow Manifesto* that had first been published in Barcelona the previous month. In tone the essay resembles the manifestos published over a decade earlier by the Italian Futurist poet, Marinetti, for it similarly praises the machine age and attacks anti-modernist provincialism. Later that year Dalí published a further, similar *feuilleton* in which he again renounced Spanish provincialism and regionalism, in favour of modernity and the new.

In the autumn of 1927 Dalí had written to Lorca:

Federico, I am painting pictures which make me die for joy, I am creating with an absolute naturalness, without the slightest aesthetic concern, I am making things that inspire me with a very profound emotion and I am trying to paint them honestly...

The works in question are pictures in which Dalí had begun wholeheartedly to explore Surrealism. Dalí's engagement with Surrealist ideas had grown apace as he kept in touch with the latest developments in Paris through reading the journal of the French surrealists, *La Révolution surréaliste*, and other, similar literature. In Surrealism he sensed a form of thinking that would finally liberate his true self.

Surrealism had evolved out of an earlier artistic grouping, known as Dada, which had been founded in Zurich in 1916 by the Romanian poet, Tristan Tzara, and by the German writer, Hugo Ball. Physically isolated in Switzerland by the Great War, and intellectually alienated by the assault on reason epitomised by that conflict, the Zurich Dadaists had turned their backs on rationalism altogether. Although Tzara re-established Dada in Paris after 1919, Dadaism soon lost impetus there, for it was essentially a nihilistic response to the world, preaching the destruction of all reason and rational communication. Surrealism, however, represented something more positive, for it wanted actively to liberate the subconscious into articulating responses to the world that were more direct than the ones created by rational thought. To this end, from the early 1920s onwards a group of leading artists, poets, and intellectuals in Paris, led by André Breton, set out to explore the vast realms of thought and response that lay behind the irrational, which they held to be a more truthful mirror to reality than rationalism.

By the late 1920s, knowledge of Surrealism was widespread in Spanish intellectual circles, and of course awareness of the work of Spanish Surrealist painters living in Paris such as Joan Miró (and Picasso, who was also somewhat influenced by Surrealism at this time) contributed greatly to that growth of interest. Thus several articles on Miró appeared in 1927-1928

in *L'Amic de les Arts*, and throughout 1927 and 1928 Dalí worked through Miró's influence, as well as that of other Surrealist painters and sculptors such as Yves Tanguy, Max Ernst, André Masson, and Jean Arp, in addition to that of proto-Surrealist artists like Giorgio de Chirico and Carlo Carra (Masson's influence can especially be detected in *The Spectral Cow*, p. 13). In 1927 Dalí even experimented with automatic drawing, in which the conscious mind played no part whatsoever other than beginning and ending a seemingly random process of mark-making. Not until the American painter Jackson Pollock would explore automatic process as an end in itself a decade and a half later would this major strand in Surrealism receive fulfilment, but for Dalí in the late 1920s such a direct means of articulating the irrational proved unsatisfactory. Instead, he gradually moved towards forging a new union between the normal appearances of things and unreality. In this respect the influence of Tanguy, Ernst, and De Chirico proved to be of seminal importance.

A particular feature of the imagery of these three artists is the degree to which they married realistic landscape settings and rational space – the traditional, perspective-based space encountered in Renaissance and post-Renaissance painting – with strange and unreal objects placed in those lifelike surroundings. Usually Tanguy created a kind of vague, desert-like landscape in which to locate his weird, polymorphic creatures and objects, while De Chirico created semi-deserted cityscapes as, occasionally, did Ernst. Dalí took over the rational use of space and the realism to be found in the works of these three artists, and he also assimilated the polymorphic forms of Tanguy in the paintings he made after 1927. Subsequently it did not take much imagination for him to move on from the desert-like landscape backgrounds that Tanguy had commonly used, to the fantastic geological formations, vast spaces, and limitless skies of his native Catalunya, and particularly those of the vast Empurdán plain around Figueres which he had known since childhood. By employing such backgrounds Dalí was greatly helped in dealing with his own experiences. In time this employment of landscape would become one of the major strengths of his art, contributing greatly to the sense of disturbing unreality in his pictures and making him arguably the foremost landscape painter of the 20th century.

In the winter of 1928 Dalí also began working in another important creative sphere: film. A year earlier he had written an essay on the subject entitled "Film-Art, Anti-Artistic Thread" which he had dedicated to his old friend from the Madrid Residencia, Luis Buñuel, who by that time was working in the Parisian film industry. In the essay, Dalí extolled the freedom of visual imagery and movement enjoyed by film and deprecated the way that the medium was usually employed simply to recount a straightforward narrative, instead of cutting across normal meanings and timescales. Moreover, Dalí equally rejected the way that modernist artists who had experimented with cinema, such as Man Ray and Fernand Léger, had employed abstractive cinematic imagery in their films. For Dalí the power of film lay in its potential to marry ordinary objects and surroundings with non-rational dramatic situations, in order to create a new dimension of meaning and open up hitherto unexplored ways of apprehending reality.

Dalí soon got the chance to turn theory into practice, for during the winter of 1928 Buñuel visited him in Figueres to show him the outline for a movie. Dalí instantly rejected this script as being too conventional, and in the following week he and Buñuel wrote a new scenario together. As Buñuel later recalled:

> Our only rule was very simple: no idea or image that might lend itself to a rational explanation in any way would be accepted. We had to open all doors to the irrational and keep only those images that surprised us... The amazing thing was that we never had the slightest disagreement; we spent a week of total identification.
> "A man fires a double bass", one of us would say.
> "No", replied the other, and the one who'd proposed the idea accepted the veto and felt it justified. On the other hand, when the image proposed by one was accepted by the other, it immediately seemed luminously right and absolutely necessary.

The result would be a film that took Surrealist cinema into a whole new dimension of psychological disturbance and cultural subversion: *Un Chien andalou*.

Cover Design for Minotaure No. 8, 1936.
Ink, gouache, and collage on cardboard, 33 x 26.5 cm. Isidore Ducasse Fine Arts, New York.

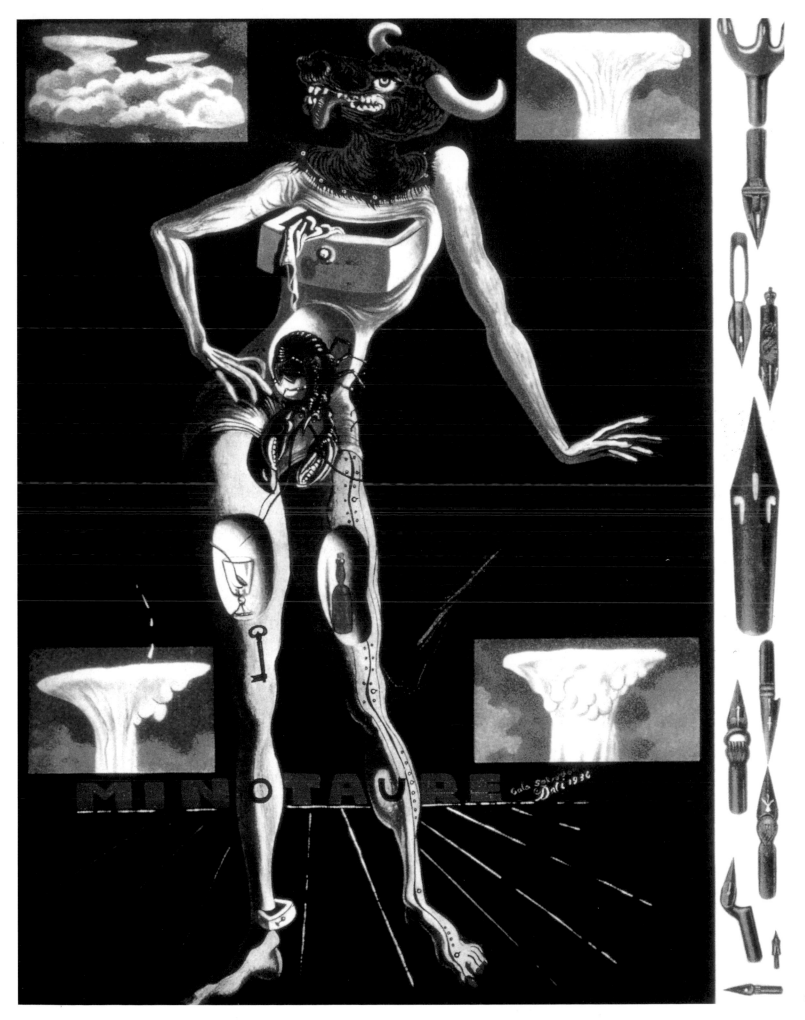

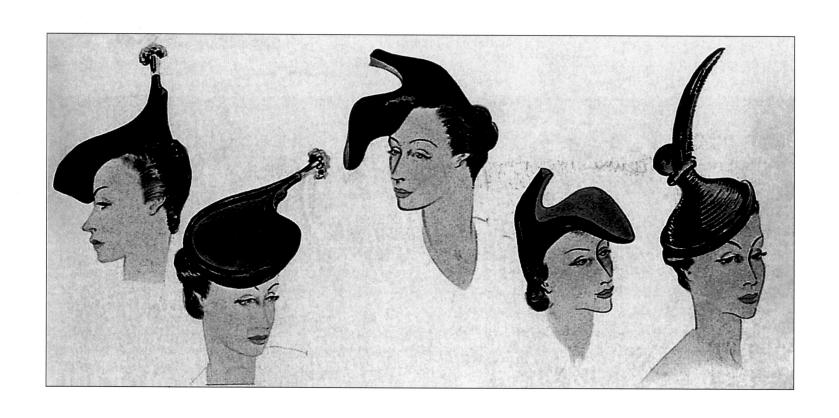

Hats Designed for Elsa Schiaparelli, 1936.

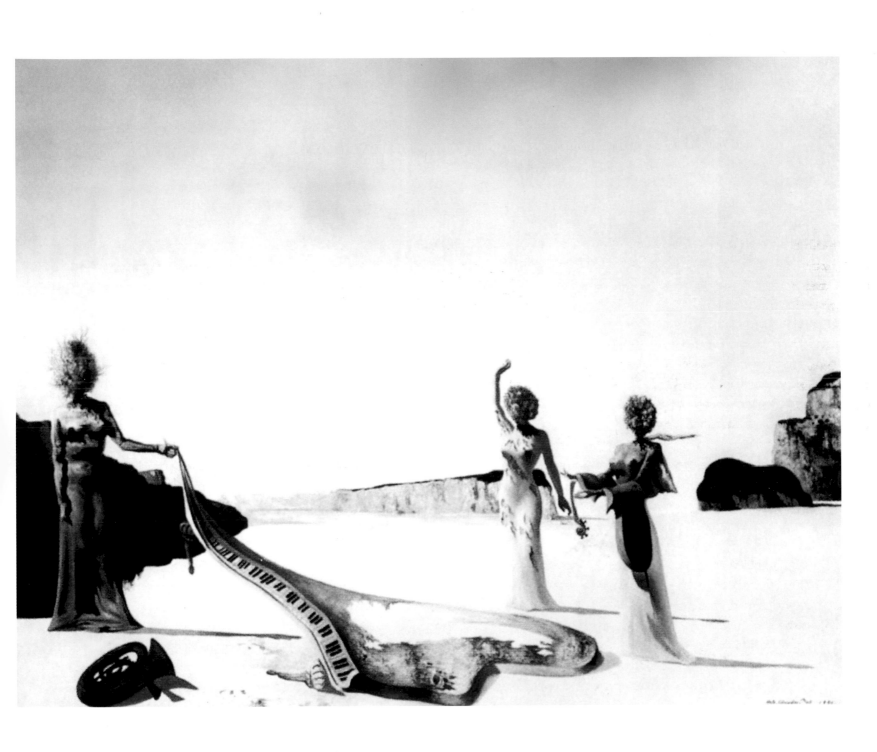

Three Young Surrealist Women Holding in Their Arms the Skin of an Orchestra, 1936.
Oil on canvas, 54 x 65 cm. Salvador Dalí Museum, St Petersburg (Florida).

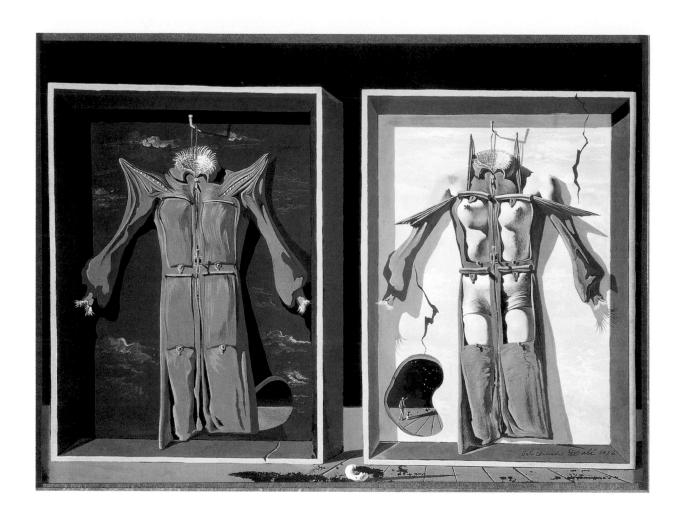

into his work in preparation for the Paris exhibition. He produced some of his finest masterworks that autumn, pictures such as a portrait of Paul Éluard, which Dalí freely admitted was a means of salving his conscience over his affair with the poet's wife; *The Enigma of Desire*, in which the painter dealt with his relationship with his mother; and *The Great Masturbator*, a work that he called "the expression of my heterosexual anxiety". The show itself, held in the Camille Goemans Gallery between November and December, included eleven paintings and was a great success, finally consolidating Dalí's reputation with both the critics and the public. Breton wrote an introductory essay for the catalogue (although even then he harboured doubts about whether Dalí would fulfil his promise as a Surrealist artist), and that put the seal upon the painter's acceptance by the Surrealist movement, with which he had aligned himself fully on the earlier visit to Paris that spring. The exhibition was a sell-out,

and Breton bought a painting (*Accommodations of Desire*), as did a leading collector, the Vicomte de Noialles, who hung his acquisition (*The Lugubrious Game*) between pictures by Cranach and Watteau. Yet although the show was a success, Camille Goemans was deeply in debt and he was unable to pay Dalí what he owed him from the sale of his pictures. The Vicomte de Noialles thereupon stepped in and advanced 29,000 francs for another painting. With the money, Dalí bought himself a fisherman's cottage in Port Lligat, near Cadaqués, in March 1930.

In addition to buying pictures, the Vicomte de Noialles was to be important to Dalí in other ways. Subsequently he introduced Dalí to his next Parisian dealer, Pierre Colle, and he gave Buñuel and Dalí the money to make a further film, although Dalí was far less happy with Buñuel's efforts this time round. The film, *L'Age d'or*, was even more violent and subversive

Night and Day Clothes of the Body, 1936.
Gouache on paper, 30 x 40 cm. Private collection.

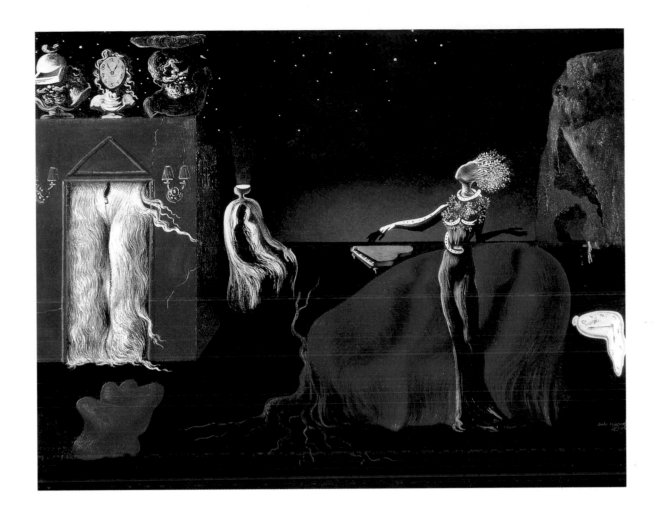

than its predecessor, but Buñuel fashioned it into a specific attack upon clericalism, a narrowing of meaning that led Dalí to feel betrayed by his collaborator. Shortly after the premiere of *L'Age d'or* in 1930, right-wing thugs smashed up the cinema in which it was being shown and destroyed works of art that were hanging in the foyer, including a painting by Dalí.

After returning to Paris in 1929, Gala Éluard briefly returned to her husband. However, by the following year she had moved in with Dalí. The painter's father took a very dim view of his son's liaison with a married woman and mother who was, moreover, almost ten years older than his son. Additionally, Dalí senior was enraged by a print made by his son which depicted the Sacred Heart and bore the legend *Sometimes I Spit with Pleasure on the Portrait of my Mother* (p. 77). Understandably, Dalí's father interpreted this as a gross insult to his dead wife. The ensuing rows culminated in

Dalí senior disowning his son completely. Soon afterwards Dalí began using the story of William Tell's shooting of an apple from his son's head as a means of dealing with his strained love-hate relationship with his own father (see the *William Tell* of 1930, p. 87, *The Old Age of William Tell* of 1931, and *The Enigma of William Tell* of 1933, p. 103). In such comparatively direct treatments of the painter's most deep-seated anxieties and preoccupations it is possible to detect a newfound psychological focusing of his art.

Dalí had long been familiar with the writings of Sigmund Freud, having read *The Interpretation of Dreams* when still a student in Madrid. The book made a profound impression on him, for as he recorded:

This book presented itself to me as one of the capital discoveries in my life, and I was seized with a real vice

Singularities, 1937.
Oil on canvas, 165 x 195 cm. Teatre-Museu Dalí, Figueres.

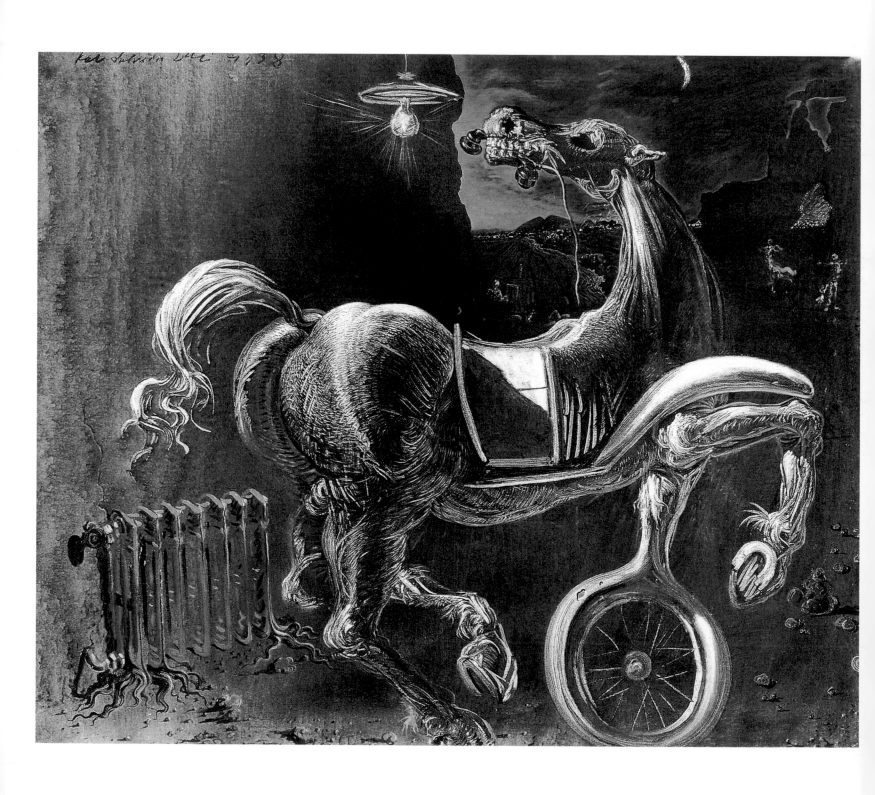

Debris of an Automobile Giving Birth to a Blind Horse Biting a Telephone, 1938.
Oil on canvas, 54.5 x 65.1 cm. The Museum of Modern Art, New York.

of self-interpretation, not only of my dreams but of everything that happened to me, however accidental it might seem at first glance.

By the end of the 1920s, Dalí had also read Richard Krafft-Ebing's *Psychopathia Sexualis*, with its exploration of sado-masochistic tendencies. Such writings were to prove fruitful for the painter not as subjects to be directly illustrated but as means of exploring his own fantasies pictorially. Within such a process the association of ideas and images became central, even if Dalí purposely employed those associations in a loose way so as not to imply specific meanings (it is the very ambiguity of meaning in his works that gives them their unusual imaginative potency). Moreover, in 1930 Dalí also began to build upon his immensely imaginative propensity for associating images through visual simile, the acute likeness that can exist between very different types of objects. Visual punning, whereby one thing stands for another, was also a favourite associative tool for an artist who could equally create images by bringing together objects that collectively constitute a very different kind of form. Then there are his double or treble images. Thus in the *Apparition of Face and Fruit Dish on a Beach* of 1938 (p. 141), we can see numerous visual similes, as well as composite imaging, whereby different components serve to make up a head of Lorca and of an "Andalusian dog", whilst in *The Slave Market with the Disappearing Bust of Voltaire* of 1940 (p. 144) we can perceive in the centre either two people dressed in antique costumes or a bust of Voltaire — the image switches from one to another when we gaze hard.

According to Dalí himself, this faculty for perceiving dual or more images within a single image derived from his schooldays; as he stated in *The Secret Life of Salvador Dalí*:

The great vaulted ceiling which sheltered the four sordid walls of the class was discoloured by large brown moisture stains, whose irregular contours for some time constituted my whole consolation. In the course of my interminable and exhausting reveries, my eyes would untiringly follow the vague irregularities of these mouldy silhouettes and I saw rising from this chaos, which was as formless as clouds, progressively more concrete images which by degrees became endowed with an increasingly precise, detailed and realistic personality.
From day to day, after a certain effort, I succeeded in recovering each of the images which I had seen the day before and I would then continue to perfect my hallucinatory work; when, by dint of habit, one of the discovered images became too familiar, it would gradually lose its emotive interest and would instantaneously become metamorphosed into 'something else', so that the same formal pretext would lend itself just as readily to being interpreted successively by the most diverse and contradictory configurations, and this would go on to infinity.
The astonishing thing about this phenomenon (which was to become the keystone of my future aesthetic) was that, having once seen one of these images, I could always thereafter see it again at the mere dictate of my will, and not only in its original form but almost always further corrected and augmented in such a manner that its improvement was instantaneous and automatic.

In time such an ability was augmented by other experiences, such as the discovery of a postcard view of an African village which, when looked at sideways, resembled the face of Picasso (in 1935 Dalí would turn that image into a painting that was later sadly destroyed). Undoubtedly a major influence upon Dalí as the creator of composite images was Giuseppe Arcimboldo (1527-1593), an Italian painter of fantastic human heads made out of pieces of meat, fish, fruit, vegetables and other foods, flowers, cereals, and the like. Eventually Dalí's employment of visual simile, punning, composite, double and multiple imaging would become one of the mainstays of his art, but it was certainly not based on anything as passive as dreaming. Dalí may occasionally have used dreams as the starting points for pictures, but more usually it was his highly developed and profoundly imaginative, wakeful 'inner-eye' which provided him with his imagery. Such an ability to connect the appearances of things would prove integral to the 'Paranoid-Critical Method' that Dalí began to evolve after about 1930, whereby associationism, when taken to

an extreme, could generate wildly imaginative and hallucinatory (or 'paranoid') states of mind.

In June 1931 Pierre Colle gave Dalí his second Parisian exhibition and introduced the painter to a New York dealer, Julien Levy, who in 1933 would mount his first one-man show in America. The 1931 Pierre Colle Gallery exhibition comprised twenty-one works, including the painting that would undoubtedly become Dalí's most popular picture, *The Persistence of Memory* (p. 93), which Colle later sold to Levy at the trade price of $250. The latter work was again exhibited in a group show of Surrealist paintings, drawings, and photographs held early in 1932 by Levy in New York, and on that occasion it was bought by the New York Museum of Modern Art in a particularly shrewd and far-sighted piece of collecting.

By 1932 Dalí was busier than ever. His customary method of work was to paint with the aid of a brilliant artificial light and a jeweller's magnifying glass placed in one eye. A good number of the canvasses produced at this time are extremely small – for example *The Persistence of Memory* is only 24.1 x 33 cm – which allowed the painter to work over much of the image with the finest of sable brushes, whilst the canvas itself has a very minute tooth so as to allow the creation of a high degree of detail without the brushmarks breaking up. And Dalí was not only creating fine paintings at this time. In 1933 he made perhaps his best set of etchings, namely the designs to illustrate a new edition of *Les Chants de Maldoror* by Isidore Ducasse, Comte de Lautréamont, which was commissioned by the Swiss publisher, Albert Skira. Moreover, during the early 1930s Dalí also began creating objects, such as those he displayed in a group Exhibition of Surrealist Objects held in 1933 at the Pierre Colle Gallery. It was very easy for him to do so, for in his paintings he had been creating for some years highly realistic spaces which he then filled with imaginative constructs, such as the form that combines a woman, two men, a lion, and a locust in *The Enigma of Desire: My Mother, My Mother, My Mother* of 1929 (p. 84). From creating such constructs in two dimensions it was a very short step to making them in three.

Dalí's first Surrealist objects had been elaborated in answer to a loss of direction felt by the Surrealists in 1929, when André Breton had instituted a commission that could propose new paths for the movement to follow; the advisory group comprised just Dalí and a young Marxist critic. Dalí had suggested the creation of Surrealist objects, and his idea was quickly taken up enthusiastically by other members of the Surrealist movement. Throughout the 1930s Dalí himself made a great number of objects, perhaps the most famous being his *Sofa in the Form of Mae West's Lips* (p. 134) and his *Lobster Telephone* (p. 135). The piece of furniture evolved as the natural offshoot of one of Dalí's most witty dual-image composites, *The Face of Mae West* (*Useable as a Surrealist Apartment*) of 1934-1935 (p. 112). Here the painter's inventiveness in creating visual puns reached new heights of genius.

In January 1933 another wealthy patron of the arts, Prince Jean Louis de Faucigny-Lucinge, was induced by Gala to persuade eleven other rich collectors (including the Vicomte and Vicomtesse de Noialles and an artistically-inclined, wealthy American widow, Caresse Crosby) to form a syndicate to support Dalí financially. The association was known as the 'Zodiac' group, and each of its members undertook to contribute the sum of 2,500 francs annually in exchange for the right to choose a large painting or a smaller picture and two drawings. The month in which the choices were to be made was to be decided by lots drawn at a pre-Christmas dinner. This syndicate stayed in existence until Dalí fled to America in 1940.

In 1932 Gala divorced Paul Éluard, and at the end of January 1934 Dalí married her in a civil ceremony in Paris, with her ex-husband as one of the witnesses. This was a frantically busy year for the painter, for in it he held no fewer than six one-man shows: two in Paris, two in New York (one of them solely of the *Chants de Maldoror* etchings), one in London, and one in Barcelona. Just before the Barcelona exhibition opened in October, Dalí travelled to Figueres and sought forgiveness from his father, which was finally forthcoming after the painter's uncle had pleaded on his behalf. Soon afterwards a political uprising in Barcelona forced the panic-stricken Dalí and Gala to make a headlong flight back

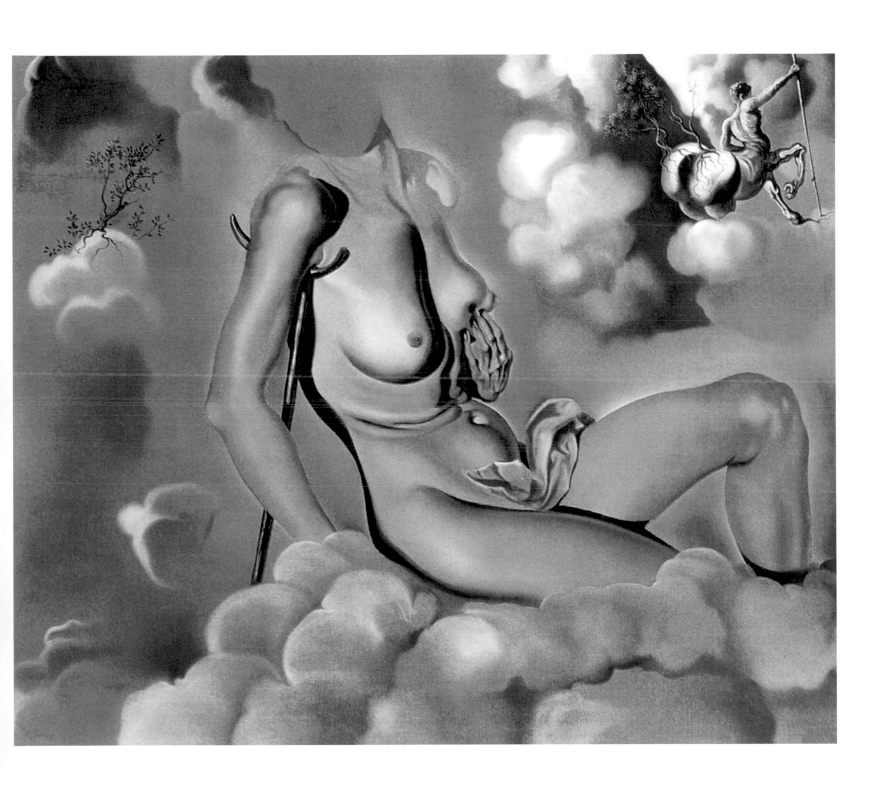

Honey is Sweeter than Blood, 1941.
Oil on canvas, 50.8 x 61 cm. Santa Barbara Museum of Art, Santa Barbara.

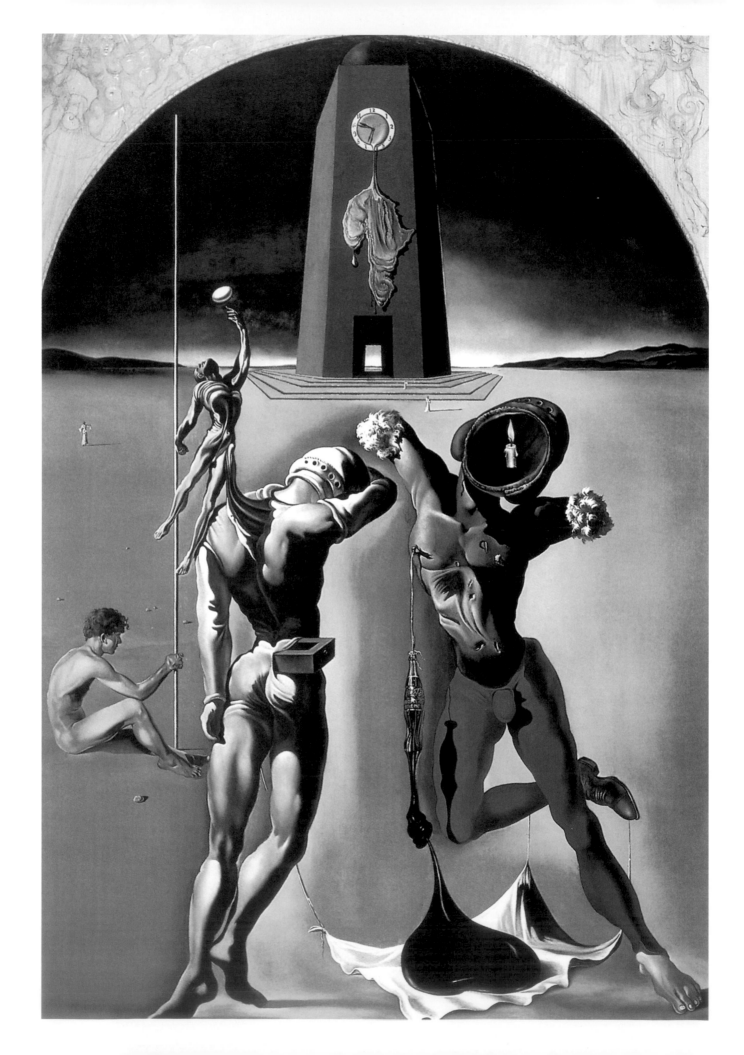

to France by car (their driver was killed by a stray bullet on his return journey to Barcelona). This taste of the unsettled state of Spanish politics shook the very unworldly painter considerably and it profoundly coloured his attitude to later political events in Spain.

In November 1934 the Dalís sailed for the United States, where they stayed until mid-January. The first showing of Dalí's work in America had taken place in 1931, at a group exhibition held at the Wadsworth Atheneum Museum of Art in Hartford (Connecticut) and his first one-man display there had followed at Julien Levy's gallery in the autumn of 1933. For Dalí's second one-man exhibition in New York, in 1934, the painter overcame his fears of travel. The trip to America was assisted financially by Picasso who had continued to take an interest in his unusually talented compatriot (whom he once wittily described as "an outboard motor continually running"). Dalí's characteristic social ineptitude surfaced on this journey, for on the train out of Paris he sat surrounded by all his canvasses with strings connecting them to himself lest they be stolen *en route*, and with his back to the engine so as to arrive sooner to his destination. On board ship Dalí wore a lifejacket continuously, although he was also balanced enough to prepare for his disembarkation in New York in a suitably eccentric manner by getting the ship's baker to prepare a loaf of bread over two metres long with which to face reporters, who untypically ignored the unusual object. But apart from that initial setback, Dalí found in America an ideal homeland for his exhibitionism, and at an ideal time. The Great Depression was in full swing by 1934, but of course it barely touched the rich who sought ever-more-elaborate ways of spending their money and more inventive diversions from the harsh realities around them. Despite his anti-bourgeois stance of some years earlier, Dalí – and perhaps even more so Gala – loved money, and from this time onwards a fundamental change of attitude began to come over the artist, one that would eventually lead to an alteration in the direction of his work.

Early in 1935 Dalí lectured in Hartford and at the Museum of Modern Art in New York, and it was during these talks that he made the much quoted claim that "the only difference between a madman and myself is that I am *not* mad". Before

the Dalís sailed back to Europe, Caresse Crosby organised a farewell fancy-dress party, the 'Dream Betrayal Ball' or 'Bal Onirique', at a fashionable New York restaurant. Dalí wore a pair of spotlit breasts supported by a brassière for this event, but for once the other participants appear to have outdone him in the surreality of their costumes. Indeed, Gala nearly caused a scandal because her headdress sported the effigy of a baby's corpse, possibly in an allusion to the kidnapped Lindbergh baby that had been murdered a few months earlier. Confronted with this act of calculated offensiveness by a reporter, the Dalís denied it, although later they privately confessed their intention.

In the summer of 1935 Dalí published an important essay, "The Conquest of the Irrational", in which he outlined his aesthetic, stating that:

> My whole ambition in the pictorial domain is to materialise the images of concrete irrationality with the most imperialist fury of precision. – in order that the world of imagination and of concrete irrationality may be as objectively evident, of the same consistency, of the same durability, of the same persuasive, cognitive and communicable thickness as that of the exterior world of phenomenal reality. The important thing is what one wishes to communicate: the concrete irrational subject. The means of pictorial expression are placed at the service of this subject. The illusionism of the most abjectly arrivisteand irresistible imitative art, the usual paralysing tricks of *trompe-l"oeil*, the most analytically narrative and discredited academicism, can all become sublime hierarchies of thought, and the means of approach to new exactitudes of concrete irrationality.

Unfortunately, what Dalí excluded from this cogent statement of aims was the possibility that the visual academicism would take over from any need to find something new to say.

In September 1935 Dalí had his last meeting with Lorca when the poet passed through Barcelona. The painter had written to Lorca suggesting that they should collaborate on an opera which would bring together King Ludwig II of Bavaria and Leopold Sacher-

Poetry of America, 1943.
Oil on canvas, 116 x 79 cm. Teatre-Museu Dalí, Figueres.

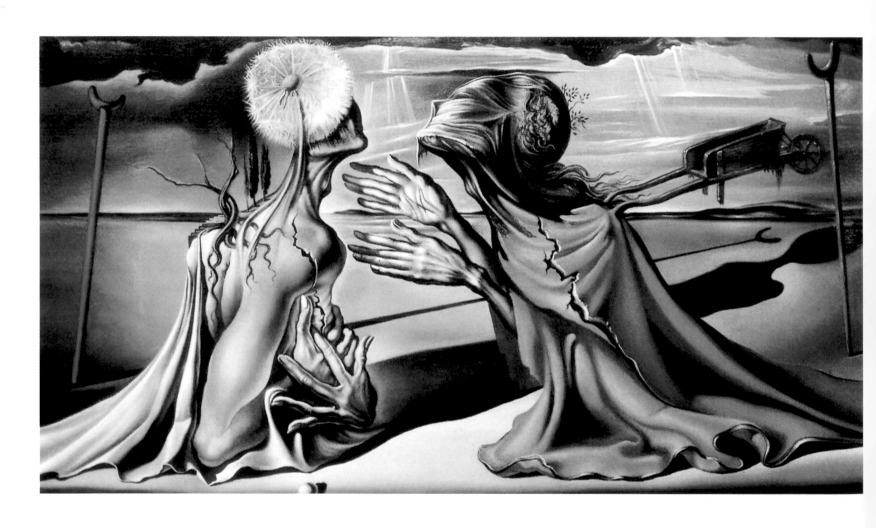

Tristan and Isolde (design for the ballet *Mad Tristan*), 1944.
Oil on canvas, 26.7 x 48.3 cm. Teatre-Museu Dalí, Figueres.

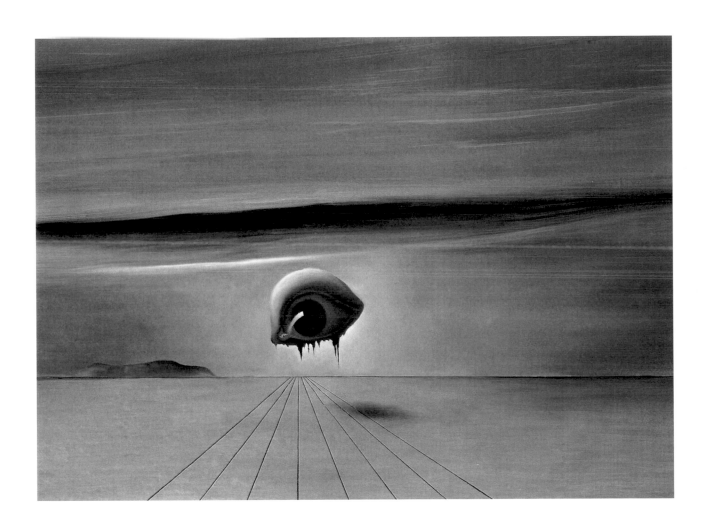

The Eye (design for *Spellbound*), 1945.
Oil on panel. Private collection.

Masoch, but the poet was evidently unresponsive. And although Lorca was overjoyed to see Dalí again – they had not met since 1927 – he was puzzled by the painter's marriage, for as he later told a friend, Dalí could never be sexually satisfied by any woman when he hated breasts and vulvas, was terrified of venereal disease, and was sexually impotent and anally obsessive.

On this trip to Spain, Dalí was accompanied by an important English art collector, Edward James, who claimed descent from King Edward VII and who had built up a superb collection of Surrealist art after inheriting a fortune as a young man. Dalí had agreed to sell James his most important works, an agreement that would continue until 1939, by which time the collector had acquired over forty of Dalí's best pictures. In 1935 James had also employed Dalí to redesign his house in Sussex in the Surrealist style, for which the painter suggested that the drawing room should recreate the feel and appearance of the inside of a dog's stomach. The architect who supervised the project, Hugh Casson, worked out how to carry out such a request, but the outbreak of World War II meant the project had to be shelved, although by that time several of Dalí's other, less ambitious proposals for the house had been implemented.

In the summer of 1936 Dalí visited London for the International Surrealist Exhibition being mounted at the New Burlington Galleries. He agreed to give a lecture there and requested a friend, the composer Lord Berners, to hire him a deep-sea diving suit in which to deliver the talk. When Berners telephoned a hire shop for such apparel he was asked, "to which depth does Mr Dalí wish to descend?", to which he replied, "To the depths of the subconscious". He was then told that because of such a requirement, the suit would have to be fitted with a special helmet, instead of the normal one. But on this occasion Dalí's flamboyant exhibitionism nearly killed him, for he had forgotten to request some means of obtaining air in his outlandish garb, and as a result he nearly suffocated before his companions on the lecture platform realised that something was amiss and freed him (the audience thought that it was calculated behaviour and enjoyed it immensely).

Shortly afterwards, in mid-July 1936, the Civil War broke out in Spain. Dalí had anticipated the conflict in the *Soft Construction*

with Boiled Beans - Premonition of Civil War (p. 121) completed just a few months earlier, and later that year he painted *Autumn Cannibalism*. In both works, food figures significantly, perhaps as a realisation of Dalí's stated thinking that:

> When a war breaks out, especially a civil war, it would be possible to foresee almost immediately which side will win and which side lose. Those who will win have an iron health from the beginning, and the others become more and more sick. The ones [who will win] can eat anything, and they always have magnificent digestions. The others, on the other hand, become deaf or covered with boils, get elephantiasis, and in short are unable to benefit from anything they eat.

Dalí's own response to the war was typically uncommitted, for again he fled Spain, although he was probably right to panic, for modernist artists such as himself – and especially those who had attacked the bourgeoisie and Catholicism, as he had done in *Un Chien andalou* and *L'Age d'or* – were not safe there. Thus on 18 August 1936, Lorca was murdered by the fascists in Granada, although when Dalí heard the news he tried to make light of it by saying "Ole!". Quite rightly, this use of the response to a successful pass in bullfighting would be thrown back in his face for the rest of his life. (Later he attempted to justify the glib remark by stating that he had uttered it in order to show how Lorca's "destiny was fulfilled by tragic and typically Spanish success".)

When he was in London in the summer of 1936, Dalí visited the National Gallery where he looked carefully at Andrea Mantegna's *Agony in the Garden*. Later he recreated the conjunction of cityscape and unusual rock structures seen in that work in paintings such as *Sleep* (p. 131) and *Swans Reflecting Elephants* (p. 132). Soon after the outbreak of the Spanish Civil War, Dalí visited Italy at the invitation of Edward James, who had rented a villa near Amalfi; from there he went on to stay with Lord Berners in Rome. It seems likely that on his way back to Paris (where he had settled after fleeing from Spain), Dalí stopped off in Arezzo and Florence to examine the works of Piero della Francesca, for he referred to them in print in 1937. The imagery of Piero's renderings of the Duke

My Wife, Nude, Contemplating Her Own Flesh Becoming Stairs, Three Vertebrae of a Column, Sky and Architecture, 1945.
Oil on panel, 61 x 52 cm. José Mugrabi Collection, New York.

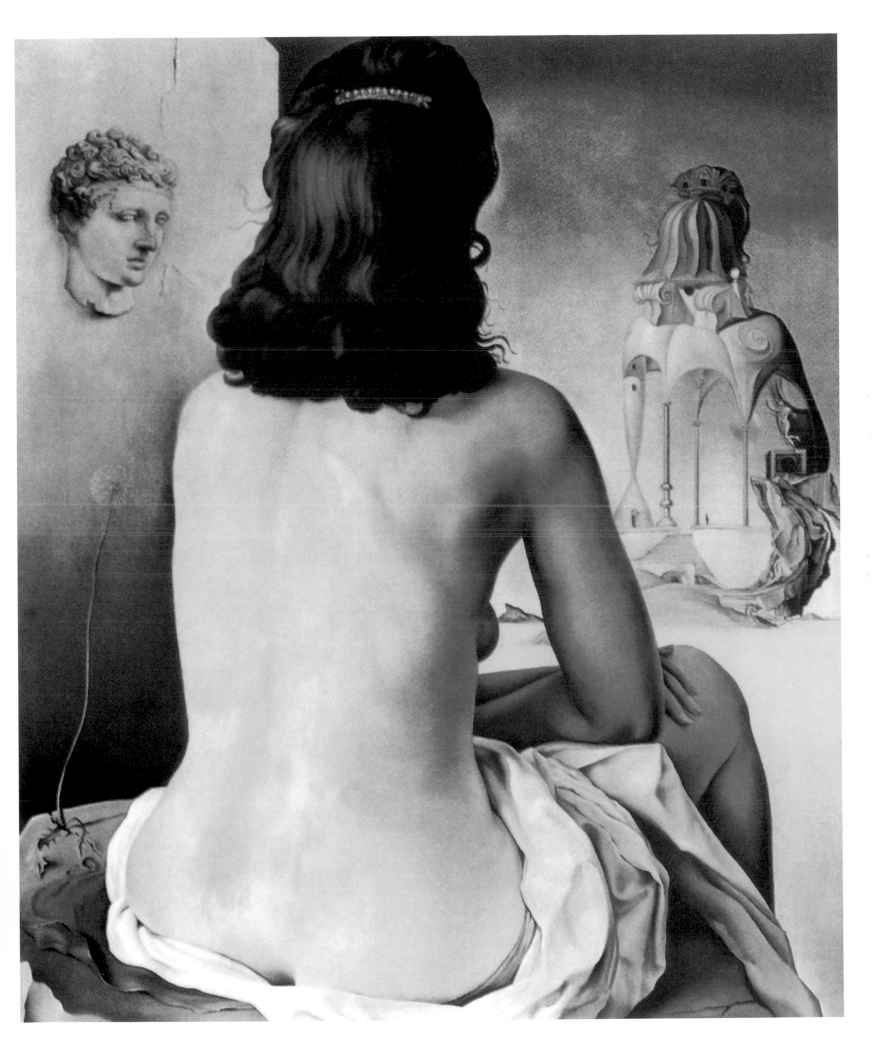

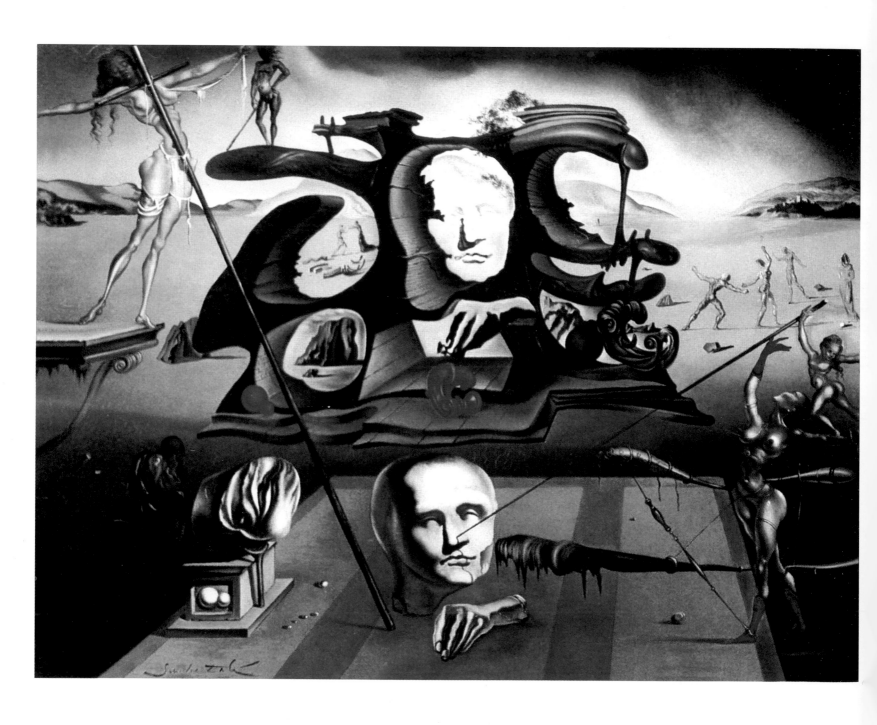

Napoleon's Nose, Transformed into a Pregnant Woman, Walking His Shadow with Melancholia Amongst Original Ruins, 1945.
Oil on canvas, 51 x 65.5 cm. The G.E.D. Nahmad Collection, Geneva.

Dematerialization Near the Nose of Nero, 1947.
Oil on canvas, 76.4 x 46 cm. Teatre-Museu Dalí, Figueres.

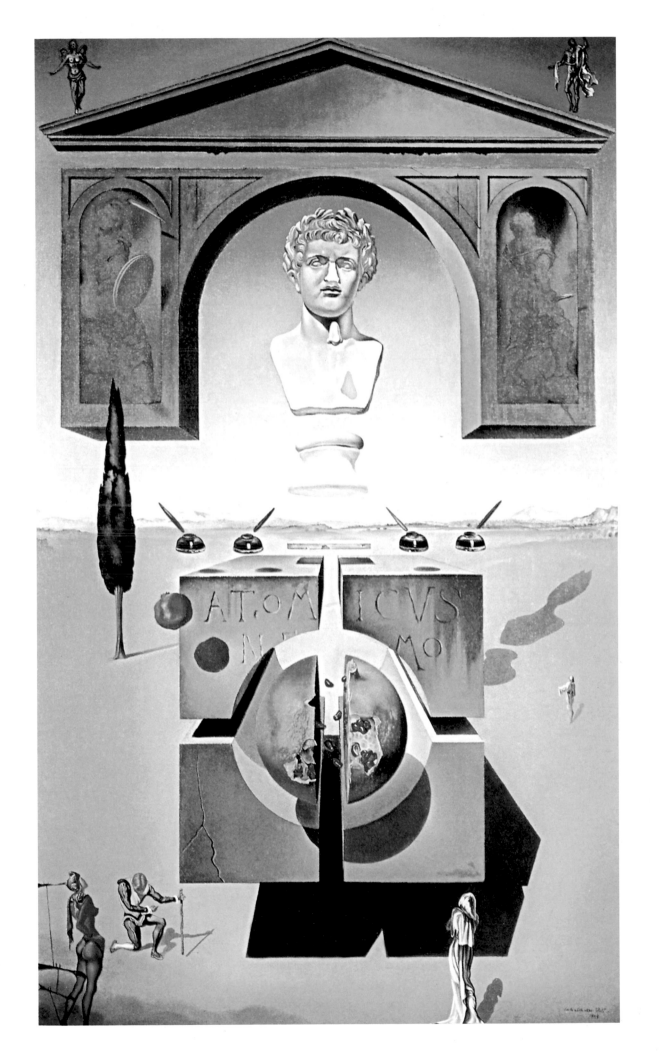

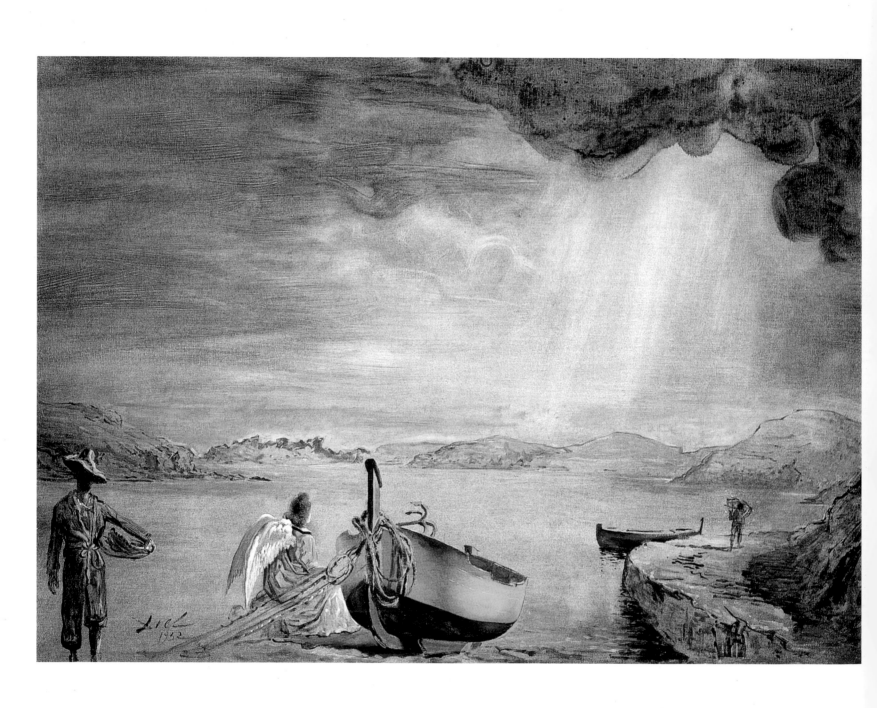

The Angel of Port Lligat, 1952.
Oil on canvas, 58.4 x 78.3 cm. Salvador Dalí Museum, St Petersburg (Florida).

of Montefeltro and his wife in the Galleria degli Uffizi, Florence, later conditioned the exact form of Dalí's 1945 *Portrait of Isabel Styler-Tas* (p. 157).

The Dalís again visited America in December 1936, and it was on this trip that the painter received that supreme accolade of American culture, namely appearance on the cover of *Time* magazine. The compliment was certainly an indication of the fundamental ineffectiveness of his cultural subversion. That Christmas, Dalí sent the comedian Harpo Marx a harp strung with barbed wire which Harpo evidently appreciated. Subsequently the painter visited Hollywood to sketch out a scenario with the funnyman Harpo, a script entitled *Giraffes on Horseback Salad*, although this would never be made into a film.

In the same year Dalí also began designing dresses and hats for the leading couturier to the *haut monde*, Elsa Schiaparelli, who had worked with Picasso and Jean Cocteau amongst others. Dalí was his usual inventive self as a designer, creating hats in the shape of upturned shoes, imitation chocolate buttons covered in bees, a handbag in the shape of a telephone and the like (p. 24).

Early in 1938 Dalí took part in the International Exhibition of Surrealism held at the Galerie des Beaux-Arts in Paris, for which he concocted perhaps his most elaborate object, the *Rainy Taxi*, a Paris taxicab whose roof was pierced so as to admit the rain. The car contained a shop-window mannequin that was dressed in a sordid cretonne print dress decorated with Millet's *Angelus*, over which two hundred live snails were free to roam. And later that year Dalí visited Sigmund Freud in London, where he made a small pen and ink drawing on blotting paper of the great Viennese psychoanalyst, a work that he later developed into some other fine portrait drawings. That autumn Dalí visited Monte Carlo to work with Coco Chanel, for whom he designed the ballet *Bacchanale* on behalf of the Ballet Russe de Monte Carlo. The painter called this entertainment, "the first paranoiac ballet based on the eternal myth of love in death", and in it he realised his intention, expressed to Lorca some years earlier, of creating a stage work around the persona and mind of the mad King Ludwig II of Bavaria, Richard Wagner's great patron.

The ballet was choreographed by Leonide Massine and accompanied by Wagner's music, and it transferred to New York towards the end of 1939.

Dalí had revisited New York in February 1939 for a further exhibition at the Julien Levy Gallery, and it was on this occasion that he was engaged by the Bonwit Teller department store on Fifth Avenue to design window displays, earning nationwide notoriety in the process. What the store had expected of Dalí is not known but what they got was a window revealing an astrakhan-lined bathtub filled with water and complemented by a mannequin wearing only green feathers and a red wig. Another window displayed a black satin bed supporting a mannequin resting her head on a pillow of live coals, over which stretched a canopy created out of a buffalo's head, with a bloody pigeon stuffed in its mouth. Not surprisingly, the pedestrians who walked past this comely display began complaining as soon as it went on view early one morning and it was hastily altered by the Bonwit Teller management. When Dalí turned up to survey his work later that day he was so enraged by the unauthorised changes that he overturned the bath through a plate glass window, and for his pains found himself hauled into court by a passing policeman, charged with disorderly conduct. He received a suspended sentence, but the publicity much enhanced his reputation for eccentricity, and the ensuing Levy Gallery show was almost a sell-out, greatly boosting Dalí's prices in the process. Clearly, scandal paid.

Dalí stayed on in America that summer in order to create a work for the New York World's Fair, his *Dream of Venus*; it was unrealised due to a disagreement with the World Fair's management. But soon after he returned to France, World War II broke out and the painter vacated Paris. Eventually he settled in Arcachon, in the south-west of France, a locale chosen for its good restaurants. Following the fall of France in June 1940, the Dalís returned via Spain and Portugal to the United States, where they arrived on 16 August 1940 and where they sat out the rest of the war.

Salvador Dalí's move to America in 1940 marked a watershed in his career, for his artistic achievements before

that date were far richer than they ever were after it. Until then the painter had genuinely and inventively grappled with his innermost responses to the world, and produced his greatest masterworks in the process. Moreover, his occasionally madcap antics seemed the natural offshoot of those responses, especially where a genuinely Surrealist subversion of accepted standards of 'civilised' behaviour was concerned. But after 1940, and especially because of the need to make money once the financial support of the Zodiac group had disappeared, Dalí the showman took over, whilst after the end of the Second World War a newfound interest in scientific, religious, and historical subject matter meant that the authenticity of Dalí's exploration of the subconscious began to drain away, to be replaced by something far more calculated in effect. Moreover, after 1940 a new banality often entered into Dalí's work, as his imagery was made to bear a more rationally comprehensible load and a more directly symbolic meaning. Of course there is nothing innately invalid about Dalí's enthusiasm for scientific, religious, and historical subject matter; the painter had as much right to pursue such interests as anyone else. But the question arises as to whether those concerns led to any creative enhancement of Dalí's imagery and its development into new areas of aesthetic experience, and for the most part the answer has to be a negative one, for too often Dalí's later quasi-scientific, religious, and historical pictures lack any innovatory aesthetic dimension and thus seem merely illustrative. Sadly too, financial greed – in which Gala played a major part – would also determine much of Dalí's artistic sense of direction after 1940, eventually making the painter into the willing accomplice to one of the largest and most prolonged acts of financial fraud ever perpetrated in the history of art.

Once safely across the Atlantic in 1940, the Dalís at first settled with Caresse Crosby in Hampton, Virginia, where they lived for a year, virtually taking over the widow's mansion and holding court there in the process. Later they moved westwards to settle in Monterey, south of San Francisco. In 1941 Dalí produced his first volume of autobiography, *The Secret Life of Salvador Dalí*, a work in which he greatly furthered the myths about himself as a madman who was not mad. This book was later analysed by George Orwell in one

of his most brilliant essays, "Benefit of Clergy" (1944), in which he took at face value the Dalínian myth but argued, "One ought to be able to hold in one's head simultaneously the two facts that Dalí is a good draughtsman and a disgusting human being". He also questioned the right of an artist like Dalí to claim exemption from the normal moral constraints of mankind (hence the title of the essay).

The American years were busy ones, with Dalí living the high life and building upon his realisation that at a time in which a booming war economy was bringing into being a new monied class in the United States, people who had never before had the time, money, or inclination to purchase works of art were now purchasing art on an unprecedented scale, and often in order to boost their social status. To reach out to such a new economic force, Dalí optimised the value of self-publicity, becoming in the process the darling of that section of the American *haut monde* which wanted the delicious thrill of dallying with danger that Dalí apparently represented, although of course he presented no real threat to it at all and would do so less and less as time went by.

In these years Dalí painted society portraits, holding an exhibition of such pictures in New York in 1943; he designed a charity dinner to raise money for wartime refugees, for which event he had 5,000 jute sacks suspended above the banquet to create a sense of suffocation, in the process re-creating in the U.S.A. an environmental sculpture that had originally been created by Marcel Duchamp for the 1938 Paris Surrealist exhibition; he designed an apartment for Helena Rubinstein; he wrote a novel entitled *Hidden Faces*, published in 1944; he created ballets; he began publishing his own self-promotional newspaper, *Dalí News*, which only ran to two issues; in 1945 he went to Hollywood to work with Alfred Hitchcock on the dream sequence of the latter's film, *Spellbound*. Hitchcock wanted a Dalínian type of sharply-focused surreal imagery because he apprehended that dreams and nightmares are often not visually vague affairs but quite the contrary. Dalí duly provided some very resonant images indeed, including a sequence of painted eyes being cut open by scissors that clearly stemmed from the eye-cutting sequence in *Un Chien andalou*. And in 1946 Dalí and

The Maximum Speed of Raphael's Madonna, 1954.
Oil on canvas, 81 x 66 cm. Museo Nacional Centro de Arte Reina Sofía, Madrid.

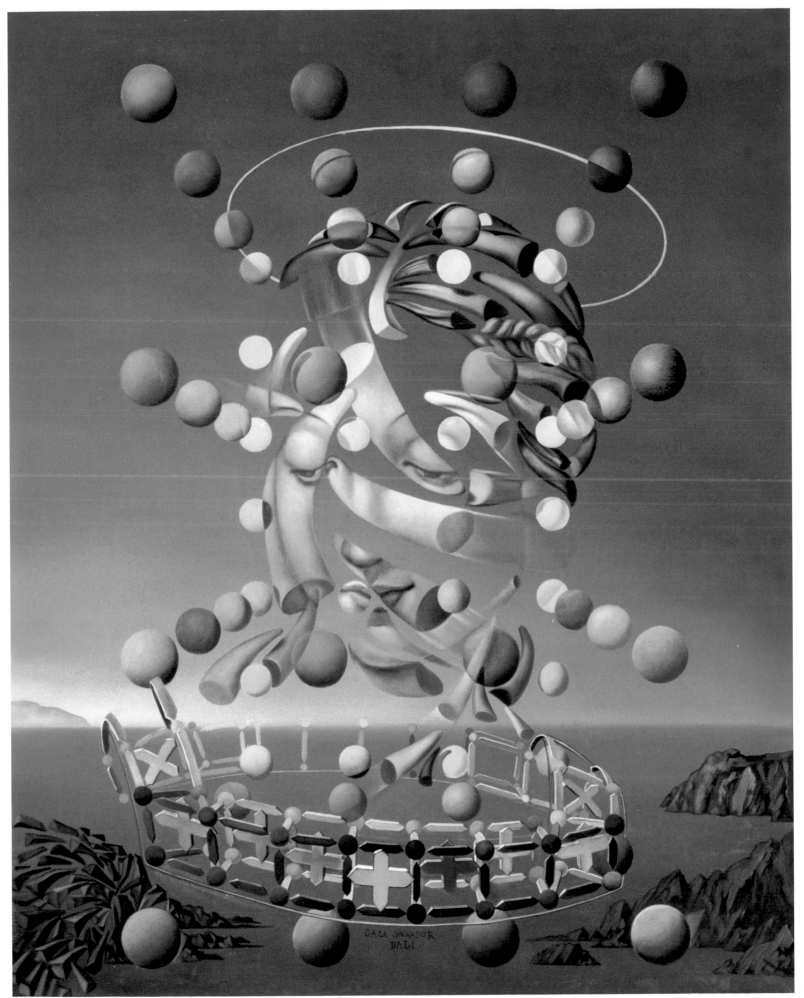

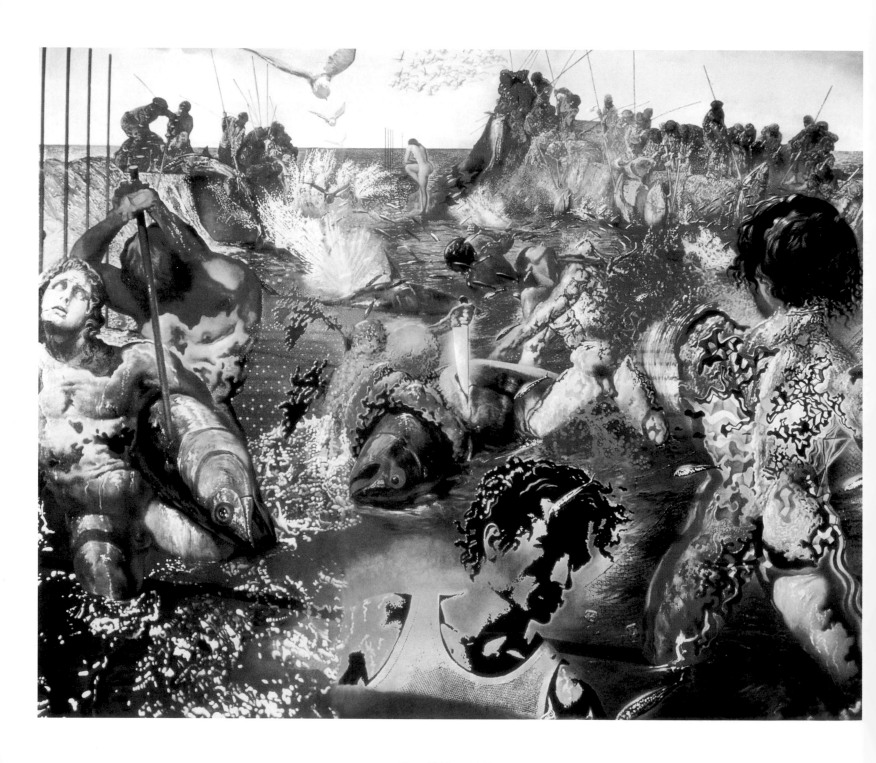

Tuna Fishing, 1967.
Oil on canvas, 304 x 404 cm. Paul Ricard Foundation, Paris.

Mad Mad Mad Minerva, 1968.
Gouache and Indian ink with collage on paper, 61 x 48 cm. Galerie Kalb, Vienna.

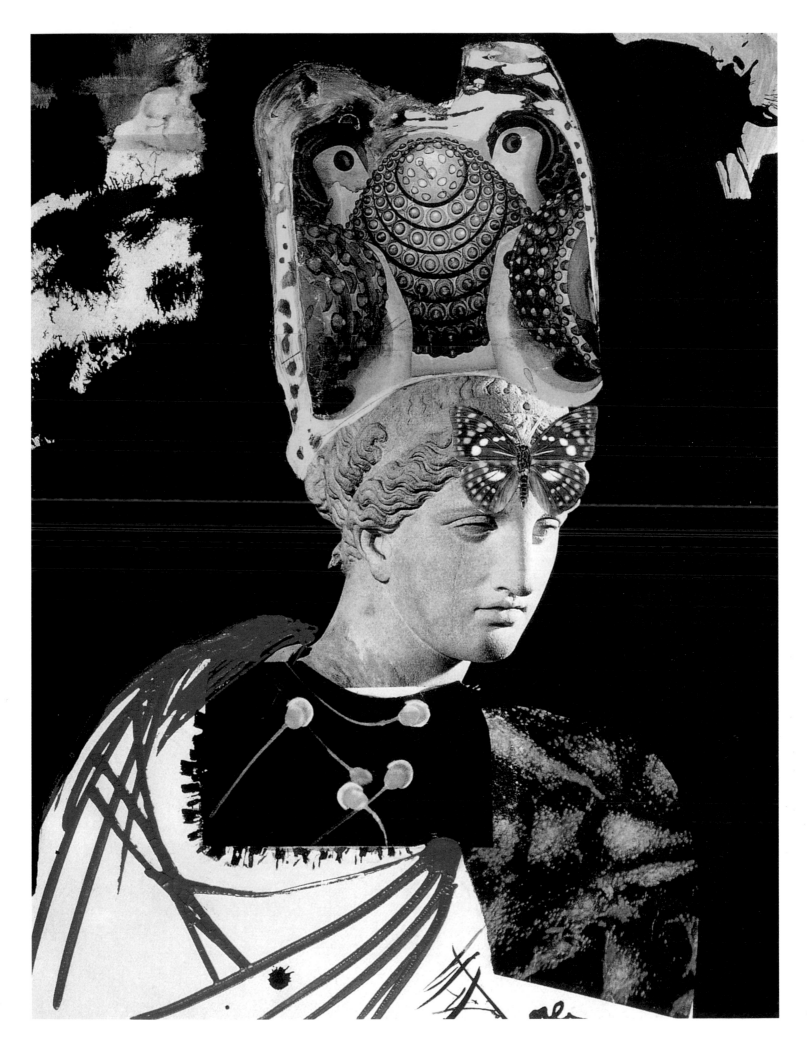

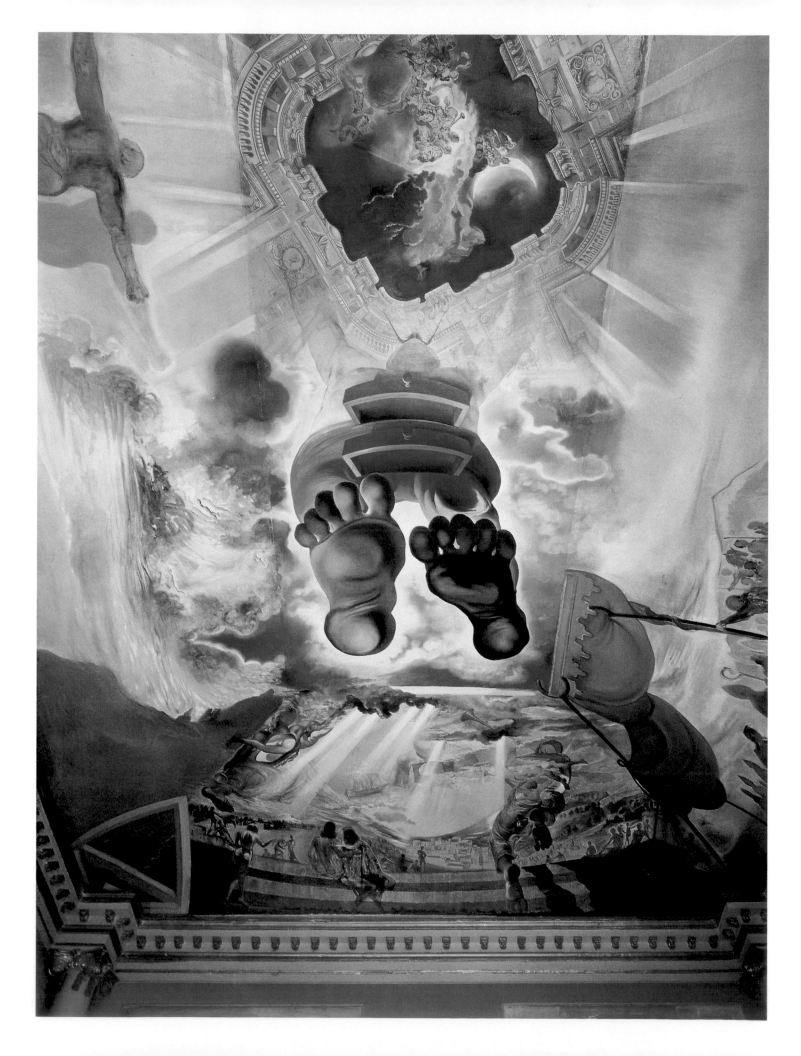

Walt Disney collaborated on a short animated sequence that was intended to form part of a full-length film called *Destino*, although this was never developed further.

In 1948 the Dalís at last returned to Europe. Thereafter they regularly spent part of each winter in New York and the rest of the year in Paris and Port Lligat. By this time André Breton had expelled Dalí from the Surrealist movement, thus bringing to a conclusion his long-lived dissatisfaction with the artist. Earlier, in 1934, Breton had been enraged by Dalí's portrayal of Lenin in *The Enigma of William Tell* and had even attempted to attack the painting physically, but failed. Equally he had been disgusted at Dalí's lack of enthusiasm for Marxism and by his professed admiration for Hitler, a response that seems to have been motivated more by the painter's desire to offend Breton than by any genuine liking for the German dictator. As a consequence of all these provocations, in February 1934 Breton had put Dalí 'on trial' in Paris. The event was very Surrealist, with Dalí running a temperature because of flu and sucking on a thermometer that made his dialogue with Breton and his fellow jurors utterly incomprehensible. Eventually Breton had allowed Dalí to remain in the group. But by 1948 Dalí's avidity for money – which led Breton to coin his memorable anagram of the painter's name, 'Avida Dollars' – as well as his professed and by now genuine sympathy for another Fascist dictator, General Franco, necessitated his expulsion from the Surrealist movement, although Dalí appears to have lost no sleep over it.

In many ways Breton's expulsion of Dalí from the Surrealist movement was understandable, for by the mid-1940s the painter had ceased to explore the subconscious and the irrational to anything like the degree he had done in the 1930s. Although the artist continued to project his fantasies, fantasy is not the same as Surrealism, for it merely embroiders reality, whereas Surrealism essentially works against its grain. But after the mid-1940s, Dalí's art was frequently supportive of rationally comprehensible experience, despite being couched in an imagery that might look unreal at first glance. Thus in a picture like *The Temptation of St Anthony* of 1946 (p. 158), the imagery does not project Dalí's psychological

responses but instead simply gives us the hallucinatory vision of the saint who is portrayed at the bottom-left – in other words, the unreal imagery serves a merely illustrative function. Similarly, in one of Dalí's most popular pictures of the post-war years, the *Christ of St John of the Cross* of 1951 (p. 166), the cross and figure floating above the landscape serve to project the floating, mystical state of the martyr, another explicable apprehension. And in a work like *The Sacrament of the Last Supper* of 1955 (p. 174), we are but one remove from a still in a Hollywood epic, with overlaid imagery that is identical in effect to that obtained by a multi-exposure photograph. Here there is little displacement of reality, and the imagery projects a very transparent religious symbolism, with its alignment of the bread and wine before Christ with the substance of His flesh above, to which He points with three raised digits in an allusion to the Trinity.

During the late 1940s and as a direct result of the growth of atomic physics throughout that decade, Dalí became intrigued by the latest scientific developments, stating that whereas Freud's theories had provided the intellectual basis for his earlier art, now those of the physicist Werner Heisenberg would do so. Dalí appreciated the massive progress of science in our time but also lamented the gap that had widened between our knowledge of the physical world and our appreciation of the metaphysical sphere, that which exists beyond the purely physical realm. Dalí became increasingly preoccupied with reconciling the two by means of a metaphysical system which he called "nuclear mysticism". Unfortunately, however, this "mysticism" did not necessarily provide the painter with an imagery that goes very far beyond physical appearances; instead, it usually just looks rather like science fiction illustration, albeit with a quasi-mystical bias. Moreover, after the 1950s Dalí frequently incorporated into his oeuvre different styles and techniques of painting, such as abstract expressionism in the late 1950s, optical art in the 1960s, and pointillism in the 1970s. He also experimented with new means of creating images such as stereoscopy, holography, and digitalisation in the 1960s and 1970s. These stylistic assimilations and technical explorations certainly demonstrated Dalí's acute creative adventurousness, but again they did not advance his art much in terms of its

Wind Palace, 1972.
Ceiling painting. Teatre-Museu Dalí, Figueres.

content – too frequently we see old and by-now-somewhat-stale wine served up in new bottles.

Yet whilst Dalí increasingly demonstrated his technical adventurousness after the 1940s, paradoxically on a human level he moved away from the radicalism of thought and social stance that had characterised his art and behaviour in the 1930s. One milestone of that change in terms of social acceptance was the audience Dalí received in November 1949 from Pope Pius XII, an occasion on which the painter presented the Pope with the smaller of his two versions of *The Madonna of Port Lligat* (the larger version found on p. 165). What the Pope made of the picture is not recorded, but he would surely have been shocked to learn that Dalí did not just use Gala as a model for such religious paintings: he genuinely thought her divine. Such an elevation was somewhat ironic, given that Gala's highly promiscuous sexual behaviour differentiated her in every way from the supposedly virginal Mother of God. Moreover, both in America and in Europe from the 1940s onwards, Gala compensated for Dalí's sexual inadequacies by maintaining a constant succession of young lovers. Ironically, one of them enjoyed 'divine' associations, for Jeff Fenholt, whom Gala acquired as a sexual partner in the late 1960s, starred as Jesus Christ Superstar in the Broadway musical of that name.

Nor was the Pope the only one of Dalí's newfound cultural heroes. Over the years the painter identified evermore closely with the fascist dictator General Franco, who in 1964 conferred a high civil order on him, the Cross of Isobel the Catholic. In 1974 Dalí painted a portrait of Franco's granddaughter, and the following year he sent the dictator a telegram congratulating him on executing several Basque secessionists, an act of support that caused uproar in Spain. Dalí then poured fuel on the flames by publicly regretting that Franco had not executed more such "terrorists". Clearly the painter had come a long way from the irreligious, anti-social Surrealist of the 1930s.

Throughout the 1950s and increasingly thereafter, the Dalí commercial bandwagon rolled on, with the painter burnishing his reputation for eccentricity by referring to himself constantly as "the Divine Dalí", and taking every opportunity to capitalise upon the widespread mass-media hunger for sensationalism. In this respect, after about 1945 Dalí became a trendsetter in his comprehension of the way that the spread of the mass-media in the post-war world was changing social expectations of what an artist should be, and how he could meet and build upon those expectations commercially by striking a sensationalist pose. Moreover, by the mid-1950s the painter was at the centre of a commercial operation that was unprecedented in the history of art. He had acquired a manager, Peter Moore, who looked after his affairs between 1962 and 1976 and who eventually boasted that when he began working for Dalí, the painter could only expect a thousand US dollars for a single canvas, whereas by the time he left Dalí's employ the artist's prices were in the half-a-million-dollar range. Moore himself made millions out of the commissions he received from merchandising every aspect of Dalí, from Dalí ashtrays to Dalí perfumes, and one can readily believe his claim that he had exhausted the yellow pages telephone directory finding products that he could link to Dalí. Moore was subsequently followed in the same role by Enrique Sabater and by Robert Descharnes.

By now the lifestyle of the Dalís obviously required vast sums of money. In New York they habitually stayed at the St Regis Hotel, in Paris at the Meurice, and they always tipped lavishly. Gala liked to gamble on a big scale, and this too added to the need for income. Faced with these pressures, at some time in the mid-1960s, Dalí became party to a massive fraud perpetrated on print collectors.

Normally, prints are produced in limited and numbered editions, with the signature of the artist that authenticates them added only *after* they have been printed. Once the printing is completed the printing plates are destroyed in order to maintain the limited nature of the printing, and thus the price of each print, the smaller the numbers of prints in each edition the greater being their resale market value. Until the mid-1960s, Dalí had respected those conventions but after that time he began signing blank sheets of printing paper which later had worthless reproductions of the artist's paintings printed upon them and were sold as genuine prints issued

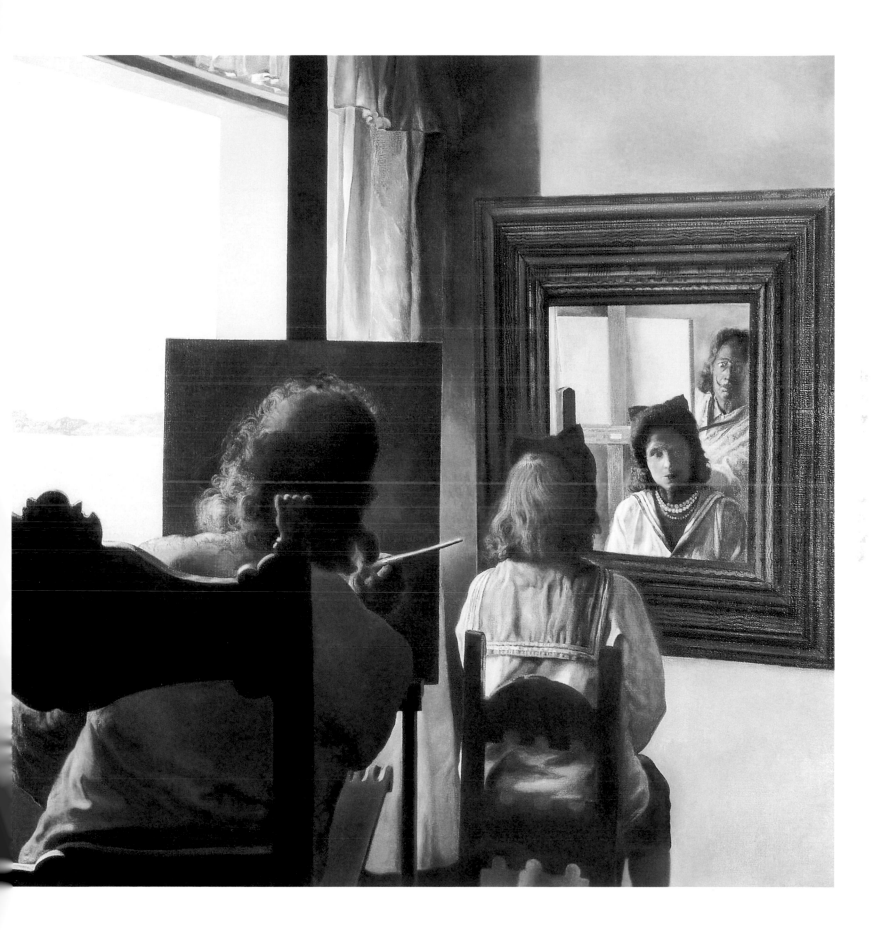

Dali Seen from the Back Painting Gala from the Back Eternalized by Six Virtual Corneas Provisionally Reflected in Six Real Mirrors (unfinished), 1972-1973.
Oil on canvas with two stereoscopic components, 60.5 x 60.5 cm (each). Teatre-Museu Dalí, Figueres.

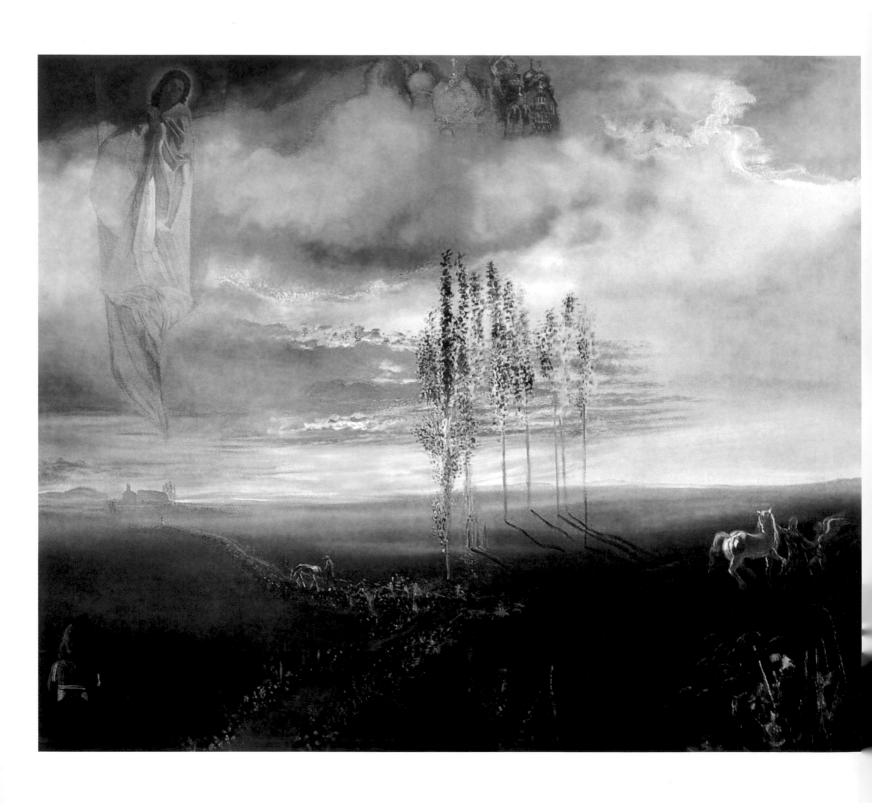

Gala's Castle at Púbol, 1973.
Oil on canvas, 160 x 189.7 cm. Fundació Fèlix Estrada-Saladich, Parc Museu 'El Pedregar', Barcelona.

from Dalí's own hand. Moreover, it did not prove difficult to forge the painter's signature either, and so many bogus prints bearing mere printed reproductions of Dalí's signature were also sold by unscrupulous dealers. Somewhere between 40,000 and 350,000 blank sheets were signed in advance by Dalí, and there is also no way of knowing how many forged signatures were produced. But as a result of this exploitative/lackadaisical attitude, the Dalí print trade was in chaos and many thousands of people have been conned into spending large sums of money to acquire utterly worthless prints. It might be argued that in debasing commercial values like this, Dalí was striking a blow against the rampant commercialism of the art market, but of course the painter was the first to profit from such exploitation, and any such justifications would therefore seem very hollow. Moreover, it was not only Dalí's prints that were faked. The painter also increasingly allowed his studio assistants to move from the permissible activity of filling in parts of his images to painting entire pictures on his behalf, works that eventually he signed and authenticated as having come wholly from his own hand. For the same reason, many of the paintings created in the 1980s must be considered extremely suspect.

In 1970 Dalí announced the creation of a Dalí Museum in Figueres, and in September 1974 the Teatre-Museu Dalí was inaugurated in the old, burned-out shell of the main theatre in the town. Another major foundation for the display of Dalí's works also opened to the public in these years, for in 1971 Reynolds and Eleanor Morse, American collectors who had built up the best private holding of Dalí's works anywhere since they started buying in the early 1940s, transferred their collection from their hometown of Cleveland (Ohio) to a purpose-built museum in St Petersburg (Florida).

Further public honours came Dalí's way in the remaining years of his life. In 1972 he was elected a Foreign Associate Member of the Académie des Beaux-Arts of the Institut de France, whilst in 1982 he was presented with the Gold Medal by the Generalitat of Catalonia and created Marquis de Púbol by the King of Spain. Large exhibitions of his work were mounted, such as the retrospective held at the Centre Georges-Pompidou in Paris in 1979, which later

transferred to London, and the similar survey put on at the Museo Español de Arte Contemporaneo in Madrid in 1983. But on a personal level these were sad years for Dalí. He suffered from medical complaints that were sometimes diagnosed as Parkinson's disease, although he does not appear to have had that illness. He was terrified of death. And he was increasingly isolated emotionally, for despite the fact that he was surrounded by acolytes, his relationship with Gala finally broke up as she ensconced herself in the castle in Púbol, near Figueres, that he had bought for her. There she maintained a succession of young lovers well into her eighties and refused Dalí admission unless he had written permission to visit her. Yet she continued to form the centre of the painter's emotional universe and not surprisingly, after she died in Púbol on 10 June 1982, he disintegrated psychologically. On 30 August 1984 he was seriously injured by a fire whilst asleep. Later it emerged that as well as suffering from burns, he was also seriously malnourished, despite having been surrounded by medical attendants, for he had simply refused to eat because of a delusion that he was being poisoned. When he was finally discharged from hospital he looked a very tragic sight indeed.

Salvador Dalí died on 23 January 1989 in Figueres. Throughout the six decades after 1930 he had been a major public figure, and for at least the first of those decades he had certainly been in the forefront of the modernist experiment, creating works that have not lost their power to intrigue and disturb us. If in the final analysis much of his later output was of a lesser creative and imaginative standard, it has still proven unusually attractive to a public avid for visual meaning and stimulation. Overall his paintings have never lost their ability to engage the eye, if only because of their immense technical proficiency. For that alone, Dalí's work will stand out from much contemporary art, which may be more advanced intellectually but which all too frequently has been shoddily crafted and done little to excite the eye. But in his finest pictures and objects, Dalí certainly made a major contribution to 20th-century art, as he reached down to the depths of the subconscious in new and revealing ways. Not for nothing did he request that diving suit in 1936.

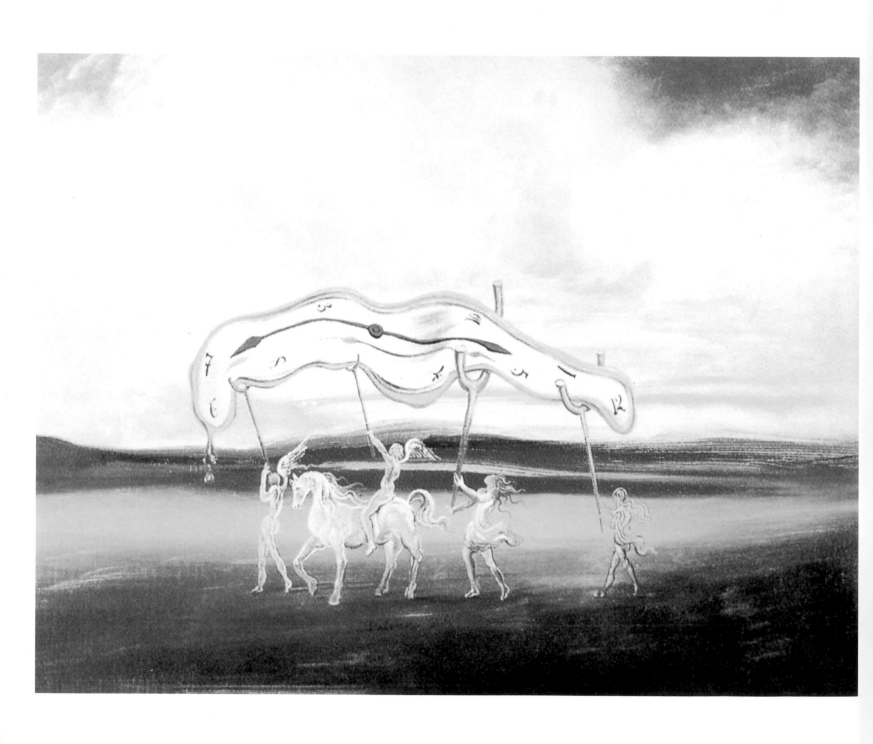

Wounded Soft Watch, 1974.
Oil on canvas, 40 x 51 cm. Private collection.

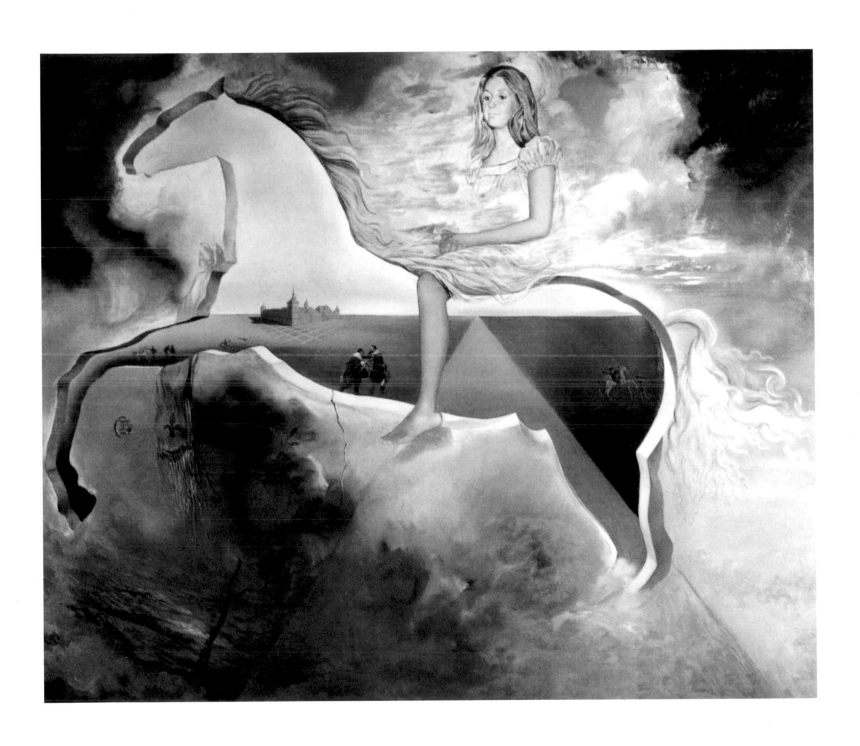

Equestrian Portrait of Carmen Bordiu-Franco, 1974.
Oil on canvas, 160 x 180 cm. Private collection.

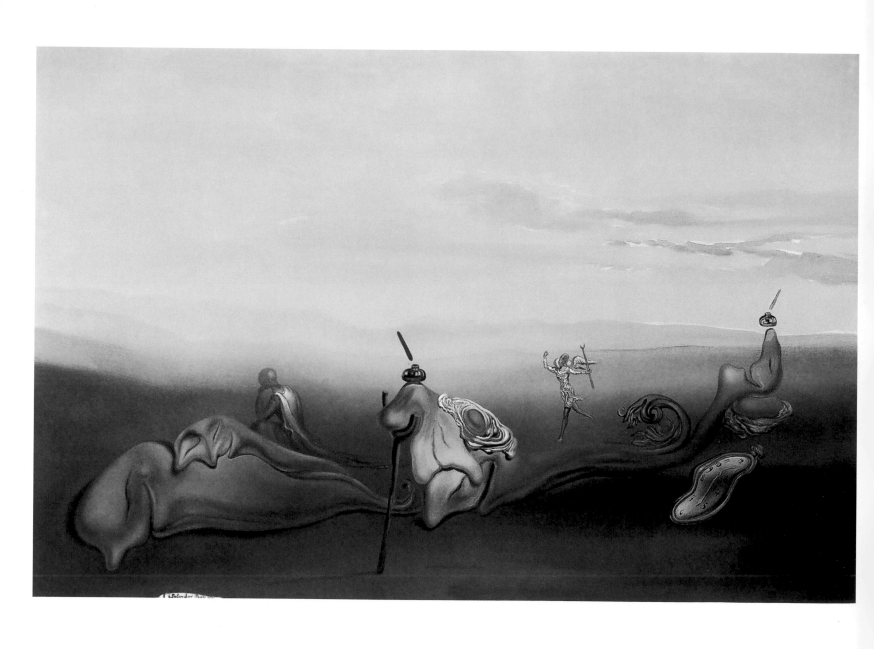

Soft Skulls with Fried Egg without the Plate, Angels, and Soft Watch in an Angelic Landscape, 1977.
Oil on canvas, 61 x 91.5 cm. Private collection.

The Masterworks

PORT OF CADAQUÉS AT NIGHT

c. 1918
Oil on canvas, 18.7 x 24.2 cm
Salvador Dalí Museum, St Petersburg (Florida)

Cadaqués is located about twenty-five kilometres to the east of Figueres, Dalí's birthplace. Today good roads ensure that a journey between the two usually takes less than an hour, but during Dalí's childhood it could easily take more than ten times as long. This was due to the poor communications over Cape Creus, a huge, intervening headland that forms the eastern-most point of the Spanish peninsula and some of whose mountains can be seen here. Cape Creus also contains fantastical rock formations, a number of which Dalí would draw upon for the "grandiose geological delirium" to be expressed in his mature images. Today Cadaqués is a lively holiday town which understandably maximises its connection with Dalí, but when the painter stayed there during the late 1900s and throughout the 1910s it was little more than a bitterly impoverished fishing village, much given over to smuggling to make ends meet.

During Dalí's early years his family would spend each summer just outside Cadaqués, renting a whitewashed house on Es Llané bay from their friends, the Pichot family. One member of that clan was the painter Ramon Pichot (1872-1925) whose influence can be detected in Dalí's early works. This is unsurprising, for Pichot's canvasses were the first real paintings Dalí ever saw. Pichot himself was deeply influenced by French Impressionism, and exposure to his work opened Dalí's eyes to the virtues of that approach, although not before he had encountered some difficulty in recognising what he was seeing. As he recalled later in his *Secret Life*:

> French Impressionism [was] the school of painting which has in fact made the deepest impression on me in my life because it represented my first contact with an anti-academic and revolutionary aesthetic theory. I did not have eyes enough to see all that I wanted to see in those thick and formless daubs of paint, which seemed to splash the canvas as by chance... Yet as one looked at them from a certain distance and [by] squinting one's eyes, suddenly there occurred that miracle of vision by virtue of which this musically coloured medley became organised, transformed into pure reality.

Certainly a number of "thick and formless daubs of paint, which seemed to splash the canvas as by chance" are much in evidence here, in the guise of distant buildings and their reflections upon the waters. As has been noted by the art historian Dawn Adés, the "black prow of the large ship seems to pierce the church on the hill", and that pictorial stab might well have carried a secondary meaning, given the young Dalí's pronounced anti-clericalism.

LANDSCAPE NEAR CADAQUÉS

1920-1921
Oil on canvas, 31 x 34 cm
Teatre-Museu Dalí, Figueres

Using a fairly-straightforward Impressionist technique, here Dalí expressed feelings for Cadaqués that he had recorded in his diary in October 1920:

And there, in that town of white houses and tranquil days I consecrated all my skills to art, to painting, and I lived like a nut, painting and learning, going into raptures in front of the nature that is also art, watching the sun set on the damp sand of the beach, inebriating myself with poetry in the long, blue twilight, half-asleep in the sweet world of greenish waves, and then the stars that reflect in the calm waters, the pale, moonlit nights, beautiful women's eyes, with a sparkle of love, and the azure mornings, full of sun, that bathed in the green waters of a bay... what pleasure and what life!

Judging by the shadows falling across the distant buildings, we are viewing Cadaqués in the late afternoon. The white sail of the boat acts very effectively as the keystone of the pictorial architecture, for without it the image would look extremely inert and unfocused.

CUBIST SELF-PORTRAIT

1923
Oil and collage on cardboard on wood, 104 x 75 cm
Museo Nacional Centro de Arte Reina Sofía, Madrid

Dalí's art-school years understandably formed a period of intense stylistic experimentation. Here the student explored the Cubist approach pioneered over ten years earlier by his fellow Spaniards, Pablo Picasso and Juan Gris. A pipe, a newspaper, and merely a few hints at a self-portrait act as the representational pegs on which the entire architecture of the image is hung. All else is jagged movement within a pictorial universe whose spatial certainties are shattered, like so many other aspects of the modern world.

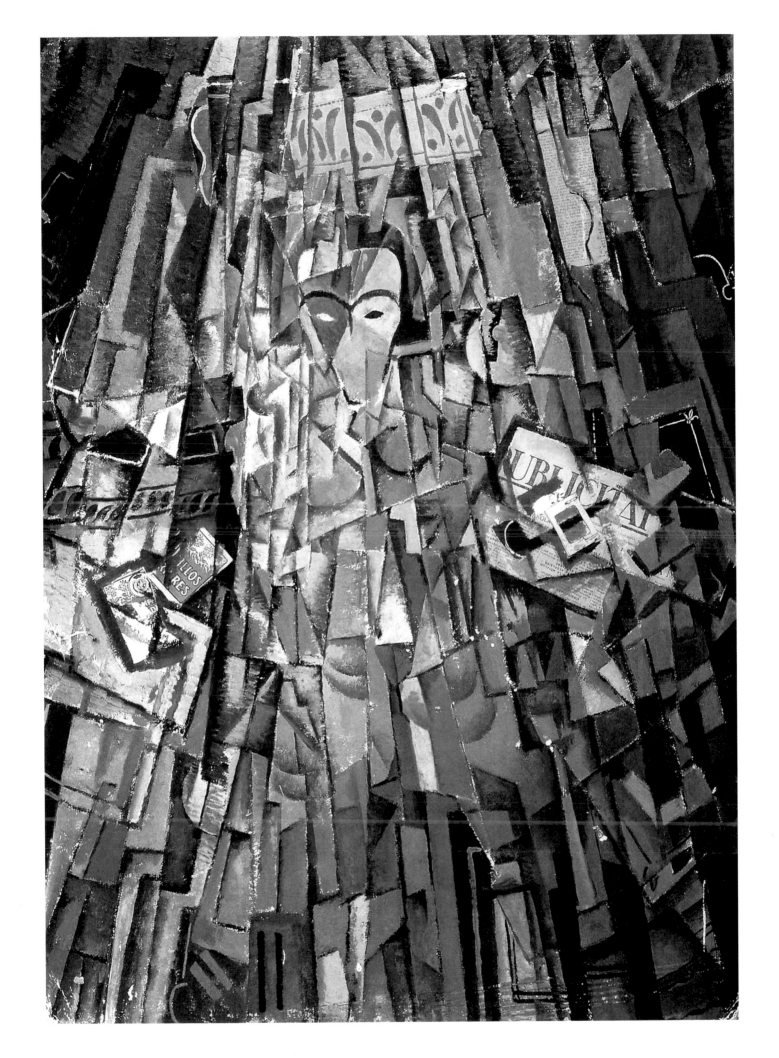

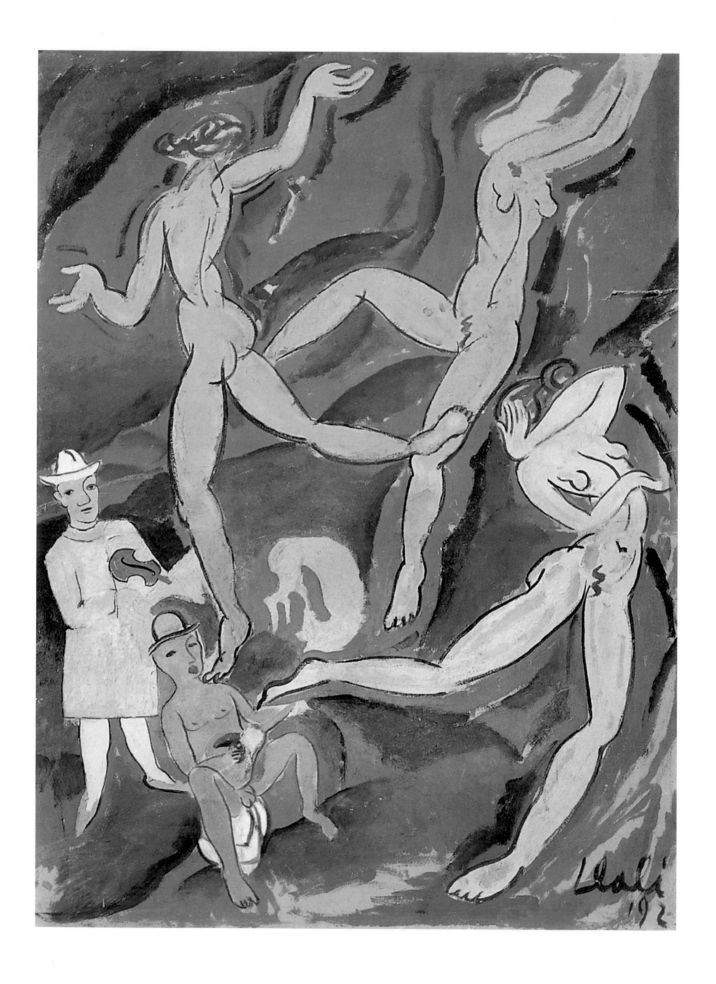

SATIRICAL COMPOSITION ('THE DANCE' BY MATISSE)

1923
Gouache on cardboard, 138 x 105 cm
Teatre-Museu Dalí, Figueres

For this work, Dalí the student of painting at the San Fernando Royal Academy of Fine Arts took his cue from one of the most renowned images by Matisse, *The Dance* of 1910, which the young Spaniard could only have seen in reproduction. In fact Dalí reinvented Matisse's figures, rather than copied them, for at no point do they correspond closely to the dancers in the French painter's image.

The standing man at lower left closely resembles Picasso. If he was intended to denote that artist, then the seated guitarist could indicate Matisse, although he does not in any way resemble the French painter. As the rivalry between Picasso and Matisse had become apparent by 1923, the inclusion of both artists in a single image would have made sense, especially as Matisse's *The Dance* had helped stoke up their rivalry.

PORTRAIT OF LUIS BUÑUEL

1924
Oil on canvas, 70 x 60 cm
Museo Nacional Centro de Arte Reina Sofía, Madrid

Dalí became friendly with the future film director Luis Buñuel (1900-1983) in the autumn of 1922 when he moved into the Residencia de Estudiantes or university hall of residence whilst studying at the art school in Madrid. At the time Buñuel was studying entomology at Madrid University, from where he would graduate with a degree in history in 1924. Later he would collaborate with the painter on two films, although even by the time they made the second one they were drifting apart. Eventually they came to detest one another as Dalí increasingly moved politically to the right and cast potentially damaging aspersions on his old friend and collaborator when doing so.

The Buñuel portrait was painted after Dalí had returned to Madrid in September 1924, following his year's suspension from the San Fernando Royal Academy of Fine Arts, as well as his subsequent brief imprisonment in Figueres and Gerona. Stylistically the image is eclectic, for it draws upon Italian Renaissance portraitists like Bronzino (1503-1572);

upon the highly representational 'Neue Sachlichkeit' or New Objectivity portraiture that had emerged in Germany after World War I, and upon the neo-classicist portraiture of Picasso's art during the same period.

In order to represent Buñuel's physiognomy, Dalí divided up the canvas into squares and accurately measured the dimensions of the subject's facial features before putting them down on canvas. Buñuel himself suggested the curiously elongated shapes of the clouds, having particularly appreciated such forms in a painting by the Italian Renaissance master Andrea Mantegna hanging in the Prado in Madrid. As we shall see below, during the 1930s Dalí would draw upon Mantegna for his representations of towns and cities in a number of his landscapes, whilst in his first cinematic collaboration with Buñuel, *Un Chien andalou*, a cloud of this shape would change into an eye that would be sliced open with a razor, in what is possibly the most horrific sequence in the entire film.

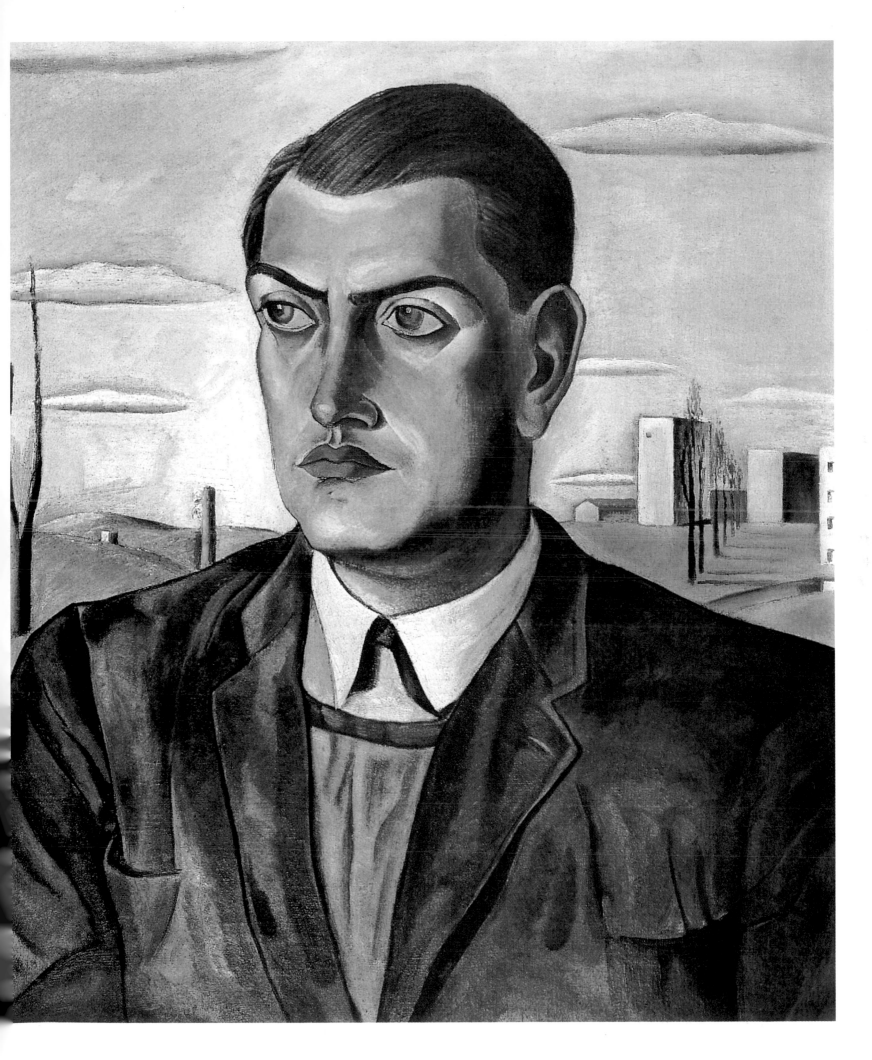

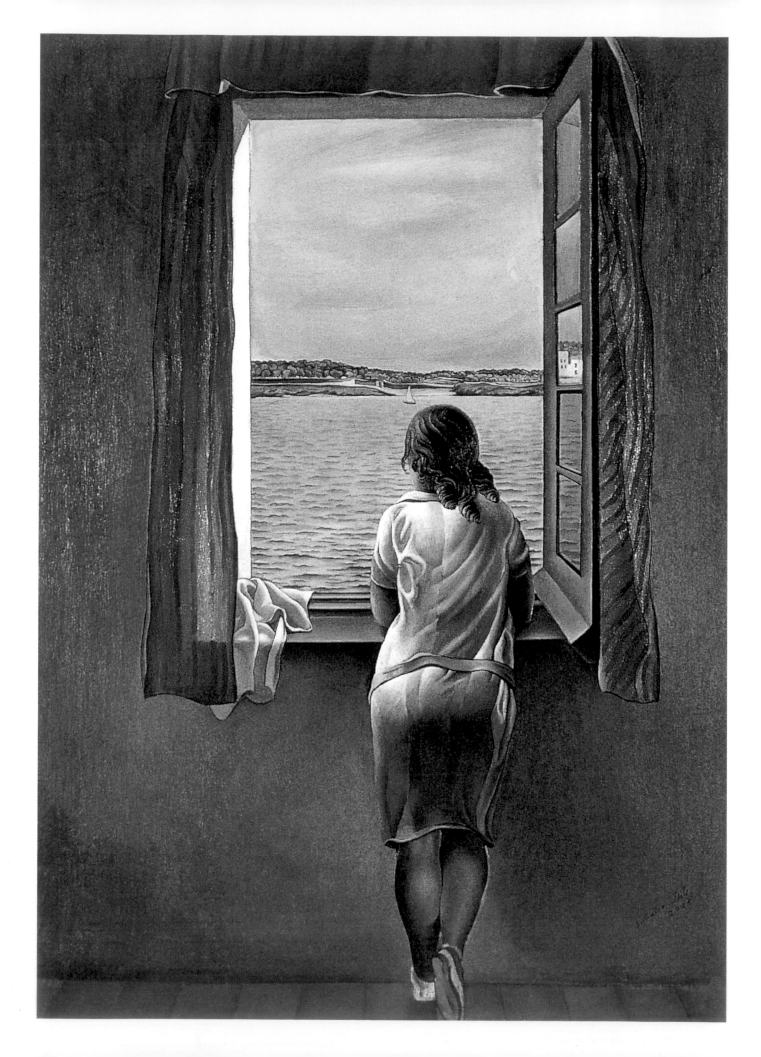

FIGURE AT A WINDOW

1925
Oil on papier-mâché,105 x 74.5 cm
Museo Nacional Centro de Arte Reina Sofía, Madrid

By 1925 Dalí not only continued to explore a Cubist approach, as in the *Venus and Sailor* discussed earlier, but at the very same time – and like Picasso before him – he created acutely realist works. Around 1925 such representationalism was often stylistically influenced by the drawings and paintings of the French artist Jean Dominique Ingres (1780-1867), but later it would become more photographic. In the long term the latter approach would better serve Dalí's creative needs.

The obvious pictorial model for this particular work was a canvas painted in 1822 by the German Romantic artist, Caspar David Friedrich (1774-1840). Now in the Neue Nationalgalerie in Berlin, Friedrich's *Woman at the Window* shows a young female seen entirely from behind as she looks through a shuttered window across a river towards some poplar trees on the far bank. Dalí must have become aware of the Friedrich painting through a reproduction. As the window area painted by Dalí is larger than the one seen in the Friedrich painting, we enjoy more of a view outwards.

The interior of the room is also far more light-filled than Friedrich's northern, dark interior.

Dalí used his sister, Ana María, as his model here. She later related:

> During the hours I served him as model, I never tired of looking at the landscape which already, and forever, formed part of me. He always painted me near a window. And my eyes had time to take in all the smallest details.

Certainly her body language as she looks southwards across the bay at Cadaqués in afternoon light projects her attentiveness. The curtains slightly ripple as they catch the breeze.

In various writings, Dalí claimed that Picasso was particularly struck by this picture when he saw it in the former's one-man exhibition mounted at the Dalmau Gallery in Barcelona, in November 1925. However, there is no evidence that Picasso visited the Dalí exhibition or was even in Barcelona at that time.

THE GIRL OF FIGUERES

1926
Oil on panel, 20.8 x 21.5 cm
Teatre-Museu Dalí, Figueres

When Dalí visited Picasso in Paris in April 1926, he took this painting along to show it to his hero. According to Dalí, Picasso looked at it wordlessly for over a quarter of an hour. That was certainly possible, for the picture does include a fair amount of fine detail.

The view depicted is the one that was visible from just above the second Dalí home in Figueres. This was the apartment at Carrer Monturiol 24, into which the family had moved in 1912 (the building still survives, although its address has altered to Carrer Monturiol 10). Carrer Monturiol 24 was a new and highly-stylish apartment block, and the Dalí flat was on its top floor. The occupants of the block also enjoyed use of a rooftop terrace, and it was up there that Dalí had created his very first studio in an abandoned laundry room when he was about nine years of age.

In *The Girl of Figueres* we see the view from the rooftop terrace, with Ana María once again acting as model for her brother. Across the Plaça de la Palmera may be seen the church of the College of French Dominican Sisters, with its belfry. In the distance are the Sant Pere de Roda mountains which border the Empordàn plain that surrounds Figueres. The cloud forms deriving from Mantegna that are visible in the Buñuel portrait of 1924 are echoed by the clouds here. It is worth noting the bare trees in the plaza, for they not only inform us we are looking at a winter scene but also foreshadow bare trees to be encountered later, most notably in *The Persistence of Memory* of 1931.

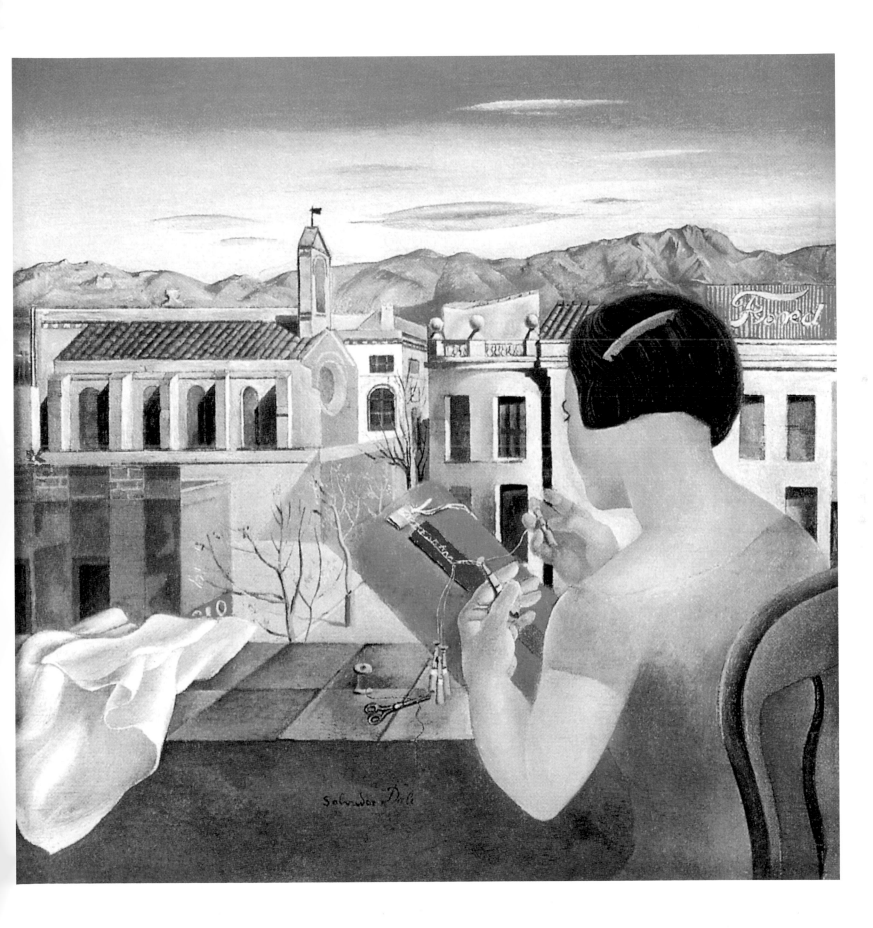

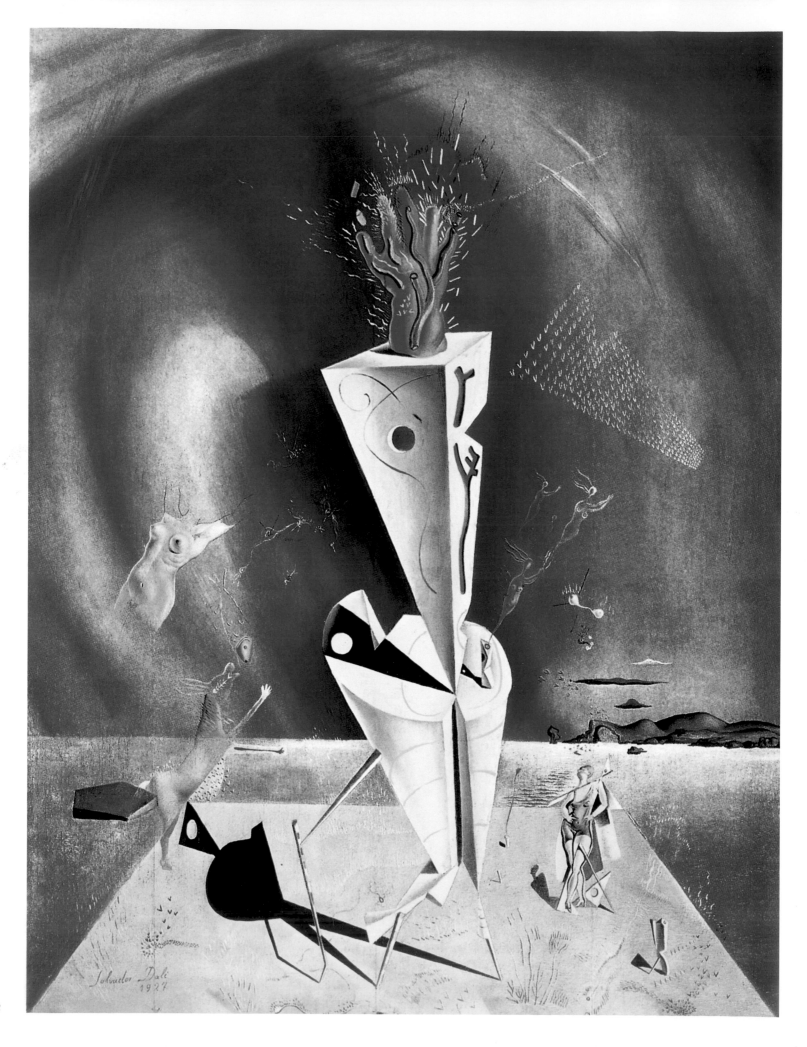

APPARATUS AND HAND

1927
Oil on panel, 62.2 x 47.6 cm
Salvador Dalí Museum, St Petersburg (Florida)

By 1927 masturbation had long been Dalí's preferred way of attaining sexual orgasm. That preference would remain with him for the rest of his life. Given the predilection, it appears likely that in this painting, he was dealing with such substitutional fantasies and the crucial role of hands in the process. The work was exhibited at the 1927 Autumn Salon in Barcelona, from which it was bought by Camille Goemans, who would later become Dalí's dealer in Paris.

Pictorially, *Apparatus and Hand* enjoys a very pronounced similarity to works by the French painter Yves Tanguy, such as the 1927 painting *He Did What He Wanted* which is now in a private collection in New York. Most particularly that likeness may be detected in the triangular shapes of the central "Apparatus and Hand", in the placing of those objects in an illusionistic space, and in the location of further things in the sky, such as the formation of birds. Simultaneously one can detect here the influence of Giorgio de Chirico, in the use of long black shadows to add to the illusion of brilliant lighting and depth, in the pronounced perspective of the rectangular, platform-like area in the foreground, in the cubistic dislocations of the nude on the right and in the objects placed around her.

Yet there is also a very Dalínian imaginative complexity here. The landscape is convincing, being a fairly free projection of the view from the Dalí house in Cadaqués. Once again cloud shapes derived from Mantegna are visible. The hand is imbued with a manic quality by means of the many surrounding flecks which suggest that drops of sweat are being shaken off it. Almost certainly the hand has been rubbed red through being overly employed for masturbation. The De Chirico-like woman standing in a see-through bathing costume to the right of the tall gadget, and the apparitional female trunk seen in the sky to the left of it, may well be the subjects of the masturbatory fantasies signified by the hand. On the left a rotting donkey reaches up as it swallows a fishbone. Two eyeballs drift through the sky with the greatest of ease. Seminal fluid also floats around, in some places adopting the shapes of naked women. At two locations blood spurts forth, one gush equally taking the shape of a nude female. Everywhere the familiar Surrealist division between conventional reality and subconscious wanderings is evident, even if the imagery has not yet fully evolved into its characteristic Dalínian form.

Two small areas of sand stand upon a plain. Upon one of these patches is a hand, with its little finger extended like a phallus; we also witness a similar hand in *Bather* (opposite). Here, however, the thumb and forefinger form an enclosure that greatly resembles the female sexual aperture. The finger points across a gap towards the divided form opposite. Is this entity male or female? The choice belongs entirely to the viewer, for Dalí provided no clues. At the tip of one of the twin phallic shapes, a tiny aperture spurts blood. If the overall shape is interpreted as male then this would be blood ejaculating from a penis; if female, then blood issuing from a vagina. And blood equally spurts from the huge phallic form that stretches somewhat more weightlessly up into the sky, only to culminate in a thumb complete with thumbnail. Everything seems curiously static and disconnected, with only a bloody outcome in sight. Dialogue on a beach it may be, but it is a very bleak and joyless one. Unsatisfied desires indeed.

BATHER

1928
Oil and sand on panel, 63.5 x 74.9 cm
Salvador Dalí Museum, St Petersburg (Florida)

Joan Miró and André Masson were clearly the stylistic influences upon this oil painting, the former acting upon the shaping of the figure, the latter upon its setting (and especially the lower half of the surround, where Dalí mixed sand with his paint).

Once again Dalí demonstrated his preoccupation with sexuality here, for one hand is located over the bather's sexual apparatus and simultaneously resembles the female aperture, whilst the fingers of the other hand equally resemble phalluses, particularly the protruding thumb and little finger. Moreover, within the palm of the hand on the left is a form that resembles a labia. The 'face' of the bather looks rather like an electrical screw fitting, complete with further screw holes that double as eyes, and given the sexuality of the figure, the central hole itself may equally bear a sexual connotation. In the sky we are wittily reminded that we are looking at an illusion, for Dalí went to some trouble to emulate exactly the types of highlighted cracks that may be perceived on walls or similar flat surfaces.

UNSATISFIED DESIRES

1928
Oil, seashells, and sand on cardboard, 76 x 62 cm
San Francisco Museum of Modern Art,
San Francisco

Naturally, in narrow-minded Spain a liking for masturbation provoked a good deal of anxiety in Dalí, and it is that disquiet that he addressed here. His original title for the painting was *Two Figures on a Beach*, and it has also been known as *Dialogue on the Beach*. It was under the former of these titles that Dalí submitted the work for exhibition at the Sala Peres, Barcelona in the autumn of 1928. However, because of its obvious sexual undertones it was rejected. Soon afterwards the Dalmau Gallery, where Dalí had earlier exhibited successfully, agreed to display the picture, although the owner then regretted his decision. Accordingly, he placed a piece of cork in front of one of the figures so that it became well-nigh invisible.

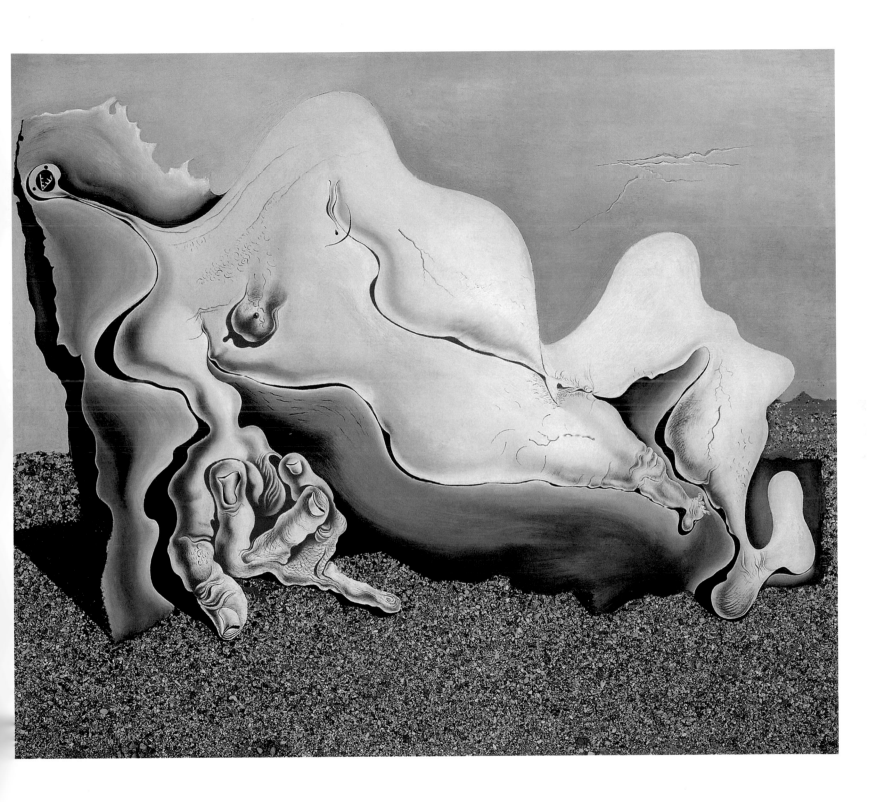

THE WOUNDED BIRD

1928
Oil, sand, and coarse sand on cardboard,
55 x 65.5 cm
Tel Aviv Museum of Art, Tel Aviv

At the bottom of one of two rectangles of differently-textured sand lies the head and wing of the bird specified by the title. Above it, and stretching across both sandy areas, is a thumb. Dalí probably received the visual stimulus for this part of the image from seeing his thumb protrude through the thumb-hole of his palette. (Indeed, we can read the overall rectangle created with the differing textures of sand as a palette.)

Dalí was well aware of the phallic associations of fingers, thumbs, and toes, and may well have intended this thumb to suggest an erect but castrated penis. If that was the case, then the titular "wounded bird" is not merely an avian one.

Lines ripple across the thumb, perhaps to suggest cracks caused by the digit. Towards the top-left, two elongated, white shapes are reminiscent of the cloud forms that Dalí originally derived from Andrea Mantegna. The vague white area behind them may represent the moon, as an identically-located white circle most certainly does in a very similar image Dalí also created in 1928, *Big Thumb, Beach, Moon and Decaying Bird*.

Once again, stylistic assimilations are evident. The head of the bird owes much to Max Ernst, the use of sand to André Masson.

THE SACRED HEART (SOMETIMES I SPIT WITH PLEASURE ON THE PORTRAIT OF MY MOTHER)

1929
Ink on linen canvas glued on cardboard,
68.3 x 51.1 cm
Musée national d'Art moderne,
Centre Georges-Pompidou, Paris

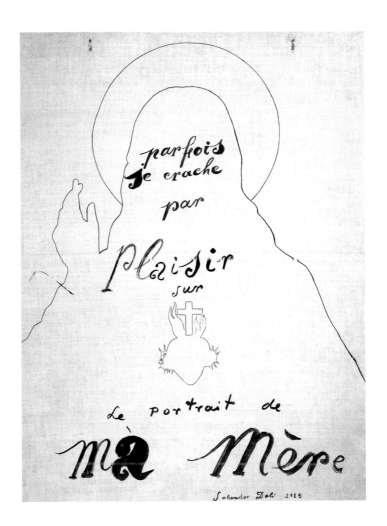

This drawing on canvas was exhibited under the title *The Sacred Heart* in Dalí's first one-man exhibition held in Paris in 1929; only later did the legend written across the image take over as the name of the work. Dalí made the canvas under the influence of the French artist Francis Picabia (1879-1953) who had similarly attacked religion by means of inscribed line drawings.

It is easy to perceive the outline of a kitsch representation of Jesus of Nazareth, complete with sacred heart. However, the raised hand of Jesus is subtly irreligious, for instead of denoting the Trinity by means of a raised thumb and two forefingers as is traditional, His fingers are crossed, as if wishing for good luck. By this means Dalí communicated the view that we might as well cross our fingers as pray for divine intervention – it is all the same superstitious nonsense.

Unfortunately this work backfired on Dalí in November 1929 when his father found out about it and took the maternal reference to stand for his dead wife, the painter's mother. Accordingly he threw his "pig of a son" out of his Figueres home (where the painter was staying with Buñuel at the time) and virtually disinherited him. It would be more than five years before he would speak to his son again, and their relationship would never be properly patched up. However, Dalí had not necessarily wanted to pour scorn on his mother's memory here; he claimed to have had a more serious intention in mind, as he explained in a lecture he gave in Barcelona in March 1930 on "The Moral Position of Surrealism":

Not long ago I inscribed on a painting of mine representing the Sacred Heart the phrase "J'ai craché sur ma mère"…

The whole point… centres on a moral conflict very similar to the one we find in dreams, when we assassinate a beloved person; and this is a very common dream. The fact that subconscious impulses often appear extremely cruel to our consciousness is a further reason for lovers of truth not to hide them.

In 1934 he returned to the subject in an interview he gave to a leading Barcelona art critic. After rhetorically asking how anyone could believe this work was intended as an insult to his dead mother, Dalí stated that:

I have always had the greatest love for my mother and father. In the case in question, all I wanted to demonstrate, in the most dramatic way possible, was the discrepancy, the traumatic rupture, existing between the conscious and subconscious. That such a rupture exists is demonstrated by the frequent dream, reported time and again, in which we assassinate someone we love.

THE FIRST DAYS OF SPRING

1929
Oil and collage on panel, 50.2 x 65 cm
Salvador Dalí Museum, St Petersburg (Florida)

Because this was one of the first works in which Dalí had finally discovered his true voice, in March 1929 he took it with him to Paris where it created a very favourable impression.

Two deeply-shadowed channels lead to the distant horizon. In the mid-distance on the left sits a man looking into space and casting no shadow. Immediately before us, a man and a woman respectively kneel and sit in front of a collaged, framed image of games on deck aboard a luxury liner. The man is gagged and his hands flow into a bucket towards which a phallic finger is pointing. Beneath the finger two balls and a hole advance an obvious sexual pun. The woman has an orifice for a face, which is attracting flies. Between her breasts, the female sexual cleft doubles as the pattern on her necktie.

On the ledge between the two channels, Dalí collaged a small photo of himself as a child. In front of the picture stands a curious form that is part fish, part grain-stack, part jug-handle, and part body tubes, complete with numbers, as though taken from a medical textbook. From this composite form stretches forth an arm whose jagged shapes owe much to Max Ernst. Its hand just grazes a head, to the mouth of which a locust has attached itself. Because very similar heads with connected locusts appear often in Dalí's work at around this time and later, we can safely assume that the head represents the artist himself. He is asleep and possibly dreaming of

the little girl whose printed image is collaged over the area where his brain would be. Above his head, a form doubles as a large stone and a thought bubble, such as are commonly found in cartoon images. Within this area collaged images of a deer, a pencil, a man with a walking stick, and a bird possibly represent elements in another dream within the overall dream of the picture.

Behind the Dalínian self-portrait is a leering character-jug head of a woman. Bird's heads that derive from the imagery of Max Ernst rise up from a patterned plinth to meet the jug/head. Further away, on the right, a young girl proffers a bag or large purse to a white-haired, bearded man. More distantly a man lying on some curious contraption that rests on the ground has his head and upper torso prised backwards by a bowler-hatted assailant. And even more remotely a man and a child stroll towards us.

What does all this signify? Undoubtedly Dalí had various Freudian theories in mind when he painted this picture but it would be dangerous to assign specific psychoanalytical meanings to the component parts of the image. Such a process might explain the imagery in ways that were not intended by the artist. All that the viewer can do is interpret the picture in the light of his or her own fears and fantasies. Dalí simply provided us with a psychologically disturbing starting point for doing so.

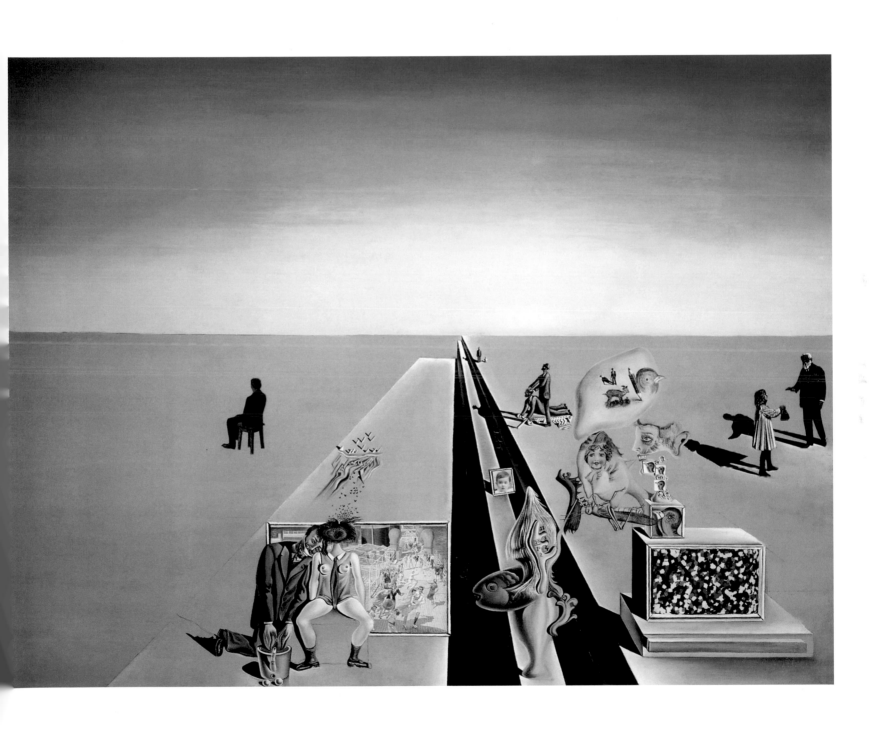

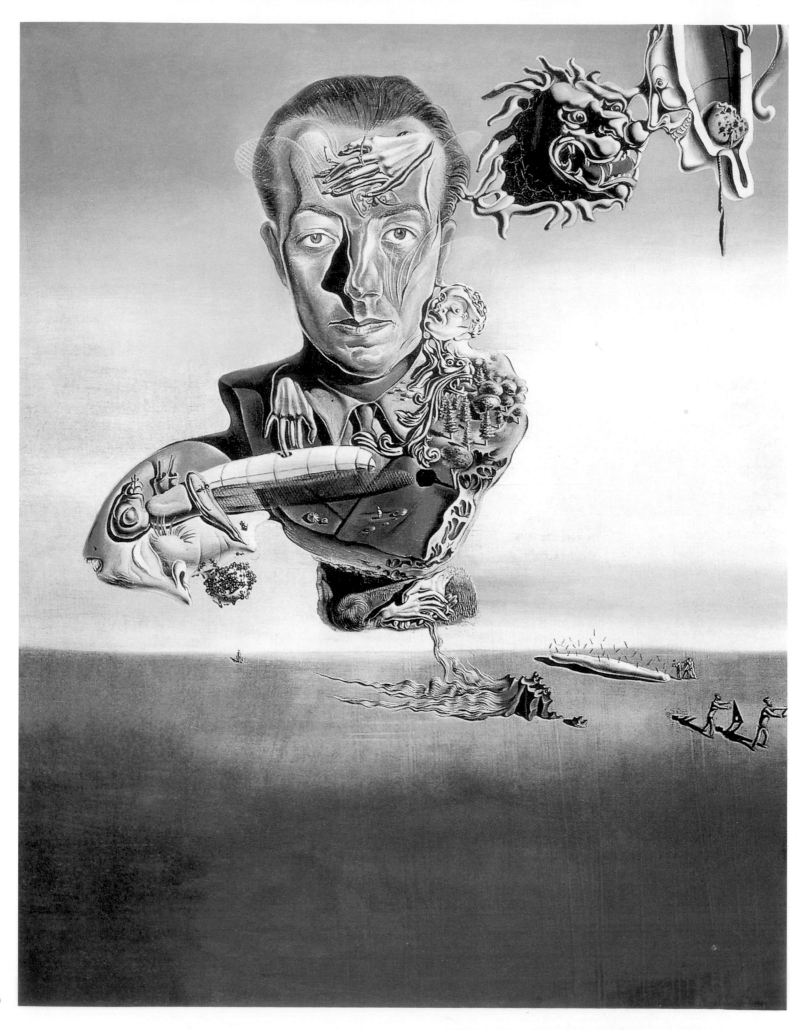

PORTRAIT OF PAUL ÉLUARD

1929
Oil on cardboard, 34.9 x 25 cm
Private collection

Paul Éluard was born Eugène Grindel in Saint-Denis, Paris, in 1895. He took up poetry when recovering from tuberculosis in Switzerland, where he met his future wife, Gala (who would divorce him in 1932 to marry Dalí two years later). Between 1924 and 1938 Éluard was active in the Surrealist movement. His *The Capital of Pain*, published in 1926, is widely considered to be one of the finest collections of Surrealist poetry. In 1933 Éluard was expelled from the Communist party for objecting to the "cretinisation of the USSR", but later he returned to it and became a great admirer of Stalin. After 1938 he turned his back on Surrealism. During World War II he was very active in the French Resistance. Eventually he produced some seventy books. He died in 1952.

Dalí painted this picture whilst conducting an affair with Éluard's wife, Gala, and the work was his way of assuaging his guilt over the relationship. A hand with long, bony fingers masks Éluard's forehead whilst another hand reaches around the poet's neck to poke a finger into a hole in a locust's stomach. In turn that creature, which in this instance is legless and armless, fixes upon a form we shall soon encounter elsewhere as a representation of Dalí asleep, with his visible eye closed, his nose pointing downwards, blood trickling from his nostril, and virtually no mouth. Fixed to the area where the mouth should be is an egg being devoured by ants. And ingeniously the Dalí head doubles as a fish seen in profile and facing to the left. In this alternative reading, the head of

the locust may simultaneously be read as the pupil and iris of the eye of the fish, the teeth and a nostril of which are visible on the left, red edge of the form.

On the other side of Éluard's torso the head of a lion metamorphoses into a classical-looking head, the top of which joins up with Éluard's earlobe. Above, a lion leaps forth in a projection of sexual aggression and untrammelled libido, Dalí's habitual associations of such a creature. A character-jug head of a leering woman faces the lion, whilst beneath that ceramic some skin drops downwards from a rotting pomegranate. At the base of Éluard's torso, clasped hands rest upon a bed of hair that falls downwards, eventually to change into a rock. Rock indentations, pebbles, shells, and trees stud Éluard's modish jacket.

On the beach, men wander about. Three of them stand next to an elongated, arm-like form, of the kind seen already in *Honey is Sweeter than Blood* (p. 33). As in that painting, the limb is accompanied by flying nails or spikes. One of the men has no trousers and his genitals are accordingly visible. The other two men hide their faces, as if ashamed. Less far away two more men exit the pictorial space, with one of them bearing a triangular form whose shape, pierced by a hole, might well allude to the female sex. Everything is unreal, peculiar, weird. Only Éluard looks untroubled and passive in this company.

THE GREAT MASTURBATOR

1929
Oil on canvas, 110 x 150 cm
Gift of Dalí to the Spanish state, Museo Nacional Centro de Arte Reina Sofía, Madrid

Dalí painted this picture in the autumn of 1929 after Gala Éluard had returned to Paris. As in *The Lugubrious Game*, the *Portrait of Paul Éluard*, and *The First Days of Spring* discussed earlier, here too Dalí portrayed himself as a softly-rounded form with a locust attached to his mouth. Even more than before, the overall shape of the self-portrait owes much to the shape of a huge rock on Cape Creus. The coastal association of the rock, plus other, darker psychological links, is brought into play by the fish hook embedded in Dalí's scalp, as well as by numerous molluscs dotted throughout. According to the painter, everything terminates in the "architecture and ornamentations" of a piece of 1900s furniture, seen in the series of curves at the centre-right. The image of a woman smelling the genitals of a man derived from a cheap 19th-century chromolithograph of a woman smelling a lily; now the lily has been relocated below the woman's head. Naturally, the protruding stamen of the lily is very phallic in form. Subtly it heightens our awareness of the sexuality of the woman, as does the adjacent lion's head with its libidinously protruding tongue. Dalí might well have derived the seamless shift from his own head into the woman's head from the cinematic dissolves that he and Buñuel had created in *Un Chien andalou*, made earlier in 1929.

In his book *The Unspeakable Confessions of Salvador Dalí*, published in 1976, the painter wrote that when creating this picture:

> I masturbated frequently, but with great control over my penis, mentally leading myself on to orgasm but disciplining my actions so as the better to savour my ecstasy. Masturbation at the time was the core of my eroticism and the axis of my paranoia-critical method. The prick I was hooked on, so to speak. There was me and my orgasm – and then the rest of the world... *The Great Masturbator...* is the expression of my heterosexual anxiety – with its mouthless character incarnated by a locust while the ants eat its belly...

Rarely, if ever, in the history of art has any painter so publicly faced his obsessions as Dalí did by giving this picture such an unequivocal title.

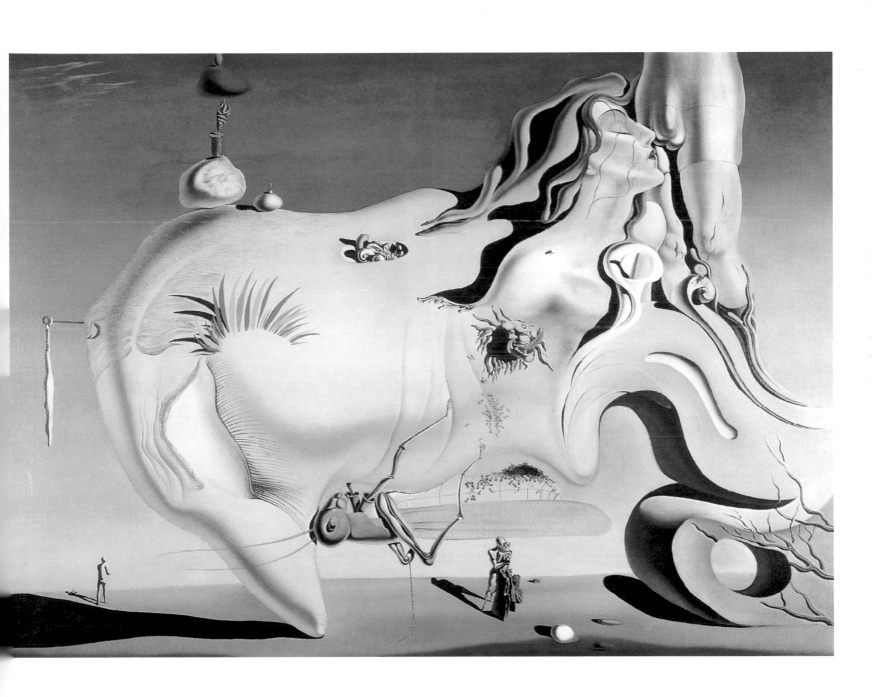

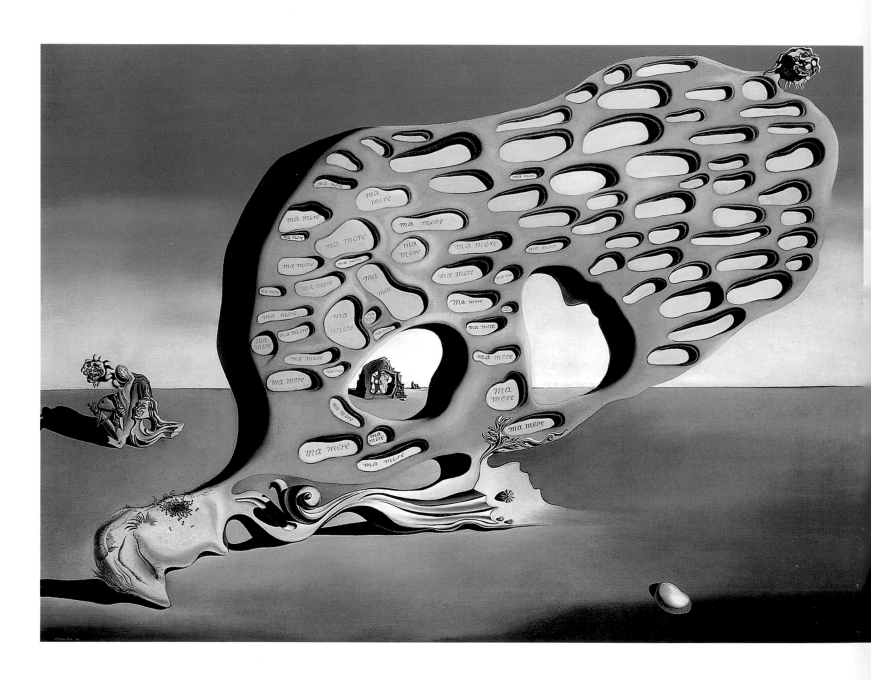

THE ENIGMA OF DESIRE: MY MOTHER, MY MOTHER, MY MOTHER

1929
Oil on canvas, 110.2 x 149.8 cm
Private collection

As was common in Dalí's pictures of this period, the humanoid, rocky form with which he denoted himself is asleep. It therefore projects the sense that we are looking at a dream. The dreamlike unreality is subtly heightened by the fact that the words *ma mère* only appear in under half of the eighty-one compartments pressed into the clay-like substance from which the self-portrait emerges – it is as though the remaining vacant depressions are waiting to have the words written in them.

On the left, directly above Dalí's diminutive head, is a further strange form. This comprises the heads of a lion and a woman, the ubiquitous locust, and a young man whose raised arm encircles the egg-like head of an older man who, in turn, reaches around to stab his companion in the back with a knife. Meanwhile, through an aperture within the large form, may be seen a distant rock structure that contains the torso of a woman.

Here again Dalí derived the self-portrait from the weird shapes of a large rock on Cape Creus near Cadaqués. That marine connection is strengthened by the molluscs at the base of the larger structure. The latter also incorporates the characteristic curved forms of *fin de siècle* architecture and furniture. And as in *The Great Masturbator* (p.83), the lions' heads, with libidinous tongues, respectively introduce a note of furious animalism and depravity.

WILLIAM TELL

1930
Oil and collage on canvas, 113 x 87 cm
Musée national d'Art moderne, Centre Georges-Pompidou, Paris

Dalí created dreamlike imagery with great power and conviction in this painting, and it remains one of his most disturbing works, for a male viewer at least. The legendary, early-14th-century Swiss archer and patriot William Tell supposedly won a bet by displacing an apple from his son's head through shooting off an arrow from a distance of two hundred paces. Tell's relationship to his son was obviously pertinent to Dalí in 1930 after his own father had broken off their relationship, although the painter later altered the balance of the William Tell myth by characterising the Swiss archer as "the man whose success depends on his son's heroism and stoicism".

Dalí dealt with the father-son connection here in startling fashion: the hideously leering father-figure on the right holds a pair of scissors which, by their horizontal alignment with the man's exposed penis, clearly suggests impending emasculation, especially as those scissors are located immediately above a gushing fountain. The man's invitational gesture to the other, younger man with masked genitals on the left clearly indicates whom he wishes to emasculate, as does the younger man's hiding of his face in his hand and his accusative gesture with his other arm.

At the bottom-left a collaged image of a bird's nest containing some eggs introduces associations of the sexual potency of the genitalia that are masked by a leaf nearby, whilst that masking quite evidently extends the notion of emasculation.

Above the bearded man, an identical figure seated at a piano is being confronted by a lion's head. As we have seen, for Dalí, lions' heads stood for sexual savagery and libidinousness. From the piano a live, leering horse with prominent genitals rises over the carcass of a dead, ant-eaten donkey. The conjunction of the two animals and their respective states obviously again links to the father-son, potent-emasculate relationships. And a further correspondence, between woman and the role of the phallus, may be seen in the imitation, low-relief sculpture at the end of the low wall at the bottom-centre.

The extended hands of the two men clearly derived from *The Creation of Adam* fresco by Michelangelo on the ceiling of the Sistine Chapel in Rome, an image extremely pertinent to the relationship between fathers and sons. The 1933 *Enigma of William Tell* is discussed later.

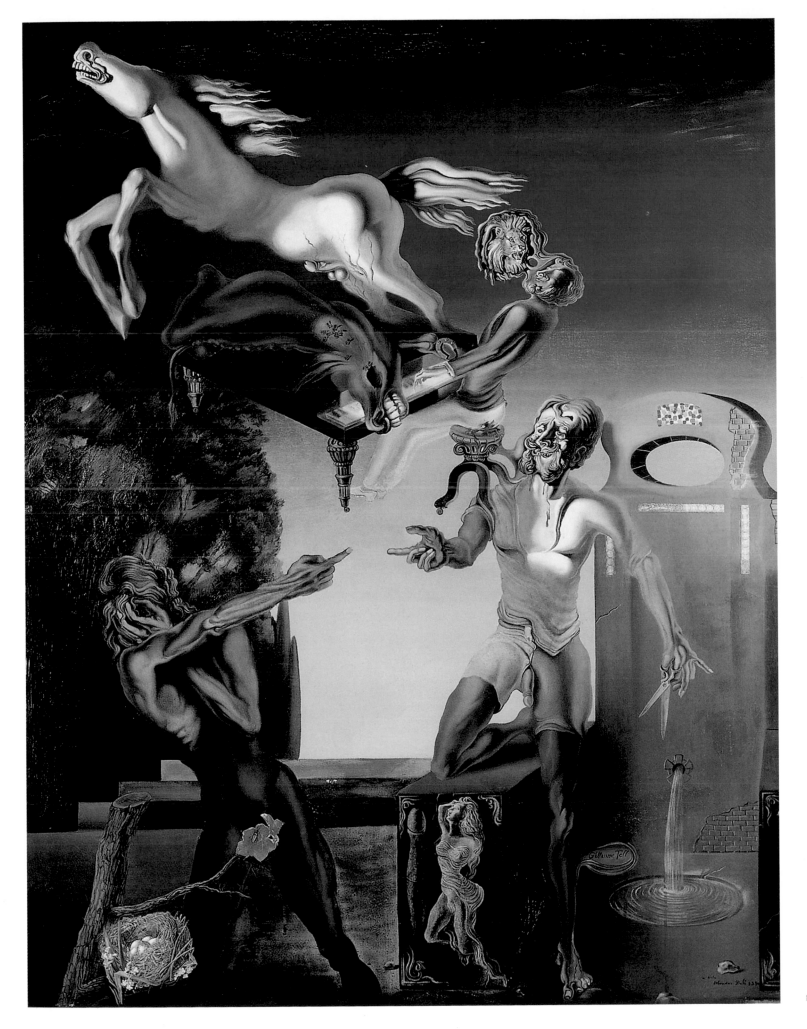

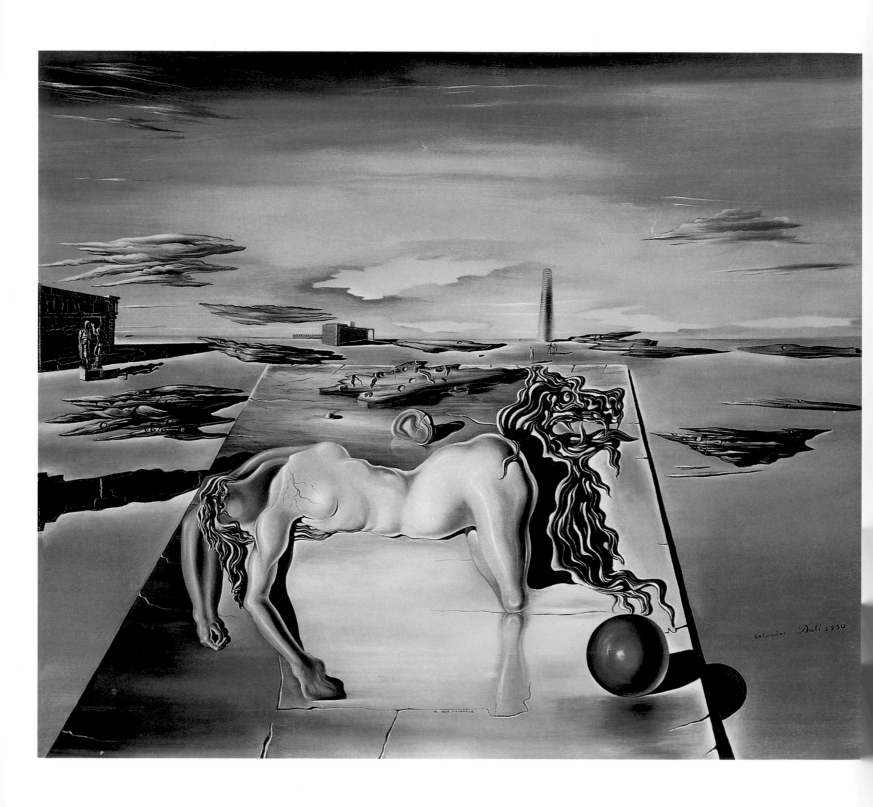

INVISIBLE SLEEPING WOMAN, HORSE, LION

1930
Oil on canvas, 60 x 69.8 cm
Private collection

Dalí's penchant for visual simile and for the creation of composite images out of subsidiary ones may be seen to even-more-brilliant advantage in this third version of a work dealing with an "invisible" sleeping woman, horse, and lion. That is because it is now easier to perceive the alternative readings of the central form as a horse with a bushy tail, as a reclining woman stretched out luxuriously, and as a lion. Such multiplicity enjoys a close correspondence to the type of fragmentation and transformation we frequently encounter in dreams.

Once again the landscape, especially the distant buildings, statue, and chimney, demonstrates the continuing influence of Giorgio de Chirico, as do the colouring and internal lighting of the picture. By 1930 Dalí had less need for obviousness, and so he provided us with just one large ball in the foreground. The striking blue of the object, plus the soft pink of a form reminiscent of an open vagina, as well as the pink brickwork of a distant building and some streaks of crimson in the sky, offset the intentionally harsh ochres, greys, and blue-greens distributed freely elsewhere.

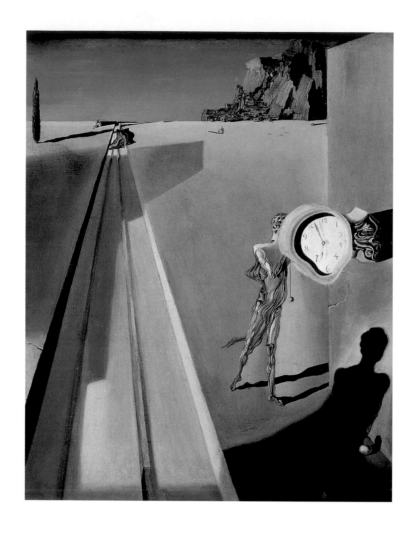

PREMATURE OSSIFICATION OF A RAILWAY STATION

1930
Oil on canvas, 31.5 x 27 cm
Alan Koppel Gallery, Chicago

Across a vast, flat, harshly-lit plain, a railway track leads towards the horizon, only for the line to be blocked by a large, female boot. Further off stands its pair. Such footware afforded Dalí much fetishised pleasure in reality.

The shadow of an unseen building falls obliquely across the plain, just as the much darker shadow of an unseen woman cuts across the wall of the ossified railway station. Next to the woman, an egg casts a distinctly priapic shadow. All the early-morning or early-evening shadows fall in the same direction except for those cast by a distant man and child. There is no rational explanation for this difference, nor need there be, for we are not in the land of everyday reality. Near to our eye, a figure is all muscles, some loose, some taut. Two beakers are appended to its body, and evidence to be supplied later in connection with the 1931 painting *Remorse, or Sphinx Embedded in the Sand* suggests that the receptacles are filled with warm milk, one of Dalí's abiding likings (or, as he preferred to call it, his "fetishes"). The gender of the figure is not apparent, nor is its face, for the latter is masked by a 'soft' station clock, complete with external pendulum. Dalí would later claim that pliant watches and clocks first came into his mind in 1931 when pondering the "problems of the super-soft" in connection with the painting *The Persistence of Memory*, as we shall see. However, this work demonstrates the falsity of that claim, although it is always possible that Dalí later genuinely forgot exactly when he had first developed such imagery.

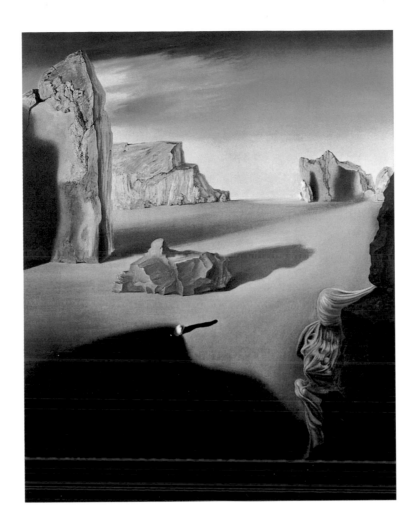

SHADES OF NIGHT DESCENDING

1931
Oil on canvas, 61 x 49.8 cm
Salvador Dalí Museum, St Petersburg (Florida)

In one corner of an otherwise-deserted space surrounded by cliffs and huge rocks lurks a completely shrouded figure. Only the tops of two drinking cups poke out from his or her covering, although a large bulge just below the person's midriff raises the possibility that this is a man with a huge erection. Clearly the figure represents the "shades of night" denoted by the title.

Near to the figure, a large, brilliantly-lit stone casts an extremely long, phallic shadow. Unlike every other shadow cast by geological forms throughout the image, this one is very hard-edged. That sharpness subtly furthers the reading of the shadow as an extended phallus because penises necessarily become taut when erect.

Dalí may well have derived the image of a shrouded figure from René Magritte. In 1928 the Belgian painter had created a number of pictures of shrouded people. These include a man and woman in *The Lovers*, a woman covered from the waist upwards in *The Symmetrical Trick*, and a person completely shrouded within a landscape setting in *The Invention of Life*. However, where Dalí really scored over Magritte is in his phenomenally detailed and atmospheric representation of landscape. This greatly furthers the unreal nature of what we see, just as the placing of the figure invests it with menace because it approaches the space we occupy in reality.

THE PERSISTENCE OF MEMORY

1931
Oil on canvas, 24.1 x 33 cm
The Museum of Modern Art, New York

This is without doubt Dalí's best-known and best-loved picture. It was first exhibited at the Pierre Colle Gallery in Paris in June 1931. In *The Secret Life of Salvador Dalí*, the painter related the genesis of the image:

It was on an evening when I felt tired and had a slight headache, which is extremely rare with me. We were to go to a moving picture with some friends, and at the last moment I decided not to go. Gala would go with them, and I would stay home and go to bed early. We had topped off our meal with a strong Camembert, and after everybody had gone I remained a long time at the table meditating on the philosophic problems of the 'super-soft' which the cheese presented to my mind. I got up and went into my studio, where I lit the light in order to cast a final glance, as is my habit, at the picture I was in the midst of painting. This picture represented a landscape near Port Lligat, whose rocks were lighted by a transparent and melancholy twilight; in the foreground [was] an olive tree with its branches cut, and without leaves. I knew that the atmosphere which I had succeeded in creating with this landscape was to serve as a setting for some idea, for some surprising image, but I did not in the least know what it was going to be. I was about to turn out the light, when instantaneously I 'saw' the solution. I saw two soft watches, one of them hanging lamentably on the branches of the olive tree. In spite of the fact that my headache had increased to the point of becoming very painful, I avidly prepared my palette and set to work. When Gala returned from the theatre two hours later the picture, which was to become one of my most famous, was completed.

In the centre is Dalí's characteristic 'soft' self-portrait; its reclining position and closed eyes subtly augment the dreaminess of the image.

Much of the impact of the work is advanced by its contradiction of our certainty that objects made of metal like watches cannot be soft or eaten by ants. In a century of relativity theory, such an image of the malleability of watches – and thus by a simple act of association, the malleability of time itself – remains very potent.

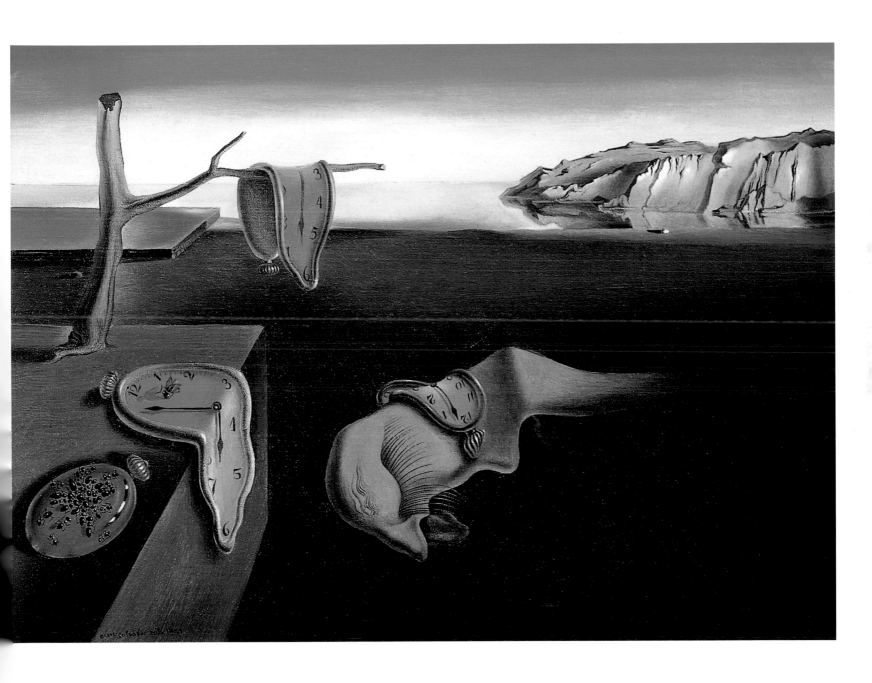

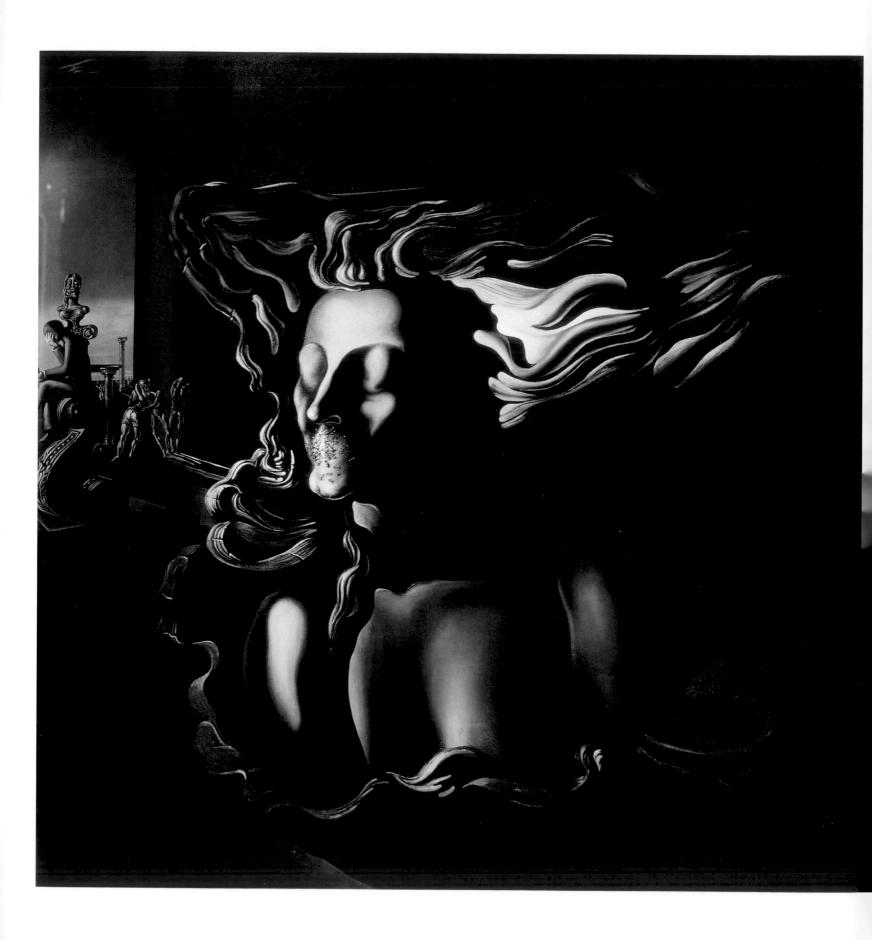

THE DREAM

1931
Oil on canvas, 96 x 96 cm
The Cleveland Museum of Art, Cleveland

An Art Nouveau-style, baptismal-font-like female head with long tresses and with ants crawling all over the space where her mouth should be had already appeared in Dalí's work by the time he created this picture, for in *The Font* of 1930 he had placed a very similar structure in the middle distance. As well as moving the font much closer here, Dalí also refined its base so that it looks somewhat more baroque than it had done previously. The painter developed the overall shape of the font from the forms of a pinbox he owned.

The heavily-dimpled chin of the woman on the font closely resembles the tip of a penis. In the distance a man sits upon a plinth shaped with the characteristic curved forms of *fin de siècle* architecture and furniture. The man holds his bloodied head in one of his hands, whilst in his other hand he clutches a butterfly-holder complete with butterfly. Both the figure and the plinth were inspired by a statue in Barcelona of the Catalan playwright, poet, and man of the theatre Serafí Pitarra (1839-1895). Immediately above the man towers a classical-looking bust which is supported by its own, elaborate plinth. The face of this statue bears a rather quizzical expression. Further off, the body language of six figures projects alarm, grief, conflict, and loss.

It is sometimes suggested that Dalí intended the ant-eaten woman to represent Medusa, one of the ancient gorgons with serpents for hair whose ugliness was so great that anyone gazing upon them would be instantly turned to stone. However, it is the woman who seems stony here, so this reading can safely be discounted.

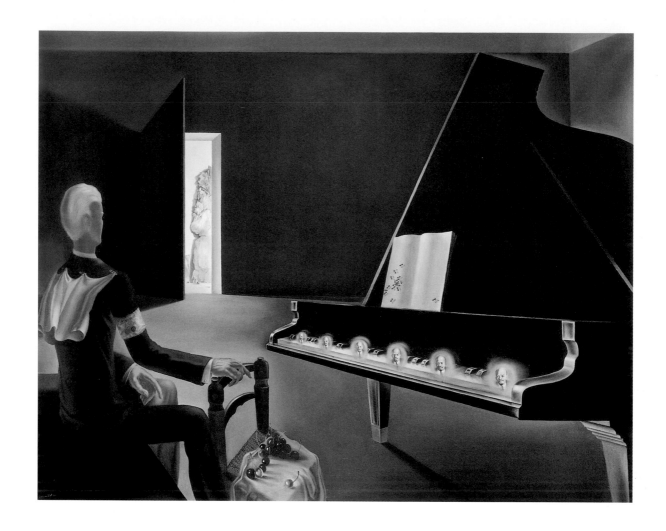

PARTIAL HALLUCINATION.
SIX APPARITIONS OF LENIN ON
A GRAND PIANO

1931
Oil and varnish on canvas, 114 x 146 cm
Musée national d'Art moderne,
Centre Georges-Pompidou, Paris

In his essay "The Tragic Myth of Millet's Angelus", published in 1963 but written in 1941 and then misplaced, Dalí recalled the genesis of this painting:

In 1932 [sic], at sunset, I saw the bluish, shiny keyboard of a piano where the perspective exposed to my gaze a series of miniature yellow phosphorescent halos surrounding Lenin's visage.

Lenin would reappear in a number of Dalí's other pictures – for an example see the 1933 *Enigma of William Tell* – and the Russian political leader had undoubtedly entered the painter's consciousness through his contact with André Breton, who was a confirmed Marxist. In the later work, however, there is a debunking level to the proceedings, whereas here Dalí was in a far more genuinely irrational frame of mind. A man wearing an armband denoting his solidarity with the cherries in the foreground gazes at Lenin dancing the light fantastic up and down the keyboard whilst ants swarm across sheet music and a Cape Creus rockface appears through an open doorway.

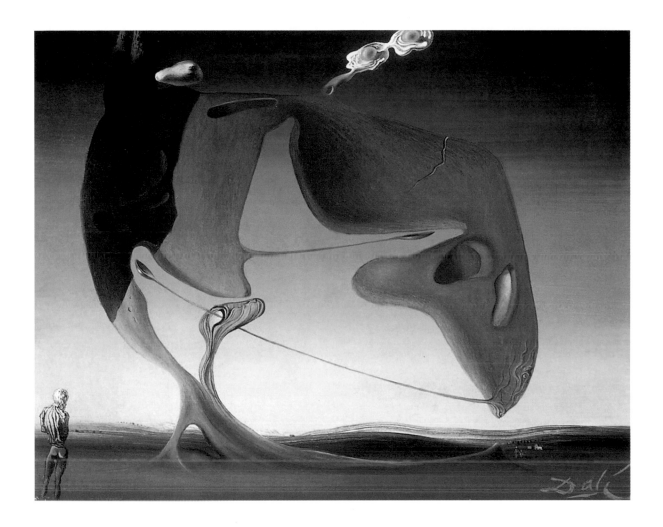

SURREALIST ARCHITECTURE

c. 1932
Oil on panel, 14.1 x 18 cm
Kunstmuseum Bern, Bern

A huge, multiform structure towers over us, its height empha-
sised by the low viewpoint from which we see it. The
piece of surrealist architecture bears obvious affinities with
one that shall be seen in *Birth of Liquid Desires* of 1931-1932 (p.
99). Here it brings forth or supports cypress trees, fried eggs, a
small rock, and two extremely elongated spoons. Because both
of these spoons fit neatly within large hollows in the rock-like
structure, they look as though they have spooned out those depres-
sions. The spoons thereby differ from the one in *Agnostic Symbol,*
which simply glides through space. Such associations of carving
point towards the use of spoons for carving and eating in the

Autumn Cannibalism of 1936. Similarly, the combination of a
low viewpoint and towering structure will again be encoun-
tered in *The Architectonic Angelus of Millet* of 1933 (p. 104),
Atavistic Vestiges after the Rain of 1934 (p. 108), and the
*Soft Construction with Boiled Beans – Premonitions of Civil
War* of 1936 (p. 121).

This tiny image is especially notable for the skill with which Dalí
dashed-in the background, for such was his mastery of landscape
depiction that broad brushstrokes adequately represent the far
horizons of the immense Empordàn plain he had known since
childhood. Dalí surely intended the two fried eggs to remind us of
eyes, if only because of their side-by-side placement (after all, if they
had been vertically aligned, we would hardly be able to make that
association). In the far distance a man and small child approach,
and we shall soon encounter them again in similar images of this
period, just as we have done already. The man on the left lends a
vital sense of scale and a note of the bizarre to the already-curious
proceedings, for why should he be naked from the waist down?

BIRTH OF LIQUID DESIRES

1931-1932
Oil and collage on canvas, 96.1 x 112.3 cm
Peggy Guggenheim Collection, Venice

This constitutes one of Dalí's most hallucinatory images, with the gigantic form in the centre approximating to the type of rock formations seen on Cape Creus which had inspired it in the first place. Judging by the hole that pierces the rock, it is thin at its centre, although adjacently it is deep enough to accommodate a virtually nude man who tentatively steps into it. There is no rational explanation for this spatial contradiction, nor can there be. We are in the territory of the unreal.

To the right, a partially obscured woman hides her face and pours liquid into a bowl, thereby implicitly washing the foot of a man with female breasts who is being embraced by another woman with a head composed of flower petals. The man rests his other leg upon a plinth, to the front of which Dalí collaged a chromolithographic reproduction of a gemstone showing the mythological flaying of Marsyas on the orders of Apollo for having had the temerity to challenge the god for musical supremacy. It may well be that Dalí saw a parallel between this story and the fears felt by his father in relation to his infinitely more artistically-talented son.

Springing from the phallic-looking French loaf that rests on the man's head is a huge form that at its top metamorphoses into cypress trees, of the type that Dalí both remembered from his school days and anyway associated with death through his awareness of Arnold Böcklin's 1880 painting *The Isle of the Dead*. Near the trees, liquid pours copiously from the cracked base of a cupboard. Items of clothing from the cupboard are also draped elsewhere, even on the yellow rock.

The meaning of all this is purposefully opaque, but therein lies its strength, for it can easily bear the viewer's own interpretative responses. The imaginative charge engendered by the picture is analogous to the type of mental process sparked off by good Surrealist poetry, wherein meaning and expressivity are communicated on a subliminal level without the intervention of reason.

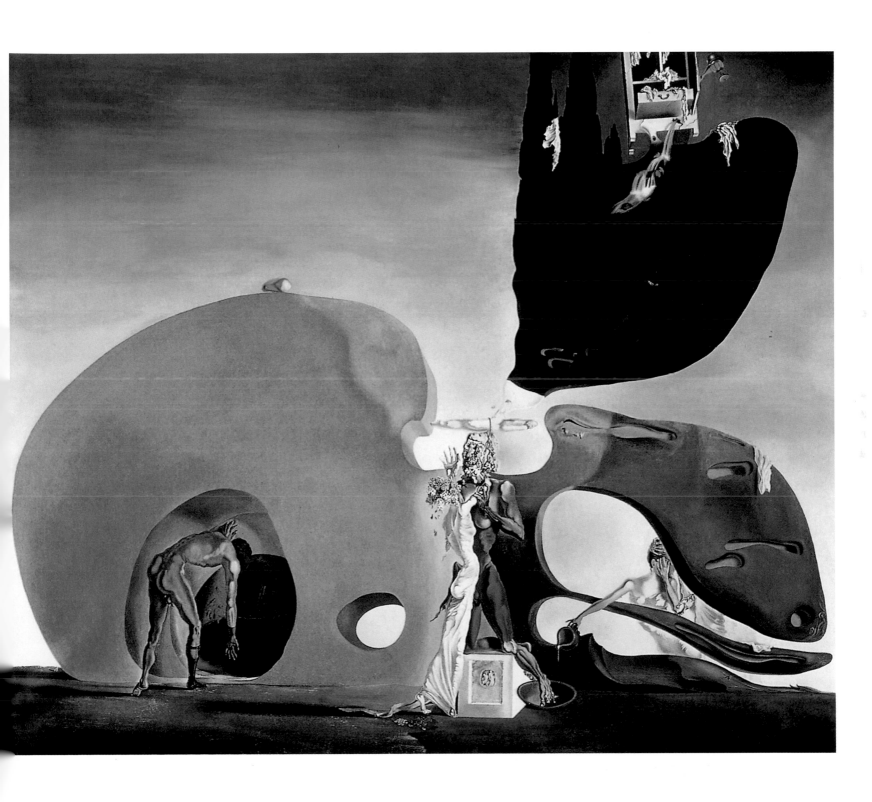

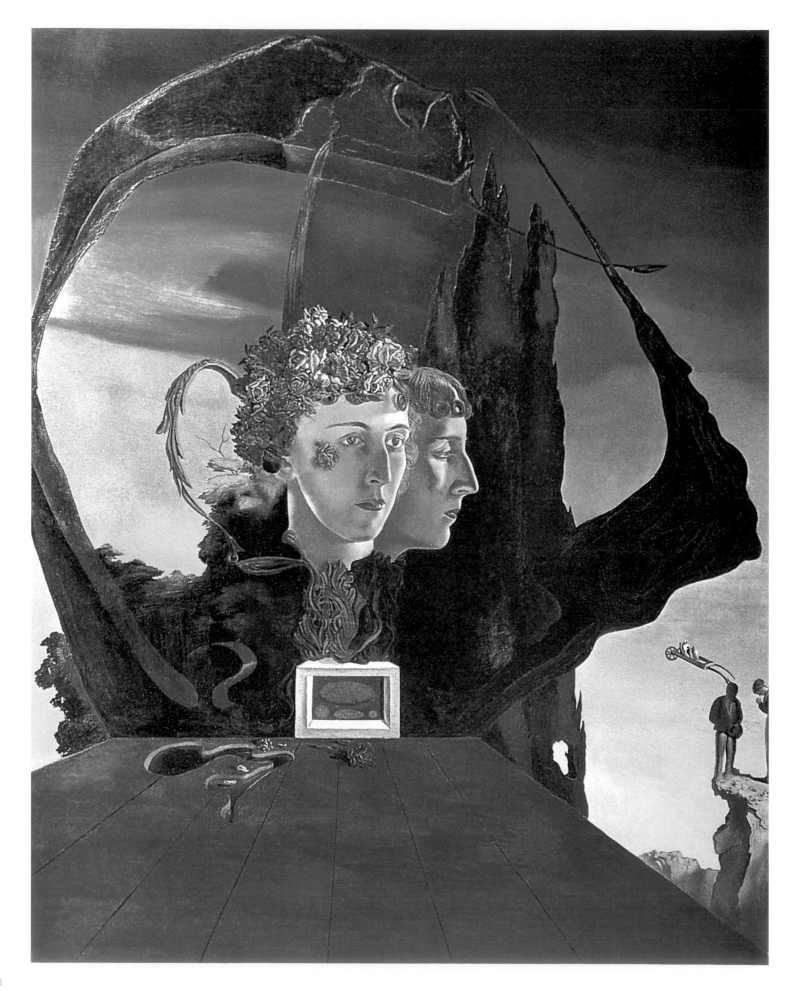

PORTRAIT OF THE VICOMTESSE MARIE-LAURE DE NOAILLES

1932
Oil on copper plate, 33 x 27 cm
Private collection

Marie-Laure, Vicomtesse de Noailles (1902-1970) was one of the leading patrons and collectors of modern art in Paris, as was her husband Charles. She was immensely wealthy in her own right, having inherited a fortune from her father, the American banker Maurice Bischoffsheim. Her maternal grandmother inspired Proust to model one of his characters upon her, whilst her mother was descended from the Marquis de Sade (which is one reason Marie-Laure purchased the original manuscript of *The 120 Days of Sodom*). At their town house located at 11 Place des États-Unis, the De Noialles maintained what was probably the most progressive and artistically-fashionable cultural circle in Paris. Among their protégés were Jean Cocteau, Man Ray, Alberto Giacometti, and François Poulenc. Both the Count and Countess de Noailles were enormous enthusiasts for Dalí's work, and they funded the second cinematic collaboration between the painter and Luis Buñuel, *L'Age d'or*.

As befits a commissioned portrait of a wealthy and influential patron, Dalí went very easy here on the disturbing side of things. Marie-Laure appears twice, once with flowers in her hair and with a rose – of the non-bleeding variety, naturally – on one of her cheeks. Beyond her, cypress trees rise up, as do rock forms that terminate in elongated spoons. For no apparent reason, a large hole is apparent near the far end of the platform leading to Marie-Laure's plinth. In the distance, on the right, the praying peasants from Jean-François Millet's painting *The Angelus* stand on top of a mountain, their wheelbarrow appearing to emanate from the head of the man, exactly as it would do in the 1933-1934 painting *Atavism at Twilight*. The relationship of Dalí to Millet's image is discussed below.

This portrait demonstrates that when Dalí painted without any real imagination, the results could look very flaccid indeed. Such weakness would always prove a major problem of his society portraiture – he just was not cut out for pictorial flattery.

THE ENIGMA OF WILLIAM TELL

1933
Oil on canvas, 201.5 x 346.5 cm
Moderna Museet, Stockholm

If Dalí dealt with sexual dominance and emasculation in the 1930 *William Tell*, and with the loss of sexual virility in *The Old Age of William Tell* of 1931, here he debunked the authority of a father-figure by making his William Tell look like Vladimir Ilyich Lenin, the father-figure of the Russian Revolution and therefore a hero to the Marxist leader of the Surrealist movement, André Breton. By such means Dalí not only demonstrated his whole-hearted identification with the irrationality of Surrealism but equally he fulfilled its revolutionary aims by demonstrating that he was no respecter of persons or of Surrealist orthodoxy, for a representation of William Tell as a hideously distorted Lenin was calculated to enrage Breton. This the picture certainly did when it went on display at the 1934 Salon des Indépendants, for when Breton saw the work he attempted to destroy it, although he failed, for it had been hung far too high on the wall to be reached. Later that year Breton put Dalí on 'trial' for his political and intellectual unorthodoxy but, faced with the sympathy that was expressed for Dalí's freethinking by his fellow Surrealists, René Crevel, Paul Éluard, and Tristan Tzara, eventually he was forced merely to caution the painter, instead of expelling him.

On the plinth in front of Tell/Lenin is one of Dalí's soft watches. Both the peak of the hat of Tell/Lenin and one of his buttocks extend enormously outwards, with the peak of the hat eventually resembling an extended tongue, and the buttock looking like a huge phallus. On the buttock/phallus is a piece of raw meat, which also resembles a lump of excreta. This chunk of meat or faecal matter respectively advances the animalism and linkage of sexuality with excretion that so obsessed Dalí.

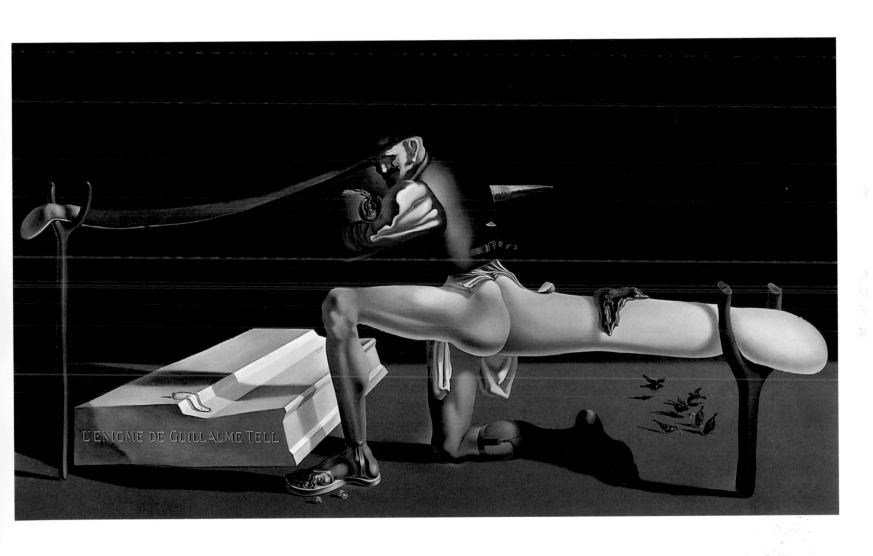

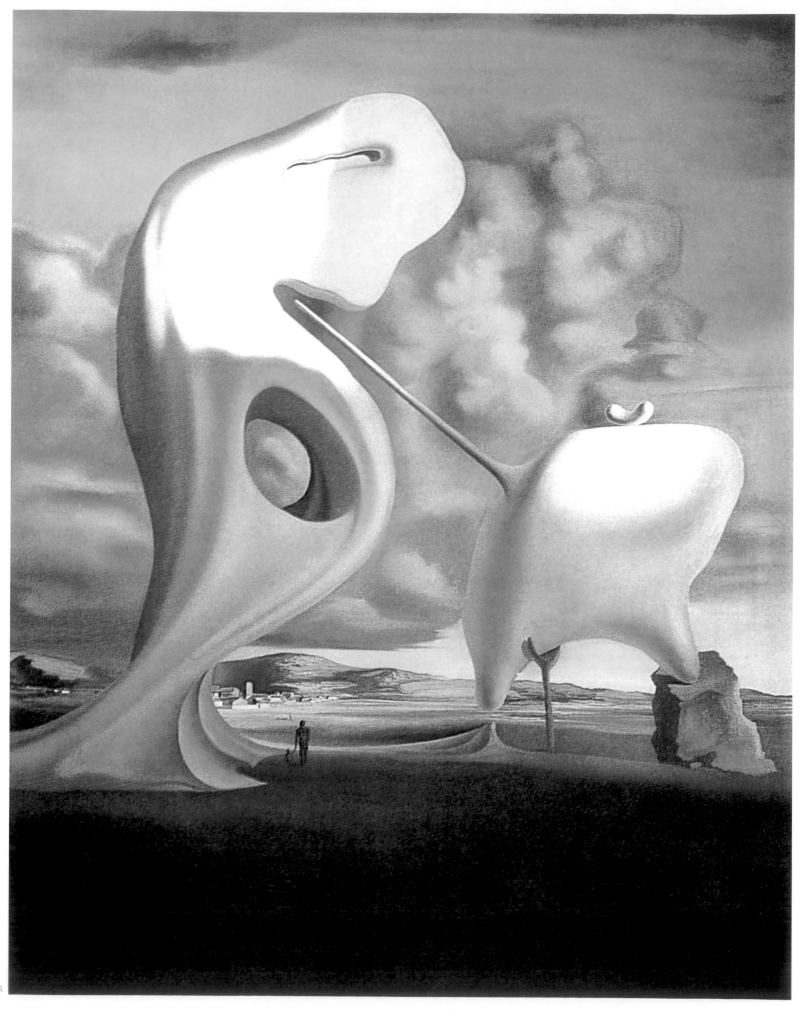

THE ARCHITECTONIC ANGELUS OF MILLET

1933
Oil on canvas, 73 x 60 cm
Museo Nacional Centro de Arte Reina Sofía, Madrid

Dalí had known Jean-François Millet's 1857-1859 painting *The Angelus* (p. 8) since his school days in Figueres, for a reproduction of it hung in the corridor just outside his classroom in the French Christian Brothers school he attended there. Subsequently he forgot all about the work until one day in 1932 when memory of it suddenly flooded back. The two figures and wheelbarrow in *The Angelus* thereafter reappeared in a great many of his pictures. In 1932 Dalí also wrote an essay entitled, "The Tragic Myth of Millet's *Angelus*, Paranoiacal-Critical Interpretation", although this would not be published until 1963. Among many other things, the essay advances the idea that the Millet image is latent with erotic violence, the man waiting to make love to the woman and hiding his erection with his hat as he does so. That sexual encounter will afterwards lead to him being devoured by the woman, just as the female praying mantis – to which creature Dalí compared Millet's woman – kills and eats her mate after copulation. Needless to say, it must somehow be doubted that Millet intended such meanings.

In a painting entitled *Angelus* of around 1932 (p. 9), Dalí portrayed the two peasants of Millet's image silhouetted against a lighter background. The man has one leg trousered and the other bare except for a sock and suspender, whilst the centre of his chest is cut out, being very shallow in depth. Beyond the two a floor stretches to distant mountains reminiscent of those visible at Cap Norfeu near Cadaqués. Between the peasants and the horizon, a motorcar is suspended from a rock. Long evening shadows fall across the scene.

In the present work Dalí abstracted Millet's peasants, transforming them into large rocks not unlike those found on Cape Creus, from which he had gained inspiration for shapes seen in *The Great Masturbator* and other paintings. The male form is on the left, with the aperture on his chest carried over from the empty chest cavity in the 1932 *Angelus*. On the right, the female snugly fits a long, proboscis-like form into a hollow below the male head, as though readying herself to suck forth his substance. Drooping, breast-like forms on this rock further suggests its femininity. Dalí often employed crutches to hint at decadence, decay, decomposition and death, and he surely did so here.

A man and child stroll through this landscape as though it were the most natural sight in the world. The intense orange colouring of part of the clouds is undoubtedly effective, although it fails to sit easily with the less vivid hues of the other clouds.

GALA AND THE ANGELUS OF MILLET PRECEDING THE IMMINENT ARRIVAL OF THE CONIC ANAMORPHOSES

1933
Oil on wood, 24.2 x 19.2 cm
National Gallery of Canada, Ottawa

Above a doorway hangs a widened version of Millet's *The Angelus*. A door into a room is opened by a man with a bushy moustache and a boiled lobster resting on his head. Inside the room another male sits looking at a spinning top, whilst beyond him is a grinning Gala. The man at the table looks not unlike Vladimir Ilyich Lenin who, as we have seen in the 1933 *Enigma of William Tell*, was certainly on Dalí's mind at this time. Up on the shelf at the left are three busts, the centre one of which represents André Breton, who was a Marxist and therefore admired Lenin. The moustachioed man has been linked to the Russian writer Maxim Gorky. However, this identification is difficult to sustain, for his moustache is extremely like the moustache visible upon a very similar-looking man with head lowered in exactly the same manner in Dalí's 1930 painting *The Average Bureaucrat*. It therefore appears more likely that Dalí simply intended the man to represent some kind of bureaucratic doorman.

According to Dalí himself, conical anamorphoses are the flat representations of images that are distorted in shape when reflected off very smooth three-dimensional cones. It appears very likely that the titular "conical anamorphoses" link to the forms constituting Lenin's right sleeve. Perhaps Dalí transposed these strange shapes from reflections he had witnessed upon a cone.

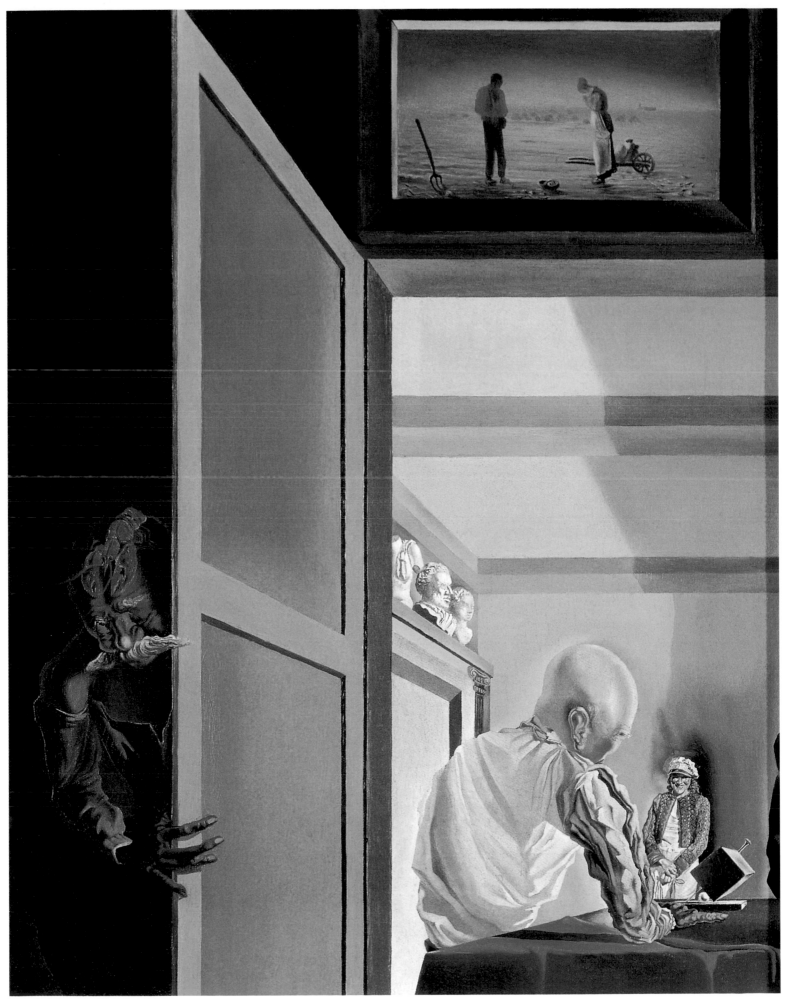

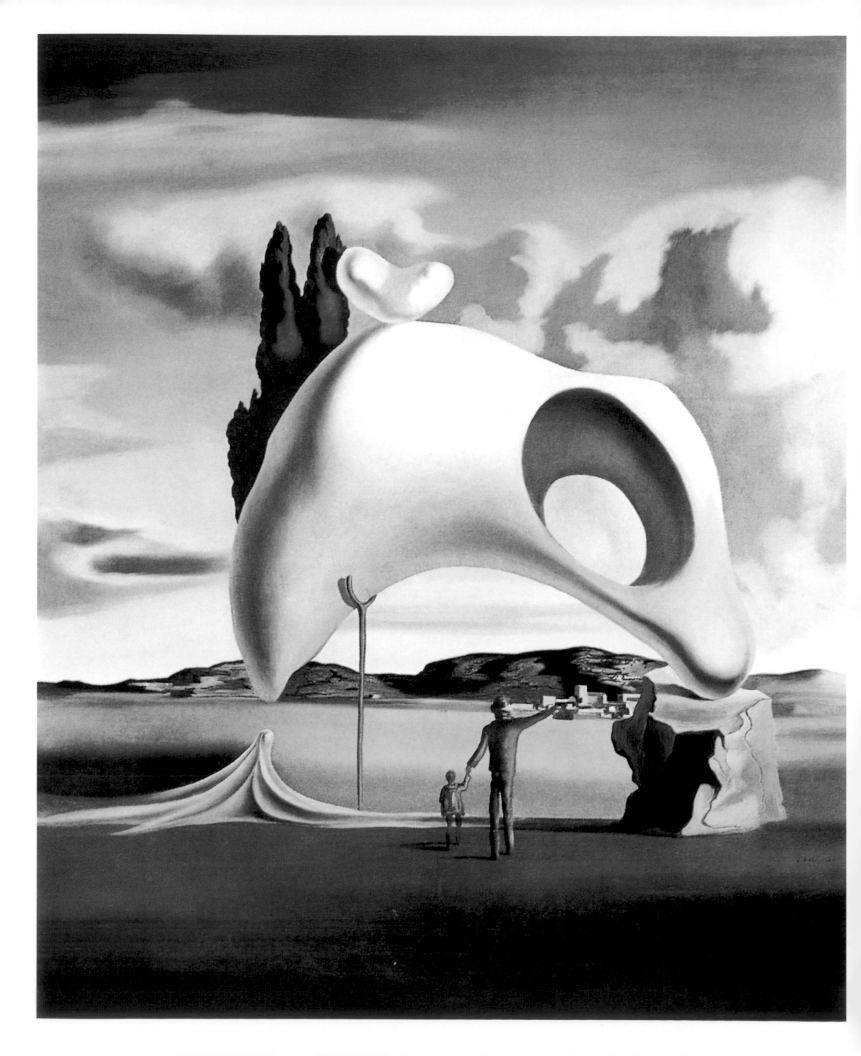

ATAVISTIC VESTIGES AFTER THE RAIN

1934
Oil on canvas, 65 x 54 cm
Private collection

In 1933 Max Ernst created a highly trenchant statement about recent European political and social upheaval, *Europe After the Rain*. In form it looks very like a map of Europe but with all of its physical boundaries altered, its surface all churned up like Flanders mud, and areas of scarlet introduced to remind us of blood. In the context of a Europe that between 1914 and 1918 had suffered the bloodiest military upheaval in human history, Ernst's imagery led to the obvious inference that the "Rain" of his title alluded to World War I, and that his image therefore represented the redrawn map of Europe after the termination of that conflict.

Here Dalí gave us an Empordàn landscape "after the Rain", but with another part of the title pointing us towards primeval disorder and its surviving vestiges in the modern world. The large rock-like form, the landscape setting, the sky and the man and child are not unlike those appearing in the 1933 *Architectonic Angelus of Millet*. Now, however, there is only one rock-like form and its central axis runs horizontally rather than vertically. That orientation reinforces the similarity of the form to the large, mica schist rock in the Cullaró cove on Cape Creus near Cadaqués that Dalí had probably known since childhood and upon which he based the shape of his self-portrait in *The Great Masturbator* and elsewhere.

The cypress trees emerging from the rock-like form introduce aptly funereal associations, for in Spain, as elsewhere, cemeteries are usually planted out with such trees. Dalí also knew them from Böcklin's *Isle of the Dead*. As is not the case in many of Dalí's other paintings in which a man walks with a child in hand, here it is possible to discern that the child is a little boy. Again we could therefore be witnessing a statement about Dalí's relationship to his father, in which case "the Rain" referred to in the work's title might have been the catastrophic breach that took place between the two men in 1929. In any event, the man points up to the dominant form, as though explaining what is going on. Sadly, we cannot hear what he says.

WEANING OF FURNITURE NUTRITION

1934
Oil on panel, 18 x 24 cm
Salvador Dalí Museum, St Petersburg (Florida)

Dalí's childhood nurse, Llúcia Gispert de Montcanut, here sits on the beach at Port Lligat in the stance adopted by the old female net-menders of the hamlet. On her lap is spread out a cloth she might be darning. At her feet is the night-table of Dalí's childhood. Understandably, the painter associated both nurse and night-table not only with each other but equally with childhood dependency (or "nutrition").

In this painting Dalí weaned himself off his nurse and night-table, just as a small night-table with a stoppered medicine bottle resting upon it has been "weaned" from the door of the larger one which, in turn, was perhaps "weaned" from the nurse's back. The contradiction whereby the small night-table is much thicker than the door from which it has been cut is clearly unresolvable and does not have its origins in rationalism. The crutch not only acts as a necessary physical prop – for anyone who lost such a large section of torso would surely be in need of one – but equally it furthers associations of old age and infirmity that were obviously relevant to Dalí's former nurse.

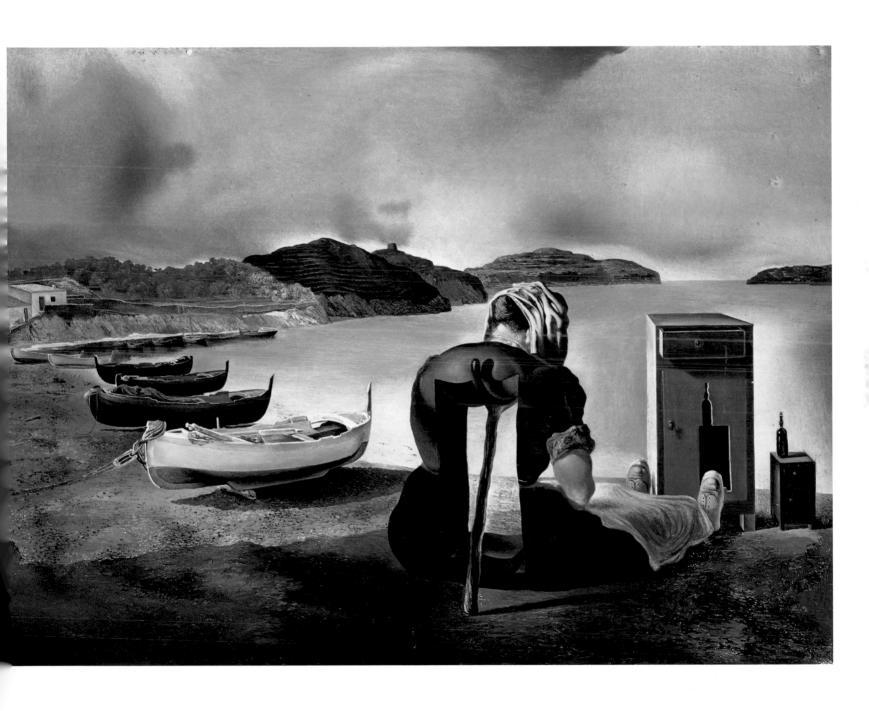

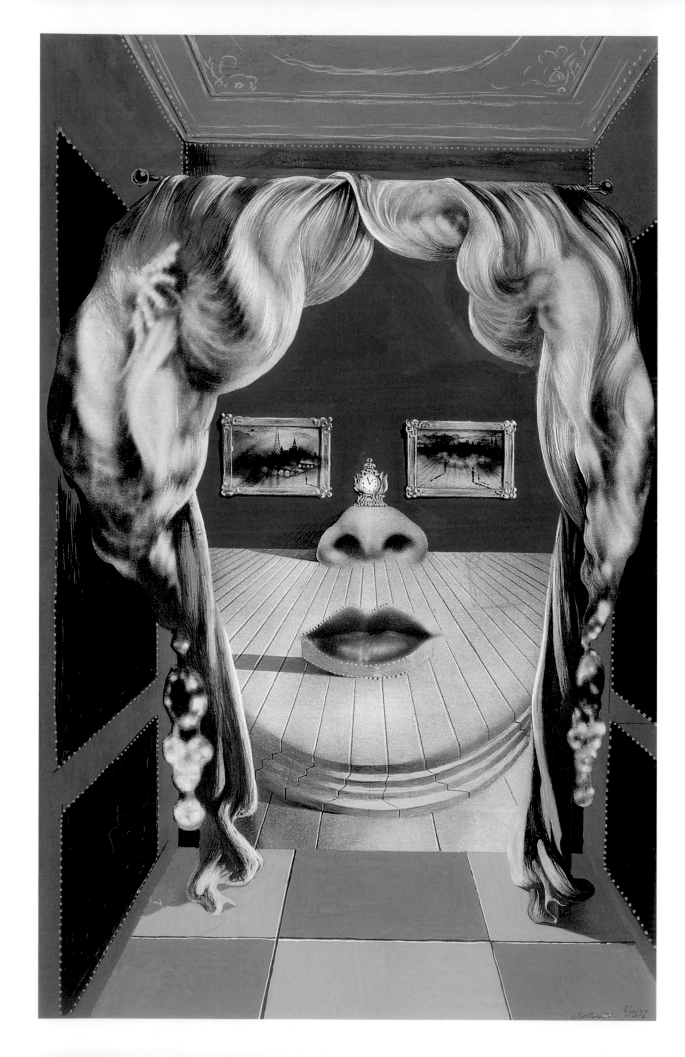

THE FACE OF MAE WEST (USEABLE AS A SURREALIST APARTMENT)

1934-1935

Gouache watercolour with graphite on newspaper, 28.3 x 17.8 cm

Art Institute of Chicago, Chicago

This drawing is one of Dalí's most inventive and witty employments of dual and composite imagery. It needs no verbal explanation, just careful scrutiny. In the 1970s the "apartment" was actually realised in the Teatre-Museu Dalí in Figueres by the Catalan architect Oscar Tunquest, working under Dalí's direction, but the result is not nearly as effective as this design, principally because in being realised three-dimensionally the imaginative level of the image was sacrificed, whilst spatial distortion also robbed the components of a good deal of their dualism. However, the *Sofa in the Form of Mae West's Lips* that Dalí made in 1938, in which the lipstick was represented by shocking pink satin, retains the witty appeal of the original.

PORTRAIT OF GALA

1935
Oil on wood, 32.4 x 26.7 cm
The Museum of Modern Art, New York

On the wall hangs a modified version of Millet's *The Angelus*, with both peasants seated on sacks resting in their wheelbarrow. The man appears to be masturbating behind his hat, which would explain why his head is in shadow, as though he is shrouded in shame. Next to him the woman prays. Dalí thought that in overall form the head of the peasant woman in Millet's painting resembles the head of a praying mantis. Here that similarity is reinforced by a flattening of the woman's face. As we have seen, in 1932 Dalí wrote of the woman/praying mantis of *The Angelus* readying herself to devour her companion after their lovemaking, and possibly she is doing that here as well.

In the foreground Gala sits with her back to us. The seat on which she rests is turned at a diagonal to the picture-plane. As a result, the lines of its edges both lead the eye into space and counter any spatial monotony that would have ensued if they had been aligned in parallel with the picture plane. Gala's brocaded silk jacket is rendered in a passage of impressive virtuoso painting. In the background Gala again wears the same jacket but is seated on a bag perched on a wheelbarrow that faces in an identical direction to the one in the Millet transcribed above her.

In 1937 Dalí described this painting as a double portrait "in which the two selves of the woman come face to face". However, the two Galas are quite clearly only "face-to-face" in a general sense, for they are not seated frontally to one another but at differing angles. Because of this, the Gala facing us is not looking at her other self but way past her. Either Dalí misjudged things or, more likely, he was not being overly accurate in 1937 about the relative physical positions of the women. Although Gala as seen from the front has been interpreted as looking "unusually cruel" – which would make connection with a praying mantis rather easy, and thus permit all kinds of psychoanalytic explorations – to the present writer she just looks serious and calm. As such she is decidedly unthreatening.

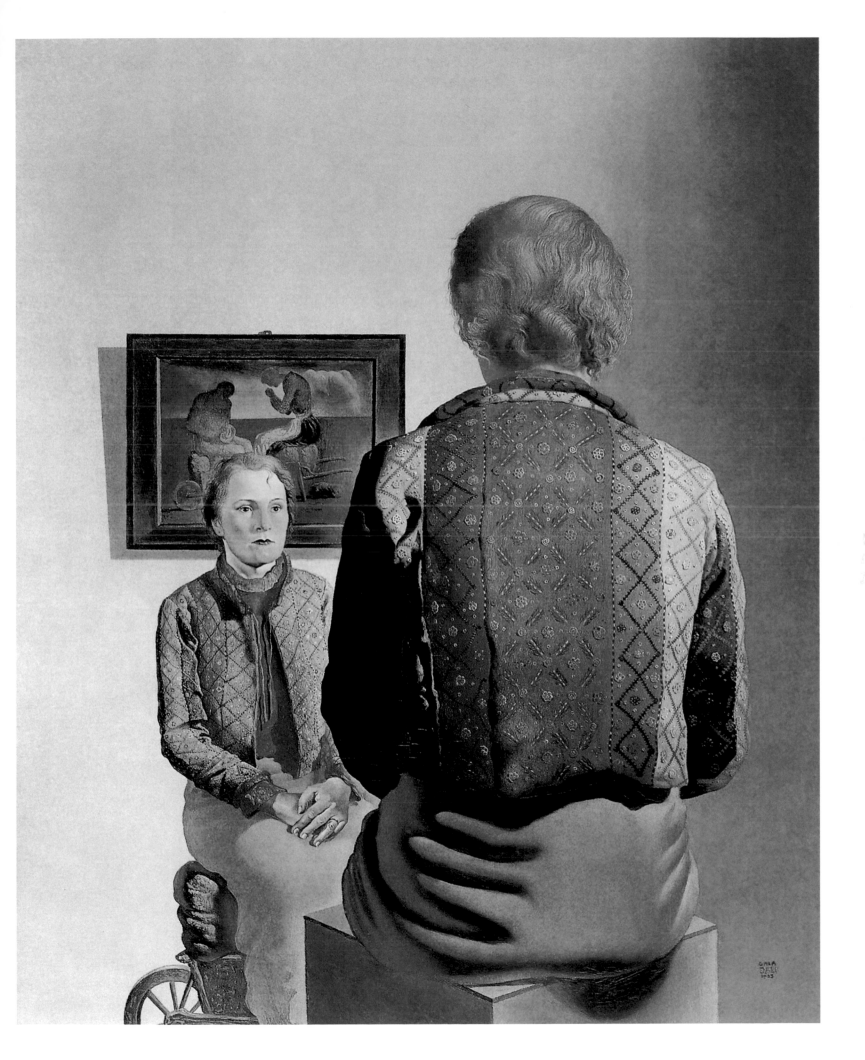

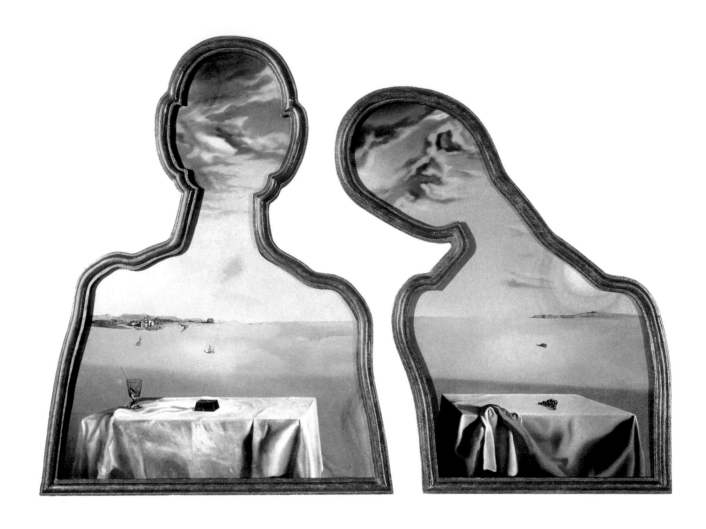

A COUPLE WITH THEIR HEADS FULL OF CLOUDS

1936
Oil on panel, 92.5 x 69.5 cm (man),
82.5 x 62.6 cm (woman)
Museum Boijmans Van Beuningen, Rotterdam

The overall shapes of the figures that form the supports for this dual image were taken from the peasants in Millet's *The Angelus*. The man is on the left and the woman on the right, with her head lowered in prayer. In both images, covered tables are placed in the open air. Given that the lighting in both scenes emanates from the right, and that the horizons in the two works align precisely, it appears likely that the scenes depicted constitute a single stretch of landscape and that Dalí intended us to bridge the gap between them.

On the left-hand table is a glass containing the last dregs of some milk, plus a spoon. Nearby is a kilo weight. In the distance, and respectively aligned with these objects, are a running housemaid and Dalí's childhood nurse Llúcia sitting in the same pose encountered in her representation in the 1934 painting *Weaning of Furniture Nutrition* (p. 111).

On the right-hand table the cloth is bunched up at a corner. It is possible to apprehend this tangle simultaneously as a figure holding its head in its hands. On the tabletop rests a bunch of black muscat grapes. In the distance, and aligned with the fruit, is the reclining figure of a man in a cloth cap. Because of his headgear he probably represents Lenin whom Dalí always painted wearing such an item of apparel. There is no logical connection between any of these juxtapositions but surely there does not need to be, given that the couple have their heads full of clouds.

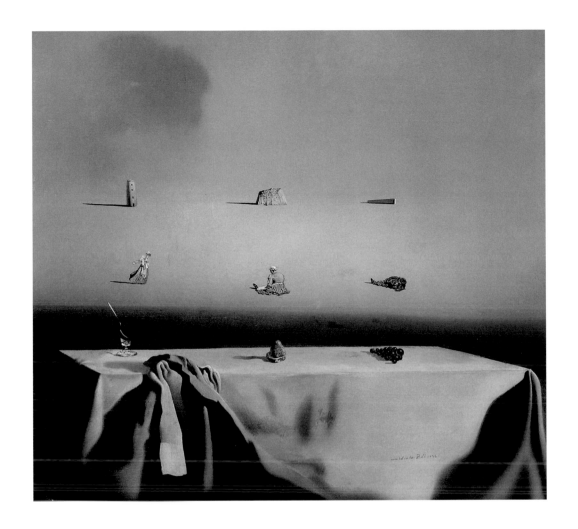

MORPHOLOGICAL ECHO

1936
Oil on panel, 30.4 x 33 cm
Salvador Dalí Museum, St Petersburg (Florida)

This work links directly to *A Couple with Their Heads Full of Clouds* discussed previously (opposite), for the table is very similar to the one appearing in the right-hand image of that work. The bunching of the tablecloth towards its left end again resembles a figure holding its head in its hands. On the tabletop can be seen objects found upon the tabletops in both parts of *A Couple with Their Heads Full of Clouds*, just as the running nursemaid, Dalí's childhood nurse Llúcia and a reclining Lenin in cloth cap equally appear there. Only the distant tower and brick wall, and a piece of bread at the centre of the tabletop, are not provided in *A Couple with Their Heads Full of Clouds*, although

the kilo weight seen in that painting has now disappeared. Dalí exploited spatial ambiguity in this tiny work, for because the objects are vertically aligned and yet cast deep shadows, we can either see them as rising above the table or as regularly receding into space beyond it. The fact that the area beyond the table enjoys no horizon line furthers this uncertainty, whilst the surround adds to the dreamlike, floating nature of the image. The hot yellows and reds introduce associations of a desert-like background, just as the table and still life equally evoke Spanish 17th-century still-life painting. Moreover, if we read the table and its contents as forming merely a still life, then the empty area beyond the table might alternatively be viewed as a blank wall with images painted upon it.

On the left, the glass, nursemaid, and tower share their verticality, in the centre the bunched nursemaid's skirt serves visually to connect the crusty bread to the encrusted rock face, and on the right all three forms enlarge towards the right. Through such overall similarities of form and texture can easily be apprehended the necessary "morphological echoes" of the title.

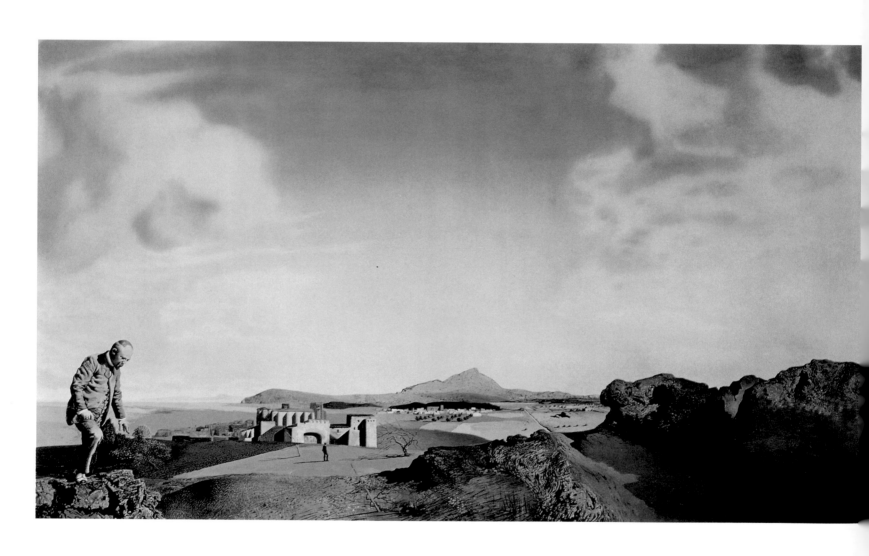

THE PHARMACIST OF AMPURDÀN IN SEARCH OF ABSOLUTELY NOTHING

1936
Oil on panel, 30 x 52 cm
Museum Folkwang, Essen

In this beautiful but fairly straightforward and unsurreal landscape painting, Dalí married the vast plain of the Empordà near Figueres with an image culled from a scientific journal, in the form of the man standing with his foot upon a rock on the left. Dalí took this figure from a magazine illustration showing a man – who might possibly be the Austrian physician, Victor Eisenmenger (1864-1932) – working a heart massage machine with his foot. With typically freewheeling associationism, in a 1934 essay entitled "The New Colours of Spectral Sex-Appeal" Dalí connected this man with a Figueres pharmacist of his youth, whom he then linked to the chemist's mathematician son, whom he subsequently associated through the name of the street in which the mathematician had lived to the name of a Catalan physicist and inventor of the world's first combustion-driven submarine, Narciso Monturiol (1819-1885).

According to the title of this painting, however, Dalí simply gave us the Figueres chemist, a Mr Deulofeu.

The title informs us that the chemist is "in Search of Absolutely Nothing". Clearly this was equally Dalí's intention in the painting: he simply wanted to depict a lovely stretch of landscape without having to search for anything, just like the "Chemist" he introduced pictorially to lend scale and a slight touch of animation to the proceedings. In the mid-distance a solitary individual may also be the same man. He too establishes scale.

Something of this landscape, plus "the Chemist", are to be seen in the Soft Construction with Boiled Beans - Premonition of Civil War also painted in 1936 (p. 121).

SOFT CONSTRUCTION WITH BOILED BEANS – PREMONITION OF CIVIL WAR

1936
Oil on canvas, 100 x 99 cm
Philadelphia Museum of Art, Philadelphia

The direct ancestor of this picture was *The Colossus (Panic)* from Asensio Julía (formerly attributed to Goya), which was possibly painted around 1812 and which shows an immense landscape filled with panic-stricken people and animals fleeing in all directions beneath a giant male nude with raised fists who towers above the scene. Dalí undoubtedly knew the work that he believed to be a Goya from his student days, for it hung in the Prado Museum in Madrid.

As civil strife was no new phenomenon in Spain, especially in the 20th century, Dalí's claim that he had a premonition of the coming civil war when he painted this picture some six months before the outbreak of hostilities was therefore not as prescient as it might seem. Even so, this is still one of the most startling images of our epoch, with its low viewpoint enabling the hideously distorted, hag-like creature to tower over us, a dominance that also allowed Dalí to paint one of the finest and most immense skyscapes in all art.

In *The Secret Life of Salvador Dalí* the painter wrote of this work:

> In this picture, I showed a vast human body breaking out into monstrous excrescences of arms and legs tearing at one another in a delirium of auto-strangulation. As a background to this architecture of frenzied flesh devoured by a narcissistic and biological cataclysm, I painted a geological landscape that had been uselessly revolutionised for thousands of years, congealed in its 'normal course'. The soft structure of that great mass of flesh in civil war I embellished with a few boiled beans, for one could not imagine swallowing all that unconscious meat without the presence (however uninspiring) of some mealy and melancholy vegetable.

Dalí also adorned the repast with the outcome of eating so many beans, namely a huge lump of excreta, to be seen draped over the thigh on the right. Just beyond the hand at the lower left is a figure from another picture that Dalí also painted in 1936, *The Pharmacist of Ampurdàn in Search of Absolutely Nothing*. This represented the father of a famous author from Figueres, whilst the figure itself was taken from a newspaper photograph.

Dalí's use of transformation is quite outstanding in this picture, for the squeezed teat on the left is grasped by a hand that emanates from an arm which is joined to another arm that becomes a thigh, then a buttock supporting a foot which eventually again becomes an arm; Dalí's long study of the similarities of things paid off handsomely here, for it allowed him to effect effortless anatomical transitions.

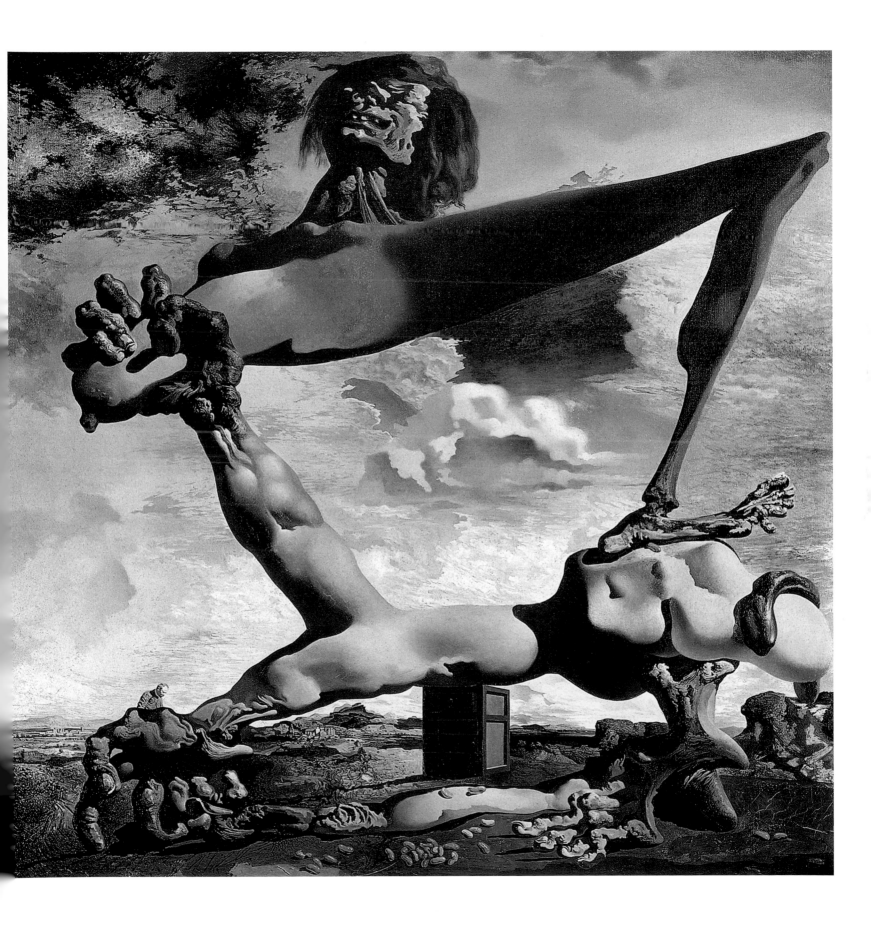

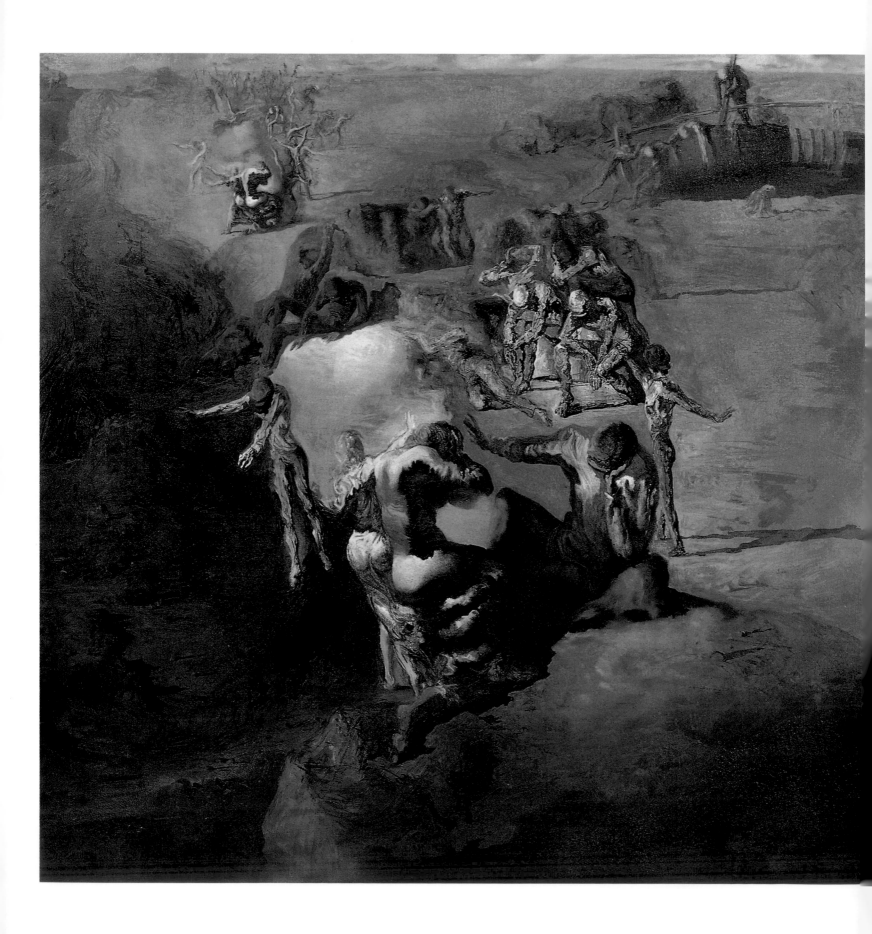

THE GREAT PARANOIAC

1936
Oil on canvas, 61.9 x 61.9 cm
Museum Boijmans Van Beuningen, Rotterdam

Dual imaging was central to Dalí's 'Paranoiac-Critical Method' but rarely did he achieve with it the complete congruence of form and content that we see here. Not only does the eye easily construct a complete head out of the various writhing figures, but equally the writhing itself vividly projects a sense of twisting nervous energy that wholly communicates the mental state referred to in the title (paranoia being a condition characterised by hallucinations or delusions). The exaggeratedly irregular contours of the shadows on and around the figures augment the suggestion of constant motion throughout. They also subtly further the notion that we are looking at a surreal image, for in places they melt softly into their surroundings, thus imparting a sense of floating detachment from reality.

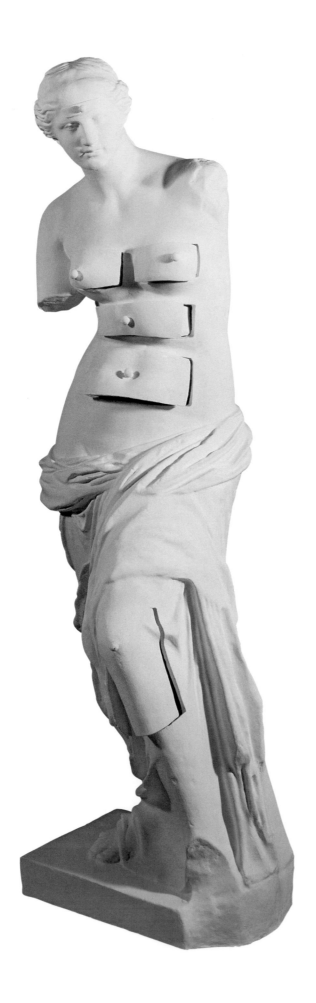

VENUS DE MILO WITH DRAWERS

1936
Plaster, white ermine fur tuft covers,
and metal knobs, 98 x 32.5 x 34 cm
Private collection

One of Dalí's patrons, the Englishman Edward James, related in his memoirs that his ancestors had:

...brought back far too many trophies from their hunting expeditions... There was even a polar bear from Greenland which was eight feet tall. He was mounted holding a silver salver, that poor bear, and in the end he got moth in his chest so, in 1934, I gave him to Salvador Dalí and shipped him over to Paris, where Dalí had him dyed mauve. He had drawers put in the bear's chest to keep his cutlery in.

The idea of putting drawers in a chest may have derived from Dalí's misunderstanding of English names for things, for when staying with James on one occasion he heard someone speak of a 'chest of drawers'. Obviously that notion tickled his fancy, for he not only gave a polar bear and the Venus de Milo just such a chest, but equally did so for a nude woman in the 1936 painting *The Anthropomorphic Cabinet* (opposite). Just as chests of drawers are divided into compartments, so too is the subconscious, which was always in the forefront of Dalí's mind.

Dalí made this sculpture with the assistance of Marcel Duchamp, who took it upon himself both to get the chest cut out from a plaster cast of the Venus de Milo, and to have drawers constructed behind each cut-out. In 1964 the sculpture was remade in bronze. It is not difficult to perceive the source of Dalí's desire to have a Venus adorned with fur, for clearly it derived from a reading of the novel *Venus in Furs* by Leopold von Sacher-Masoch (1836-1895), published in 1870. Paradoxically the result of Dalí's intervention was to de-sexualise the armless goddess of love even further.

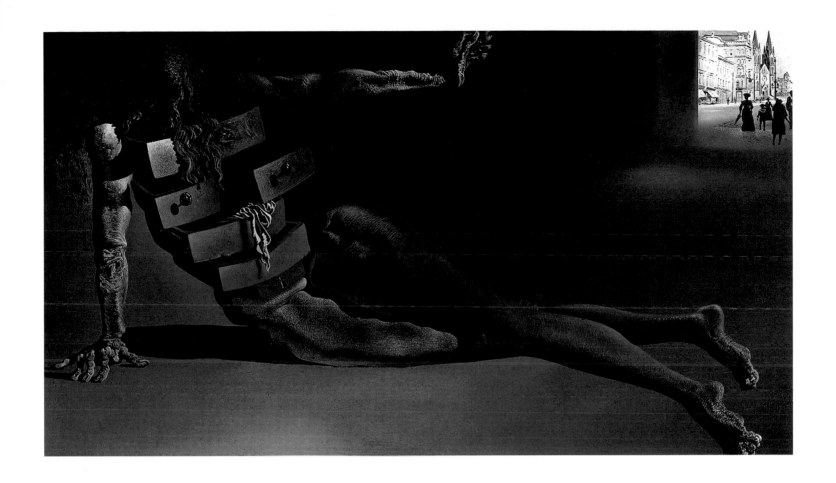

THE ANTHROPOMORPHIC
CABINET

1936
Oil on wood, 25.4 x 44.1 cm
Kunstsammlung Nordrhein-Westfalen, Düsseldorf

As the title of this painting tells us, the cabinet represented is no ordinary one. Dalí had painted an open drawer in the 1932 *Birth of Liquid Desires* (p.99), but by 1936 he became especially concerned with placing such drawers at various anatomical locations within his figures, as can also be seen in *The Burning Giraffe* (p. 128) of that year, to be discussed below.

With one exception, the drawers here are empty, and the woman with her head buried in the topmost drawer seems utterly despondent. At the top-right Dalí has carefully recreated a *fin de siècle* view of a city. Judging by the woman's gesture, withered skin and empty drawers, her despair seems to be caused as much by the loss of her past as by her inner emptiness.

METAMORPHOSIS OF NARCISSUS

1937
Oil on canvas, 51.1 x 78.1 cm
Tate Collection, London

In Ovid's *Metamorphoses* Narcissus is an unusually handsome youth whose punishment by Nemesis is to make him fall in love with his own reflection in a pool. In turn he is loved by the nymph Echo, who is punished by Juno into only ever becoming capable of repeating the last words that are spoken to her.

We see Narcissus gazing downwards on the left. By means of a complete visual correspondence between that figure and the hand and bulb sprouting a Narcissus flower on the right, Echo's verbal repetitiousness is suggested. The warm colour of the body and the cool tones of the hand add to the sense that we are looking at complementary forms, and thus advance the Narcissus and Echo theme, whilst the group of distant nudes between the figure and hand amplify the sexual undertones of the original myth.

Soon after this painting was completed, Dalí published a poem and essay entitled "The Metamorphosis of Narcissus" in which he related that in Catalonia the phrase "to have a bulb in the head" means to suffer from a psychological complex. The painter then went on to state, "If a man has a bulb in his head it might break into flower at any moment. Narcissus!" This is probably why we see the narcissus flower springing forth here. And in the far distance on the right may be seen the tips of further fingers holding another bulb. Before them is a youth (or perhaps a statue of a youth) standing on a plinth; this too may be Narcissus.

When Dalí visited Sigmund Freud in London in 1938 he showed him this painting and was purportedly told:

> It is not the unconscious I seek in your pictures, but the conscious. While in the pictures of the masters – Leonardo or Ingres – that which interests me, that which seems mysterious and troubling to me, is precisely the search for unconscious ideas, of an enigmatic order, hidden in the picture, your mystery is manifested outright. The picture is but a mechanism to reveal it.

However, this response may have been wishful thinking on Dalí's part, for by 1938 Freud had difficulties in speaking due to the onset of throat cancer. Yet in a letter that the psychoanalyst wrote to Stefan Zweig right after the meeting with Dalí, he did make it clear that the painter had changed his attitude toward Surrealism, which he had previously thought foolish. Now he told Zweig, "This young Spaniard, with his ingenuous fanatical eyes, and his undoubtedly technically-perfect mastership has suggested to me a different estimate".

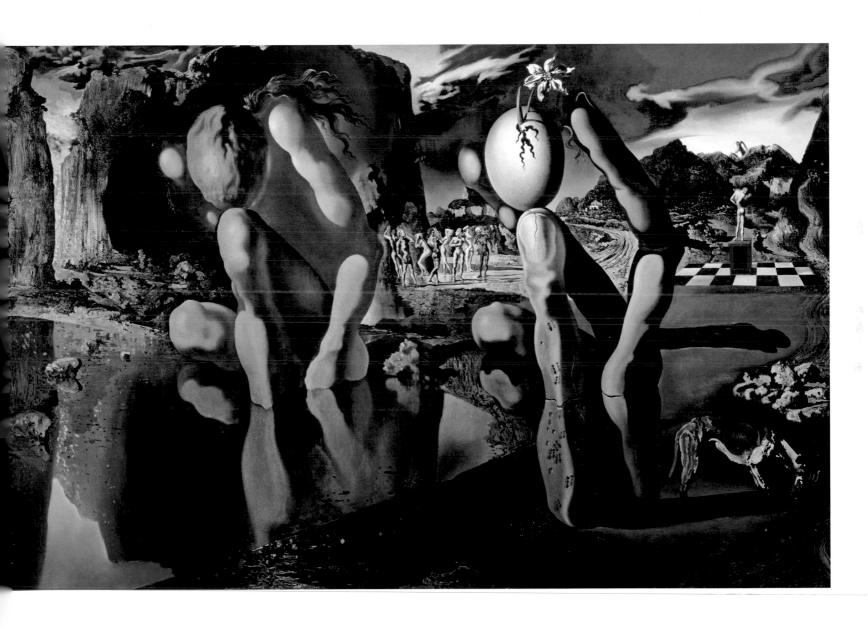

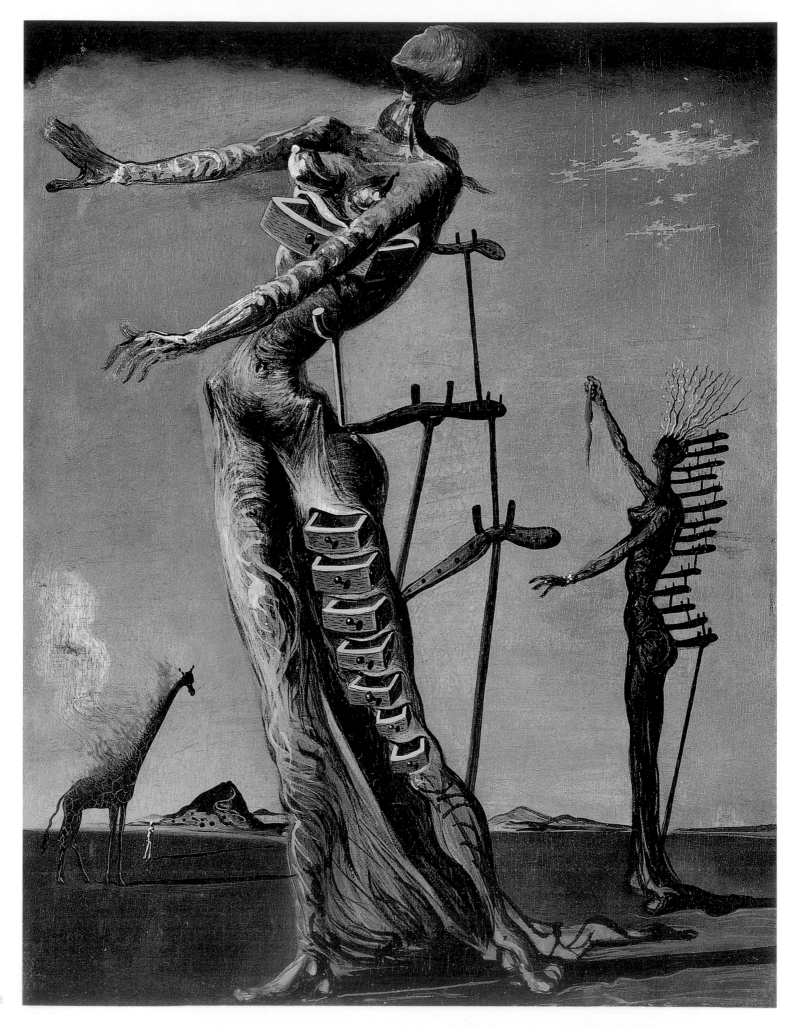

THE BURNING GIRAFFE

1937
Oil on panel, 34.9 x 26.9 cm
Kunstmuseum Basel, Basel

As he also did in his 1937 painting *Invention of the Monsters*, Dalí identified a creature of the type seen here as being a "flaming giraffe equals cosmic masculine apocalyptic monster". On that basis we can interpret the distant giraffe as a cosmically phallic and apocalyptic creature as well. Open drawers, crutches, and belts adorn the woman in the foreground, as they do the one beyond. The hair of this second lady resembles the twigs of a tree and she bears aloft a sliver of red meat or some similar matter. The predominantly blue colouring of the image serves both to accentuate the warmth of the distant fire and to augment the unreal mood throughout.

The pose of the woman closest to the viewer is shared by a woman in a drawing by Dalí entitled *An Imaginary Costume for a 'Dream Ball'* that was published in *The American Weekly* in March 1935.

SLEEP

1937
Oil on canvas, 51.1 x 78.1 cm
Museum Boijmans Van Beuningen, Rotterdam

In an article published in the Surrealist review *Minotaure* in the winter of 1937, Dalí stated that when sleeping, "It is enough for one lip to find its exact support in a corner of the pillow or for the little toe to cling imperceptibly to the fold in the sheet for sleep to grip us with all its force". That declaration helps us understand the presence of so many supporting crutches in the image. In the essay Dalí further drew attention to the dog on the extreme left leaning on his crutch, opening one eye and then going back to sleep, as well as to "the well-known summering town" (seen on the right) that had appeared "in the boring dream of Piero della Francesca". This referred to Piero's *Legend of the True Cross* fresco cycle in the Church of St Francesco in Arezzo, wherein may be found the image of the Emperor Constantine lying asleep in his tent.

Dalí later described this work as a "painting in which I express with maximum intensity the anguish induced by empty space" and stated that "I have often imagined the monster of sleep as a heavy, giant head with a tapering body held up by the crutches of reality. When the crutches break we have the sensation of 'falling'." In the far distance a beached boat induces associations of severance from a normal environment. The area where we would expect to see an ear is covered by a cloth, suggesting that all sound has been shut out. On the right the elongated and utterly limp form resembles a used or unused balloon or condom. The limpness of the head projects the spent energies that induce sleep, whilst the huge empty space and detachment of the head from direct earthly support also fully projects our disembodiment when asleep.

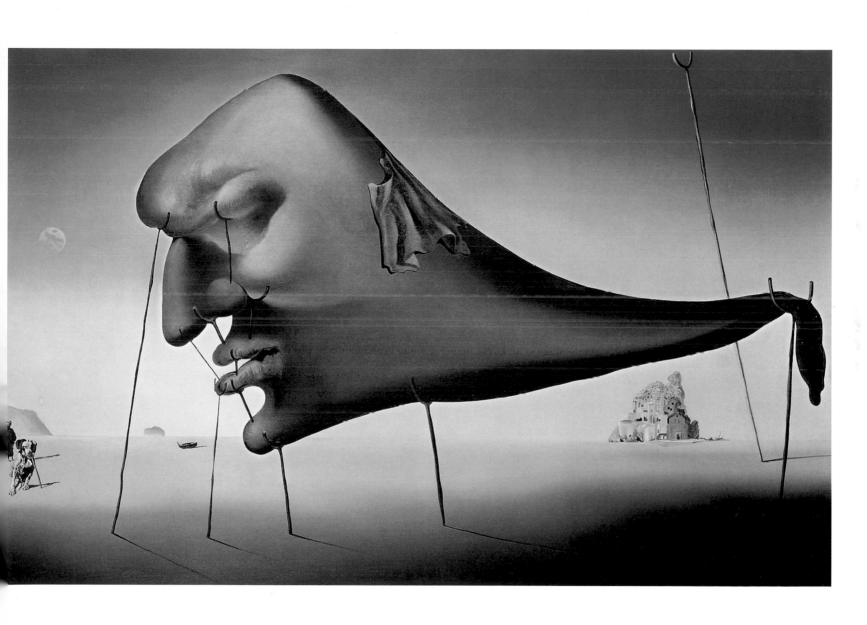

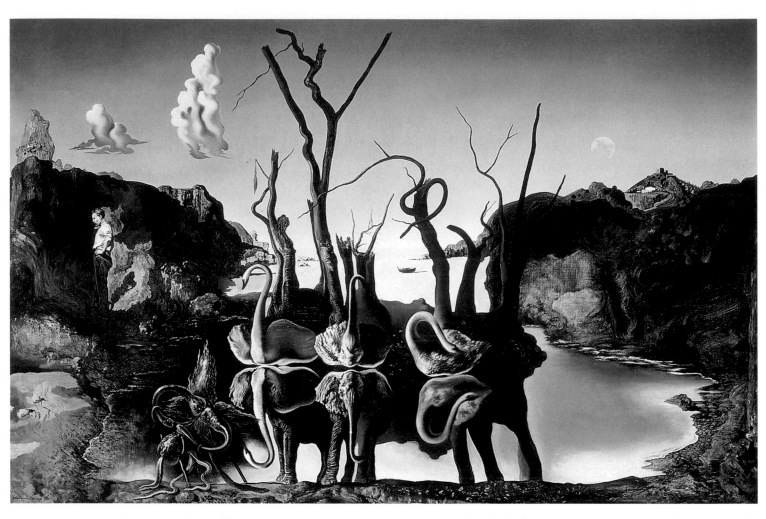

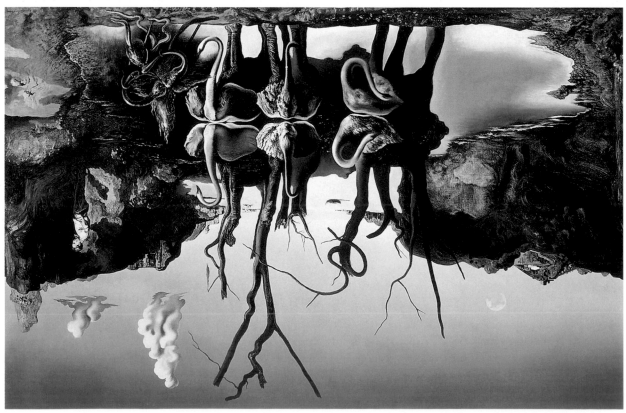

SWANS REFLECTING ELEPHANTS

1937
Oil on canvas, 51.1 x 77.1 cm
Private collection

Here again we encounter a highly poetic, inexplicable universe whose strangeness is greatly heightened by sharp contrasts of 'furious precision' and loose areas of form. Through reproductions of this picture, unlike reality, one can enjoy Dalí's inventiveness to the full, for if the colour plate is turned upside down the elephants that support the swans in the centre will themselves be transformed into swans and the swans into elephants: Dalí has not only perceived their similarity of form but doubled the number of times he played upon it, using the stumps of trees beyond the swans to provide the legs of the upside-down elephants.

The sinuous curve of a branch above the left-most swan counterpoises the sweeps of neck and trunk below it. In the far distance on the left appears a strange rock formation and hill town that Dalí clearly appropriated from early Italian painting, of the type that may also be seen in the *Sleep* painted in the same year. The painting is also inverted opposite.

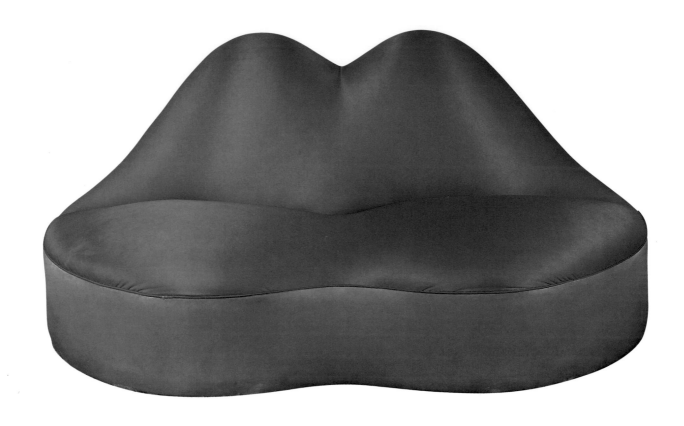

SOFA IN THE FORM OF MAE WEST'S LIPS

1938
Wood structure covered in pink satin,
86.5 x 183 x 81.5 cm
Trustees of the Edward James Foundation, Chichester

The idea for this unusually witty Surrealist object originally came to Dalí in 1934 when he created *The Face of Mae West* (*Useable as a Surrealist Apartment*).

(p. 112). There the lips of the actress double as a sofa. In 1936 the painter's English patron, Edward James, suggested that he turn the drawing room of his town house at 35 Wimpole Street, Marylebone, London, into a complete Surrealist environment. Although that project was not realised, Dalí did permit James to have five Mae West sofas constructed in three differing sets of materials by two furniture companies. James then had two of the completed sofas taken down to his house in Sussex, whilst a third was placed in the dining room of the London residence.

Sadly, it is not known what Mae West thought of the sofa. However, it seems likely that Andy Warhol greatly admired it, for in 1962 he would make a painting of Marilyn Monroe's lips that owes much to the Dalí object.

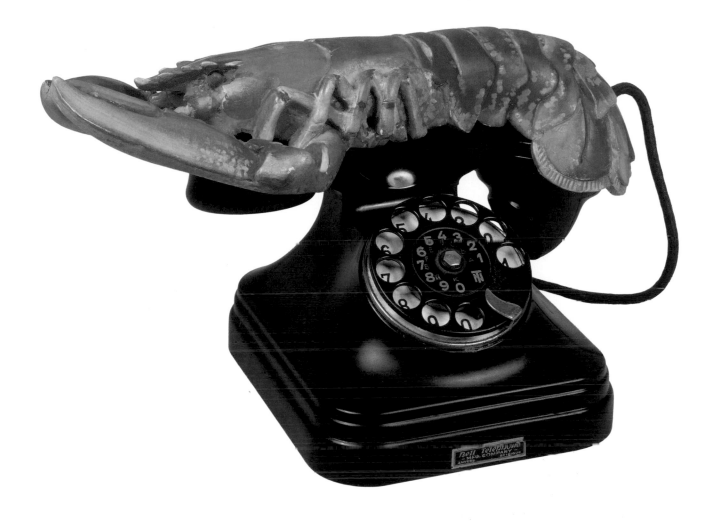

LOBSTER TELEPHONE

1938
Painted plaster, Bakelite, and metal telephone,
19 x 31 x 16 cm
Trustees of the Edward James Foundation, Chichester

In June and July 1938 Edward James had ten Dalí *Lobster Telephones* created and hand-painted. The story has been widely disseminated that Dalí had received the inspiration for the Surrealist object when staying with James in London in June, 1936. Supposedly a group of people, including the painter and his patron, were eating lobsters and throwing the shells aside when one fortuitously landed on a telephone. This incident then led James to recall seeing a bedridden lady pick up and put to her ear not the telephone on her bedside table but a cooked lobster that also lay there. However, as we have seen, Dalí had already placed a two-dimensional lobster upon a very different kind of form in the 1933 painting *Gala and the Angelus of Millet Preceding the Imminent Arrival of the Conic Anamorphoses* (p. 107). It therefore seems very likely that well before the occurrence at Edward James's house the idea had already come to Dalí to place a three-dimensional lobster upon a contrasting support.

It should be noted that Dalí's lobster is female. Its sexual organs are therefore located in its tail and thus immediately above the telephone mouthpiece.

SPAIN

1938
Oil on canvas, 91.7 x 60.3 cm
Museum Boijmans Van Beuningen, Rotterdam

As well as looking carefully at early Italian paintings on his trips to Italy in the mid-1930s, Dalí also studied the works of Leonardo da Vinci, and that influence can easily be perceived in the distant figures here. Such an assimilation was of course apt, for Leonardo himself had advocated the apprehension of things in other things, much as Dalí often forces us to do, and does again on this occasion. In overall terms the painting is reminiscent of Leonardo's unfinished *Adoration of the Magi* in the Uffizi, Florence, as well as some of its related drawings, and facially Dalí's leaning woman is markedly similar to many of Leonardo's women. But Dalí's woman is formed compositely out of the distant, struggling figures, and her face appears only as an alternative to the struggling figures who form it – we cannot see *both* the face

and the figures at once, as we might with many of Dalí's other dual images; we have to read one set of images or the other. And the painting also forces us to question the nature of illusion and reality in other ways too. Thus the chest, drawer, foot, and arm in the foreground are more tangible than the sketchier forms elsewhere, being more highly-modelled, and yet they remain mere illusions.

By 1938 Spain was approaching the climax of its Civil War, so it seems highly appropriate that Dalí epitomised that country as both a desolate plain peopled with struggling figures, animals, and odd bits of furniture, and equally as a fragmented woman composed of many warring creatures.

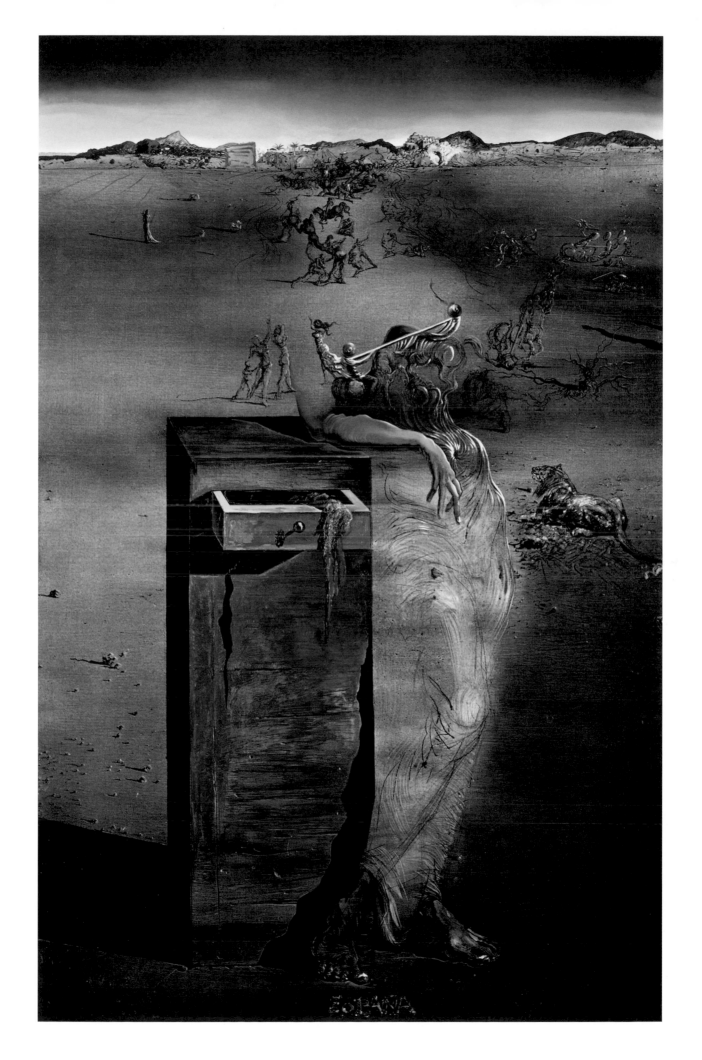

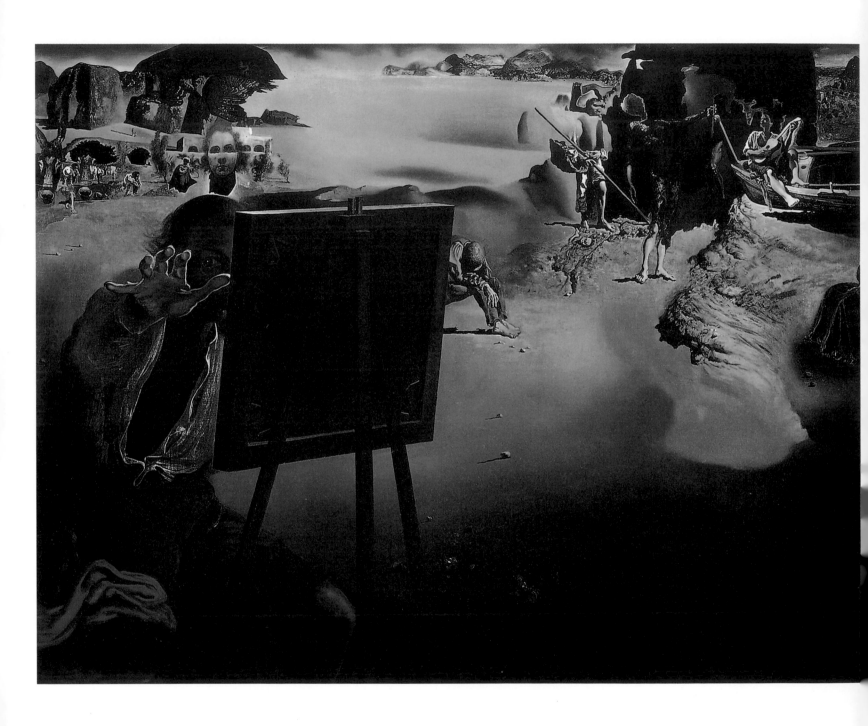

IMPRESSIONS OF AFRICA

1938
Oil on canvas, 91.1 x 117.4 cm
Museum Boijmans Van Beuningen, Rotterdam

For Dalí the playwright Raymond Roussel (1877-1933) was "the greatest French imaginative writer", and it was from a play by Roussel entitled *Impressions of Africa* that he obtained the title of this picture. By 1938 Dalí had never visited Africa, and he painted *Impressions of Africa* (p. 138) in Rome after a visit to Sicily, wherein he had found "mingled reminiscences of Catalonia and of Africa". Roussel was very fond of playing games with words and meanings, which is why his work greatly appealed to Dalí and the painter similarly played around with illusion and reality here, as well as with intense contrasts of the broad and the minute.

On the left is Dalí himself, with Gala behind him, the shadowed areas around her eyes exactly aligned with some adjacent Moorish archways. The emptiness and dreaminess of the central area of the image are greatly augmented by the contrasting crowded and fragmented areas to either side. The wide tonal shifts and hot colours certainly project the heat and dust of Africa.

APPARITION OF FACE AND FRUIT DISH ON A BEACH

1938
Oil on canvas, 114.8 x 143.8 cm
Wadsworth Atheneum Museum of Art, Hartford (Connecticut)

In 1938 Dalí made a painting that looks rather similar to this one and entitled it *Invisible Afghan with the Apparition on the Beach of García Lorca in the Form of a Fruit Dish with Three Figs*. The title and imagery of that work provides a vital clue to the identity of the person 'portrayed' here.

This is one of Dalí's most brilliant inventions, for it not only provides us with a surreptitious portrait of Federico García Lorca but equally represents a beagle mastiff; both of these images are made up from other things. Thus the forehead, nose, mouth, and jaw of Lorca are provided by the bowl, bulbous projections, and flutings of a fruit dish, whilst the shapes of some pears above them double as Lorca's hair. Simultaneously a beagle mastiff can be made out, with its head at the top right. A rock arch doubles as its eye, a glacier as its snout, a dark shadow as its nose, and a bridge as its collar. Off to the left its hind quarters and legs are visible, with the 'head' of Lorca equally standing for the front legs of the canine. The hindquarters of the dog further serve a third purpose as a wall of water, with the lines of dog hair doubling as cascading lines of the liquid. The wall of water towers over a small pool that doubles as the elongated shape of a fish lying on its side.

It may be that Dalí intended the severed rope to allude to Lorca, whose life had been torn from him about two years before this picture was painted. But certainly the dog alludes to the poet, for of course Dalí was well aware that Luis Buñuel had intended the title of their joint filmic collaboration, *Un Chien andalou*, to allude to the Andalusian poet. This painting is not just a portrait of Lorca therefore; equally it doubles as a representation of the poet's second – albeit unwanted – persona as an "Andalusian dog".

The nearest object to the eye is a tiny circular pebble in the right foreground, and its rotundity is picked up and amplified at the top-left by the moon, the most distant object in the image. The spatial transitions are especially fine in this painting, with the eye being gradually led off into the far distance, and with the moon acting as the climactic form both spatially and poetically.

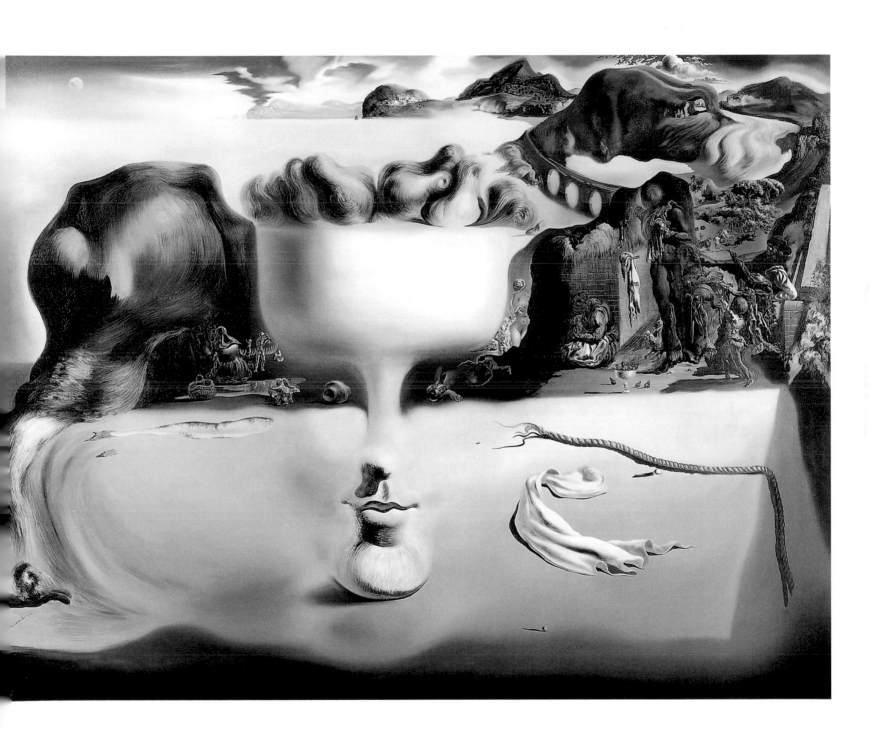

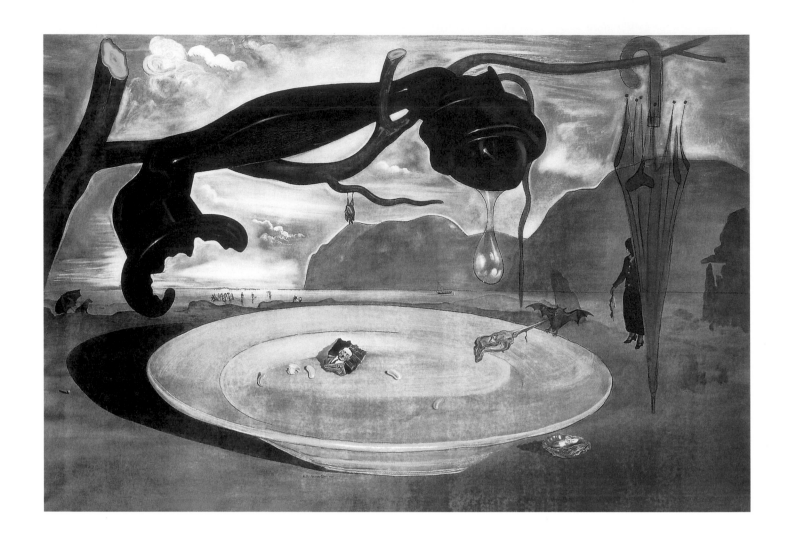

THE ENIGMA OF HITLER

1939
Oil on canvas, 95 x 141 cm
Museo Nacional Centro de Arte Reina Sofía, Madrid

This work was made after September 1938 when the conference held in Munich between Germany, Great Britain, France, and Italy headed off European war by permitting Nazi Germany to seize the German-speaking area of Czechoslovakia, the Sudentenland. The vital clue to that timing derives from Dalí's *The Secret Life* in which the painter wrote of this picture that it is:

[A] very difficult painting to interpret, [a work] whose meaning still eludes me. It constituted a condensed reportage of a series of dreams obviously occasioned by the events of Munich. This picture appeared to me to be charged with a prophetic value, as announcing the medieval period which was going to spread its shadow over Europe. Chamberlain's umbrella appeared in this painting in a sinister aspect, identified with the bat, and affected me as very anguishing at the very time I was painting it…

The telephone dripping a heavy, viscous fluid, its shattered mouthpiece, the broken olive branch above it, the bat sucking on a 'soft' oyster, the solitary oyster shell just below them, the British Prime Minister's umbrella, the empty plate with a scrap of photograph and a few beans, as well as the subdued, limited colour-range and purposefully unfinished areas of canvas,

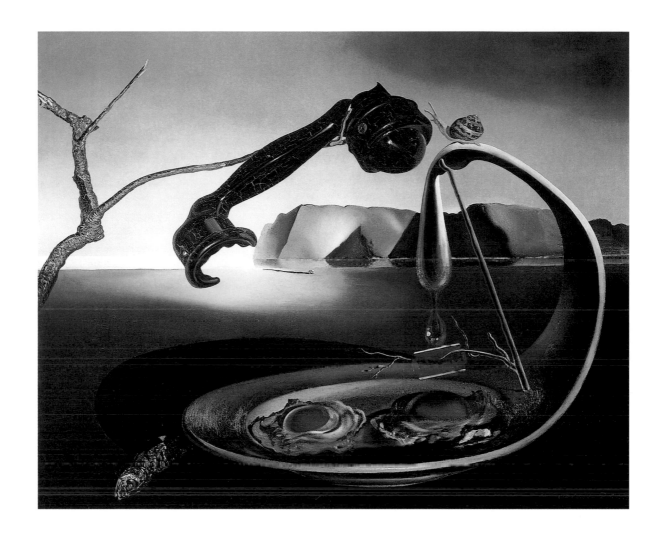

all combine to project a sombre and enigmatic mood that appropriately expressed Dalí's forebodings of coming war and the dearth it would bring in its wake. More particularly, the broken telephone evokes the breakdown in communication that necessarily foreshadows human conflict, the sperm-like fluid that oozes from it the wasted effort involved, the broken olive branch the futility of peace-making gestures.

THE SUBLIME MOMENT

1938
Oil on canvas, 39 x 46.9 cm
Staatsgalerie Stuttgart, Stuttgart

Here the telephone is virtually identical to the one in *The Enigma of Hitler* (opposite), and it is located in the same position pictorially. Now, however, the landscape is fully realised, with the olive branch painted with almost photographic realism. The grey palette of *The Enigma of Hitler* has been superseded by full colour, while the meagre repast of the 1937 painting has been replaced by a small fish and a pair of fried eggs lying on a plate. This utensil stretches around to ooze down upon itself whilst exuding a less-dense fluid that is poised upon the edge of a razor blade. In *The Enigma of Hitler* various shadowy figures appear. Now, however, merely a solitary snail enlivens the scene. It introduces unmistakeable associations of slow movement that are fully commensurate with the slow dropping of both the plate and the fluid. As time almost stands still, we are witnessing a sublime moment indeed.

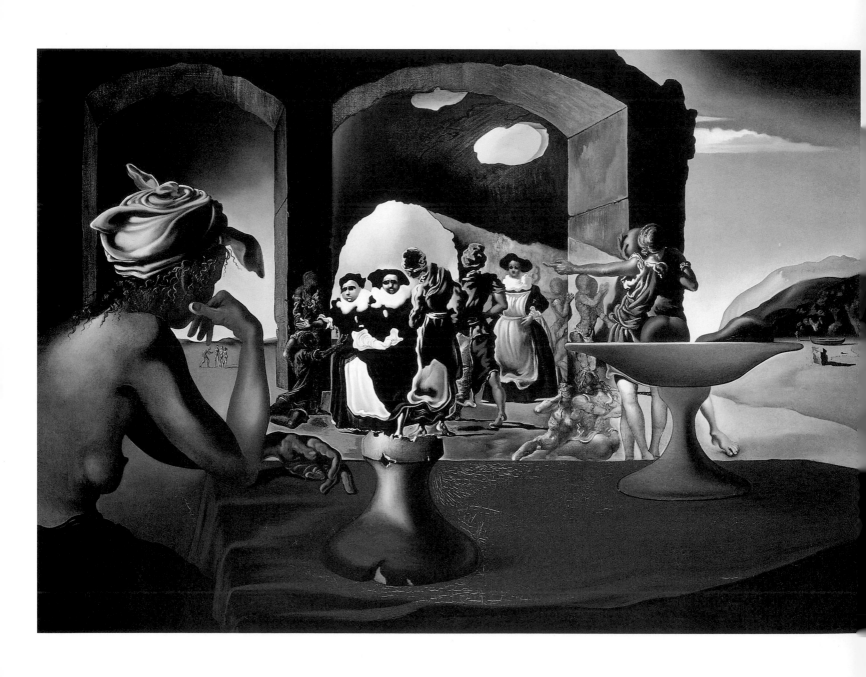

THE SLAVE MARKET WITH THE DISAPPEARING BUST OF VOLTAIRE

1940

Oil on canvas, 46.3 x 65.4 cm

Salvador Dalí Museum, St Petersburg (Florida)

On the left is Gala; beyond her is the slave market where two people dressed in 17th-century black-and-white formal garb are framed by an archway. These figures and the arch alternatively switch over optically to form the head of the 18th-century philosopher, historian, and satirist Voltaire, in a monochromatic rendering of the well-known portrait bust of 1778 by the sculptor Jean-Antoine Houdon (1741-1828), of which there are several versions. To the right of these figures is another person dressed similarly in 17th-century garb but who does not enjoy any alternative visual appearance.

For Dalí, Voltaire epitomised reason, and thus everything that Surrealism held in contempt; as the painter wrote in his *Unspeakable Confessions*:

The illustrious Monsieur de Voltaire possessed a peculiar kind of thought that was the most refined, clearest, most

rational, most sterile, and misguided not only in France but in the entire world. Voltaire did not believe in angels or archangels, nor in alchemy, and he would not have believed in the value of the 1900-style entrances to the Paris Metro...

Voltaire's dedication to reason explains why Dalí set him in a slave market, for here the slavery is clearly a subservience to rationalism.

On the right, visual confusion is purposefully created by the juxtaposition of some fruit in a bowl with a girl holding a circular object (which doubles as the bald head of her companion). The crowding of the central part of the picture is intensified by contrast with the placid and virtually empty landscape beyond. Gala's languid, contemplative pose also stands in opposition to the hectic movement before her.

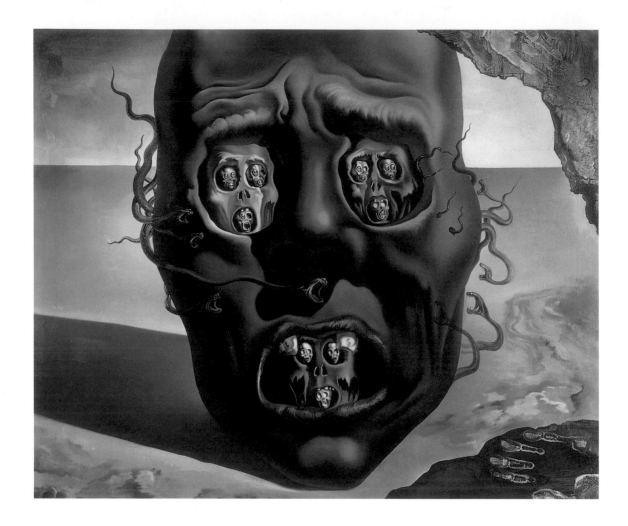

VISAGE OF WAR

1940
Oil on canvas, 64.1 x 79 cm
Museum Boijmans Van Beuningen, Rotterdam

For Dalí, the eyes in this skull were "stuffed with infinite death". Yet although the image is undeniably effective, it also demonstrates that a certain obviousness, if not even banality, had begun to enter Dalí's art by 1940. The head is entirely explicable in symbolic terms, and therein lies its weakness, for whilst Dalí could imbue irrational-looking imagery with intense feeling, when it came to rational meanings – and symbolism is a decidedly rational process, involving the matching of image to meaning – then his touch could easily desert him, as here: we are only one remove from a propaganda poster, of the type that was becoming common by 1940.

SOFT SELF-PORTRAIT WITH GRILLED BACON

1941
Oil on canvas, 61 x 51 cm
Teatre-Museu Dalí, Figueres

As in his earlier 'soft' self-portraits, here Dalí rejected the notion of affording a window into his own soul. Instead he employed his usual elliptical approach to reality. Thus the pliant, brown form that constitutes this witty self-portrait could be interpreted as a piece of excreta, whilst the strip of grilled bacon lying in front of it certainly augments culinary associations.

The ants that congregate at the corners of Dalí's eyes and mouth, as well as the well-worn crutches, add a subtle note of decay to the proceedings and one that was certainly apposite to the painter's own awareness of mortality by 1941.

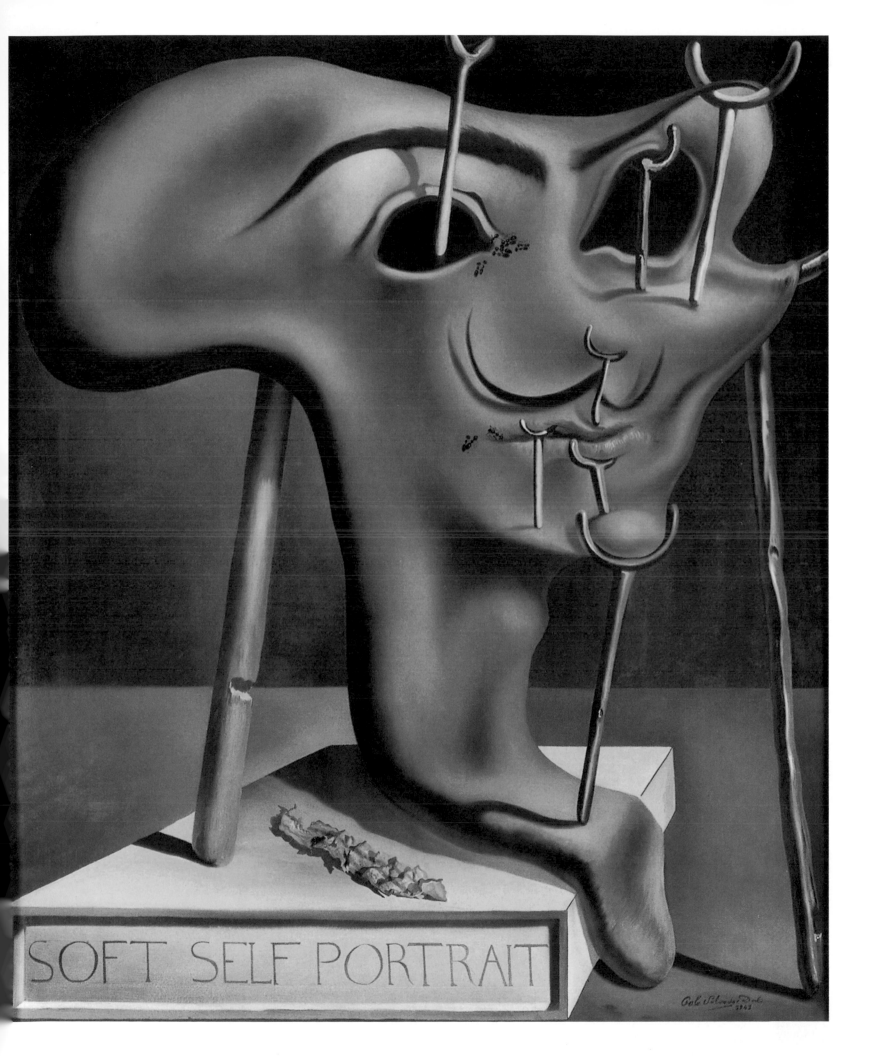

SOFT SELF PORTRAIT

DESIGN FOR THE INTERIOR DECORATION OF STABLE-LIBRARY

1942

Collage over chromolithograph also repainted with gouache and Indian ink, 51 x 45 cm

Teatre-Museu Dalí, Figueres

As with *The Sheep* (opposite), here again Dalí brilliantly modified a kitsch image. In the original print some sheep were accompanied by a rooster. Now they have been joined by repainted flooring, furniture, an open Dalínian drawer, a lamp, and some cloth. An equally kitsch image of a reclining girl was also pasted onto the print. The combined additions create a very witty interface between normality and the surreal.

THE SHEEP

1942
Gouache watercolour over chromolithograph,
22.8 x 34.2 cm
Salvador Dalí Museum, St Petersburg (Florida)

This is one of the wittiest works of the early 1940s. It was made over a chromolithographed reproduction of an oil painting by a minor creator of animal kitsch, Albrecht Schenck (1828-1901); Dalí superimposed the floor and all the background furniture, fittings, bookcases and the wall. He also added the reclining woman and the golden, decorative 'feet' to those of the sheep. The light that appears through the lampshade above the amusingly Dalínian lampholder is the wan sunshine from the original winter scene, as are the bird perched on the woman's head and the shepherd supporting a superimposed dish or ashtray on his head. Yet although the sheep, birds, and shepherd all appeared in this image first, such was Dalí's visual inventiveness and technical fluency that they seem to be invading the safe, cosy world of the library instead.

HELENA RUBINSTEIN'S HEAD EMERGING FROM A ROCKY CLIFF

1942-1943
Oil on canvas, 88.9 x 66 cm
Helena Rubinstein Foundation, New York

If in *The Sheep* Dalí wittily superimposed his own particular brand of disorder upon kitsch, here he came perilously near to producing kitsch himself. In order to survive financially whilst in American exile during the war years – and for Dalí and Gala 'survival' meant leading a very affluent lifestyle indeed – the painter took to producing society portraits. But the people he painted did not want their visages replicated in soft, culinary, or excretory terms; what they evidently required was flattery supported by just a little safe Surrealist oddity. This certainly optimised Dalí's financial success but it did not make for very good paintings, as we can see here.

Helena Rubinstein created her fortune in the cosmetics industry and Dalí was extremely scathing about her in his *Unspeakable Confessions*. In this picture he represented her as Andromeda chained to a rock by her emeralds, with a female nude beyond her articulating the struggle against such entrapment. This device permits Helena Rubinstein to look quite unperturbed. As always, Dalí's technique and attention to the appearances of things is impressive, but the portrait seems slick and artificial in its lack of any convincing intensity of vision or authentic Dalínian insanity.

DREAM CAUSED BY THE FLIGHT OF A BEE AROUND A POMEGRANATE ONE SECOND BEFORE AWAKENING

1944

Oil on canvas, 51 x 41 cm

Museo Thyssen-Bornemisza, Madrid

Dalí appropriated the tigers he included here from a circus poster. Indeed, the entire image has the look and visual immediacy of a poster, which perhaps accounts for its popularity. But ultimately this picture is Surrealism made easy. That is because the dream-events it depicts take place around someone sleeping. We therefore tend to interpret them as occurring in that person's mind – as the manifestation of *her* dream – rather than as the projection of a dream *per se* that we need to fathom wholly in terms of our own non-rational experience. Moreover, both title and imagery enjoy a sense of connection and sequence. Thus in the foreground are the bee and pomegranate, while a further pomegranate bursts on the left, disgorging fish, tigers, and a rifle whose bayonet is about to prod the prostrate form of Gala awake in just one millisecond from now. Such connections and the sequence they follow are rational processes that make the proceedings very approachable conceptually. We are now a long distance away from "the depths of the subconscious" because it is so easy to understand things in rational terms. By the mid-1940s Dalí's Surrealism was becoming a little too pat and predictable. Although there are undoubtedly memorable images here – the elephant with extended legs is a superbly imaginative conceit – nonetheless there are not enough such fancies to push the work into that ineffable imaginative dimension that lies beyond mere illustration.

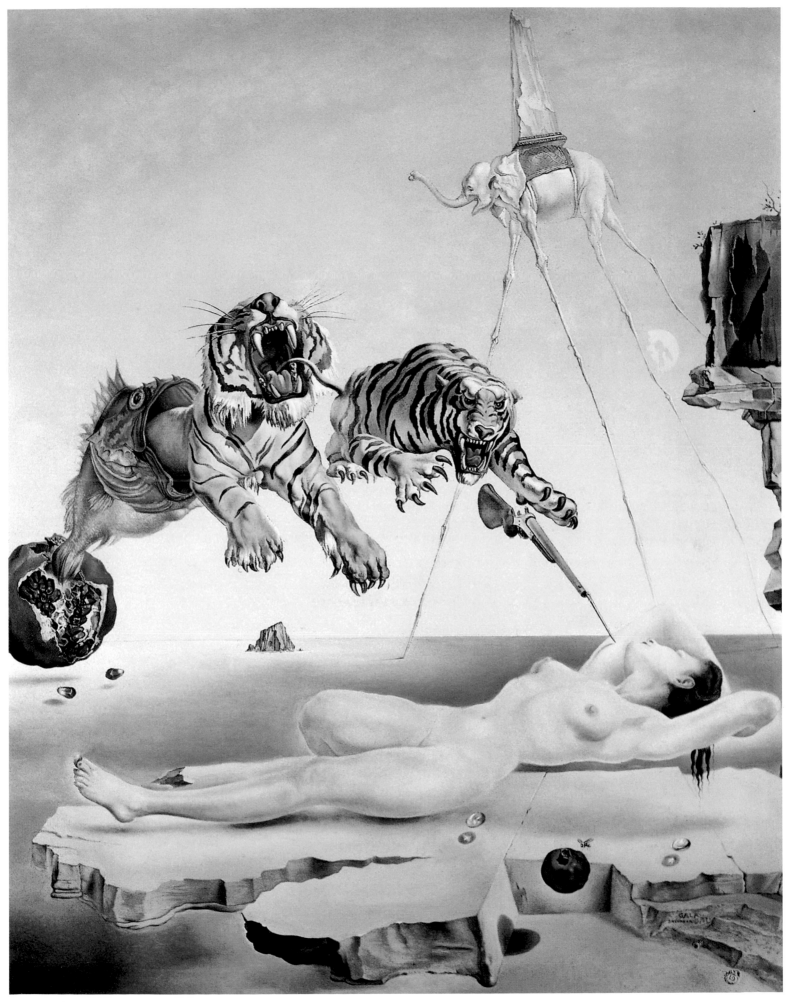

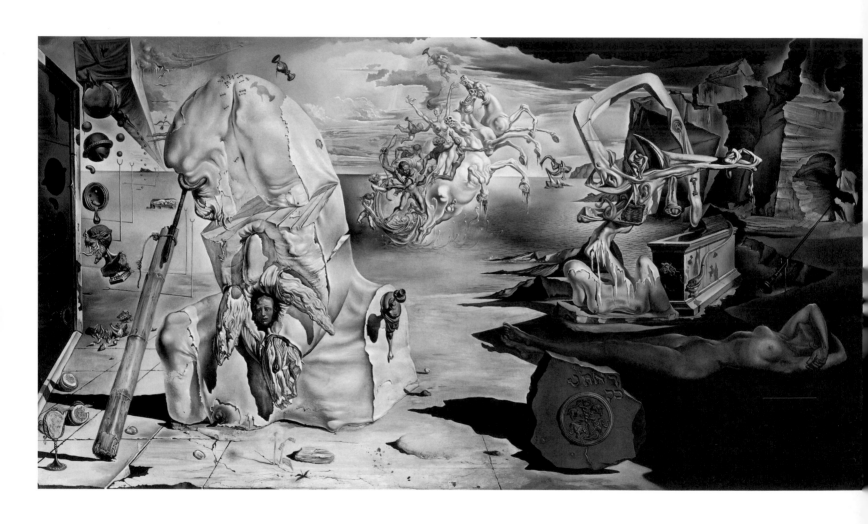

THE APOTHEOSIS OF HOMER

1944-1945
Oil on canvas, 64.1 x 118.4 cm
Pinakothek der Moderne, Munich

This is one of the last works in which the manic Dalí still shone forth with his old imaginative intensity. The painting enjoys the subtitle *Diurnal Dream of Gala*, and Gala is stretched out on the right. Although the picture thus projects someone else's dream, nonetheless its imagery does enjoy all the authentic disconnection of a dream – it is impossible to relate the objects and occurrences to one another in any rational way. A preliminary drawing for this picture was made in 1943. It looks rather like a work by Nicolas Poussin in its straightforward distribution of light and shade, as well as its figures and landscape. But in this oil the calm classicism of the drawing has been replaced by a truly surreal and rather nightmarish intensity of mood. In the middle-distance a baroque and somewhat Poussinesque chariot rises up, and all kinds of unrelated cultural fragments are placed in seemingly random spatial relationships around and before it.

PORTRAIT OF ISABEL STYLER-TAS

1945
Oil on canvas, 64.1 x 86 cm
Neue Nationalgalerie, Staatliche Museen zu Berlin, Berlin

Although Dalí wrote disparagingly of Piero della Francesca in 1937 (p. 130), nonetheless his comment shows that he had been looking carefully at the Italian painter's works by then. In this work such analysis paid off, for it is one of the better society portraits of the World War II period. Although there is little sense of Surrealism to the image (despite the blossoming crutches and hair on a pendant upswelling into a miniature tree on the sitter's chest), the work does enjoy a modicum of visual and art-historical wittiness that offsets such a deficiency. The obvious model for the basic layout of the work was Piero della Francesca's dual

portrait of Federico de Montefeltro and his wife in the Uffizi in Florence, a picture in which that Duke of Urbino faces his duchess in a similar manner to which Isabel Styler-Tas confronts a rock formation here. It must have caused Dalí little imaginative effort to perceive in the sitter's hat the beginnings of a related form. By making the rock look vaguely human, Dalí was building upon the influence of Giuseppe Arcimboldo (1527-1593), an Italian painter popular with the Surrealists for his composite heads fashioned out of disparate objects such as fruit, vegetables, fish, and shells. Dalí owed a great deal to Arcimboldo, and here he repaid that debt with interest.

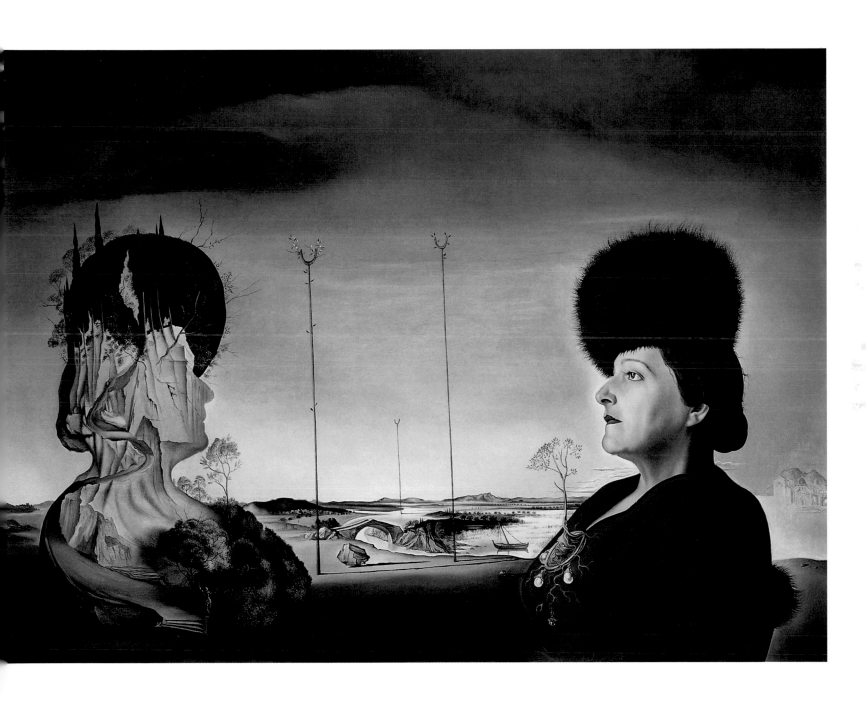

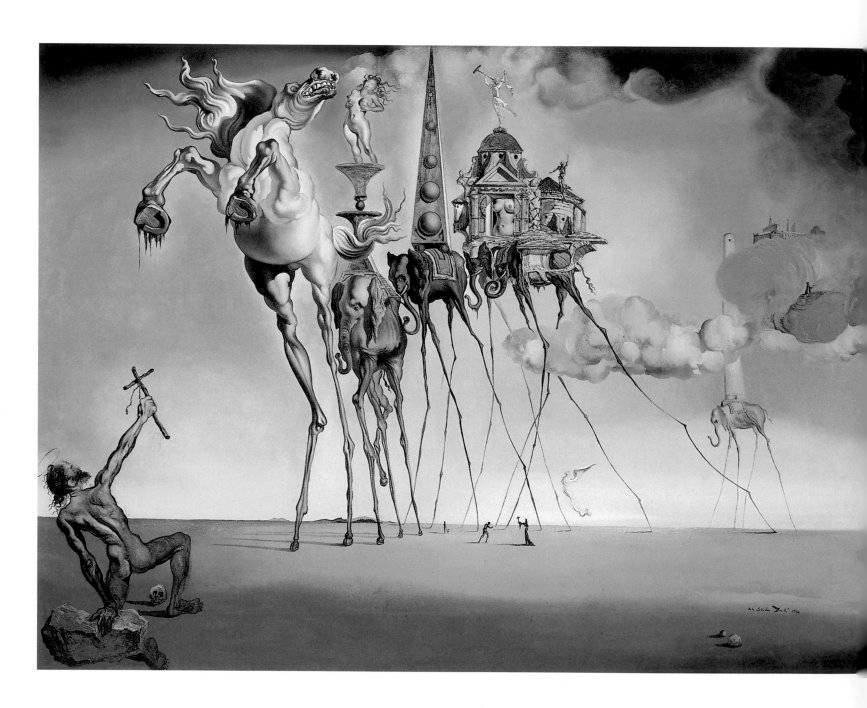

THE TEMPTATION OF ST ANTHONY

1946

Oil on canvas, 89.5 x 119.5 cm

Musées royaux des Beaux-Arts de Belgique, Brussels

Dalí painted this picture for a competition organised by Albert Lewin in connection with his film of Maupassant's *Bel Ami*; the competition was won by Max Ernst. Here again we see the illustration of someone's state of mind, rather than the projection of a state of mind in itself, for by looking over St Anthony's shoulder we therefore see the phantasms ranged before him through his eyes. Dalí has merely employed his vivid imagination to transmit the saint's mystical experience. That projection brings the picture very close to illustration because of the subservience of the imagery to an extra-visual programme (as we shall see, such a criticism may be levelled at many of Dalí's later religious pictures as well).

PORTRAIT OF PICASSO

1947
Oil on canvas, 65.5 x 56 cm
Teatre-Museu Dalí, Figueres

Although Dalí looked up to Picasso when young, by 1947 he had turned against him, as this portrait makes clear. The work was painted at the height of the Cold War, by which time Dalí had become violently anti-Communist. After Picasso had joined the Communist party in 1944, Dalí felt as much alienated by Picasso's politics as by his long-acknowledged position as the supreme modern artist, a position that Dalí felt belonged to himself.

We can perceive this change in attitude in a passage in Dalí's second volume of autobiography, the *Unspeakable Confessions*:

Picasso is doubtless the man I have most often thought about after my own father. He was my beacon when I was in Barcelona and he was in Paris. His eye was my criterion. I have come across him at all the high points of my reign. And when I left for America, once again he was there: without him I would have had no ticket. I thought of him as the apple-crowned boy thought of William Tell taking aim. But he was always aiming at the apple, not at me. He radiated prodigious Catalan life. When the two of us were together, the spot at which we were must have become heavier and the noösphere assumed special density. We were the highest contrasts imaginable and conceivable. My superiority over him lay in my name being Gala-Salvador Dalí and knowing that I was the saviour of modern art that he was bent on destroying, while his name was simply Pablo. I was two and predestined. He was so alone and desperate that he had to become a Communist. He never ceased cuckolding himself.

The downside of Dalí's latter-day, love-hate relationship with Picasso may be seen here. Once again it is a work in which Dalí drew upon Arcimboldo, with Picasso's 'head' composed of an array of disparate objects such as molluscs and amphora handles, and its brain re-emerging through its mouth as an elongated tongue. Dalí obviously remembered the particular shape of Picasso's mouth, for that part of the head rather resembles it.

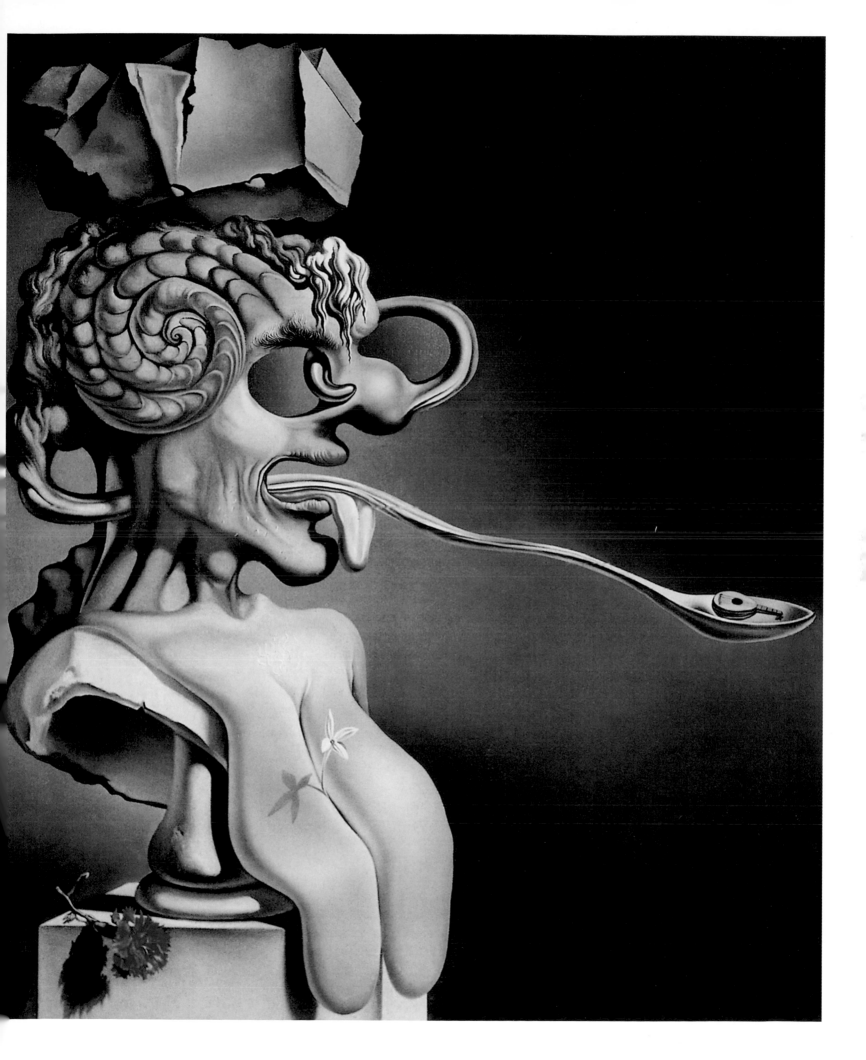

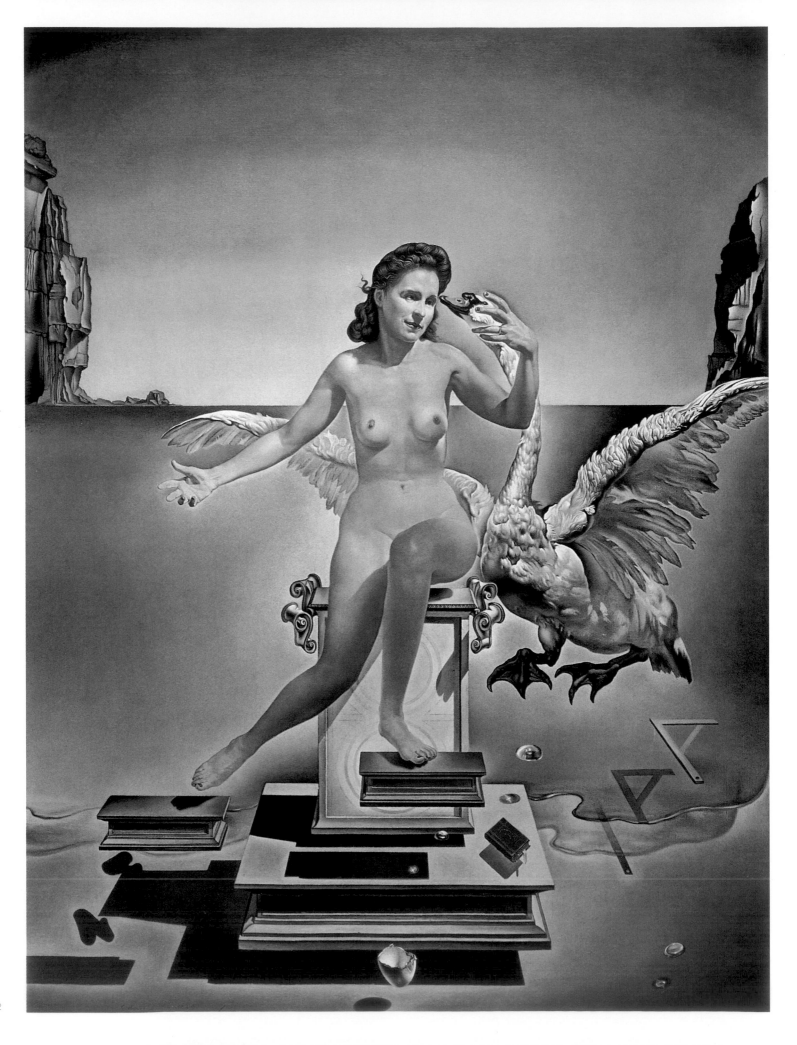

LEDA ATOMICA

1949
Oil on canvas, 61 x 46 cm
Teatre-Museu Dalí, Figueres

In classical mythology the god Zeus once spied the nymph Leda when she was bathing. In order to approach her, the god then transformed himself into a swan and had his way with her. From their union issued the twins Castor and Pollux, as well as Helen of Troy. Because Gala's real first name was Helen, it was perhaps natural for Dalí to associate her with that identically-named, outstanding beauty of the ancient world. Similarly, because Helen of Troy was issued from Leda, so too Dalí regarded Gala as the indirect heir of his own dead mother.

Here we see Gala in the role of Leda about to taken by Zeus in his avian guise. They do not quite touch, just as everything around them does not quite touch either. In the 1944 *Dream Caused by the Flight of a Bee around a Pomegranate One Second Before Awakening* (p. 153) we have already encountered a nude Gala being not quite touched by an approaching object, but here the spatial separation of people and objects reflects Dalí's interest in atomic physics and the fact that atomic particles never touch one another.

In November 1948 the painter wrote of the study for the present work in terms that are equally applicable to the final version too:

As far as I know – and I believe I do know – in *Leda Atomica* the sea is for the first time represented as not touching the shore; that is, one could easily put one's arm between the sea and the shore without getting wet. Therein resides, I believe, the imaginative quality which has determined the treatment of one of the most mysterious and eternal of those myths in which the 'human and the divine' have crystallised through animality.

Instead of the confusion of feathers and flesh to which we have been accustomed by the traditional iconography on this subject, with its insistence on the entanglement of the swan's neck and the arms of Leda, Dalí shows us the hierarchised, libidinous emotion, suspended, and as though hanging in mid-air, in accordance with the modern 'nothing touches' theory of intra-atomic physics.

Leda does not touch the swan; Leda does not touch the pedestal; the pedestal does not touch the base; the base does not touch the sea; the sea does not touch the shore. Herein resides, I believe, the separation of the elements earth and water, which is at the root of the creative mystery of animality.

Throughout the image everything that is suspended in space casts a shadow, with the exception of the swan. By this omission Dalí subtly denoted that the bird belongs in a completely different and more divine realm.

THE MADONNA OF PORT LLIGAT

1950
Oil on canvas, 275.3 x 209.8 cm
Fukuoka Art Museum, Fukuoka

Dalí regarded this huge picture as his finest work to date. The relationship between mother and child is certainly far closer than it was in the study, and as in the earlier work things are fragmented, although because there are more objects floating around 'atomically', there is a greater sense of fragmentation to the proceedings. The palette employed is more naturalistic than the one used for the study. At the top, curtains induce associations of baroque altarpieces.

Again we look across the bay at Port Lligat. Above the sands to left and right appear cuttlefish bones, with angels on the right enforcing a visual simile with those structures. In November 1950, when this painting was exhibited in New York, Dalí had something to say about the space within the Madonna, as well as the physical disconnections that are apparent throughout:

> [M]odern physics has revealed to us increasingly the dematerialisation which exists in all nature and that is why the material body of my Madonna does not exist and why in place of a torso you find a tabernacle "filled with Heaven". But while everything floating in space denotes spirituality it also represents our concept of the atomic system – today's counterpart of divine gravitation.

Within the empty space forming the inside of Jesus's torso may be seen the bread of the Holy Eucharist.

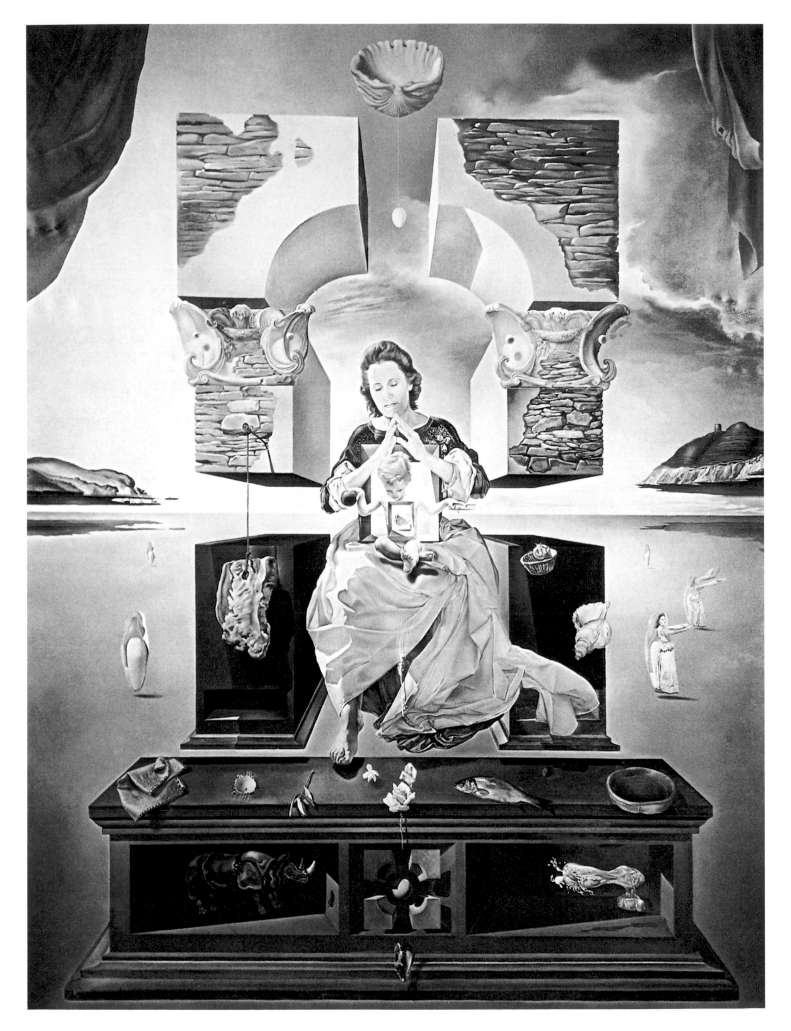

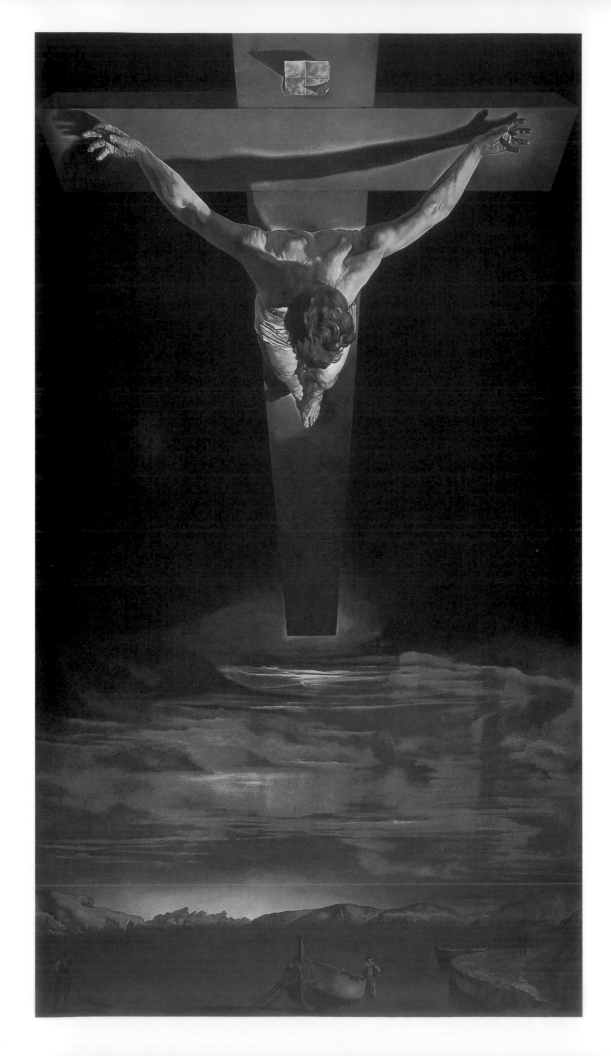

CHRIST OF ST JOHN OF THE CROSS

1951
Oil on canvas, 205.1 x 115.9 cm
Kelvingrove Art Gallery and Museum, Glasgow

The painter received the inspiration for this work from a drawing that was supposedly made by St John of the Cross himself. There the crucifixion is also viewed from above, although from an oblique rather than a frontal angle.

On a study for this picture now in a private collection, Dalí wrote that:

> When... I saw the Christ drawn by St John of the Cross, I geometrically decided upon a triangle and a circle, which "aesthetically" summed up all my previous experiments... AND PUT MY CHRIST IN THAT TRIANGLE.

The triangulation is very evident, and evidently relates to the Trinity. Moreover, Dalí also appears to have been aware that triangles relate to a Platonic tradition in European thought, whereby basic forms like triangles and circles were deemed to enjoy metaphysical powers, being universal constants. Naturally, such a form is highly appropriate to the representation of a religious figure who supposedly enjoyed or does enjoy universal powers, depending on your beliefs.

This is one of the most successful of Dalí's religious paintings. Much of its appeal derives from its simplicity, acute attention to detail and visual control, the anatomical representation and division between intense light and shadow being particularly felicitous. Yet here we are not witnessing Surrealism at all; by 1951 Dalí had replaced it with religious mysticism, which is something different and which, for better or worse, has to be accepted on its own terms. Usually Dalí's late mysticism does not ring true, and this is not surprising, for the painter himself was anything but a fervent believer in God, let alone a mystic. But in works like this he did successfully project some modicum of religious belief, whilst avoiding his more usual tendency to make such offerings look like something straight out of a Hollywood movie.

In 1952 Glasgow Art Gallery purchased this painting for £8,200, a price that caused so much outrage that one furious person slashed the work. By 1958, however, the museum had already made a profit on the picture through the sale of entry fees to view it and royalties and reproductions of it, thus justifying its investment.

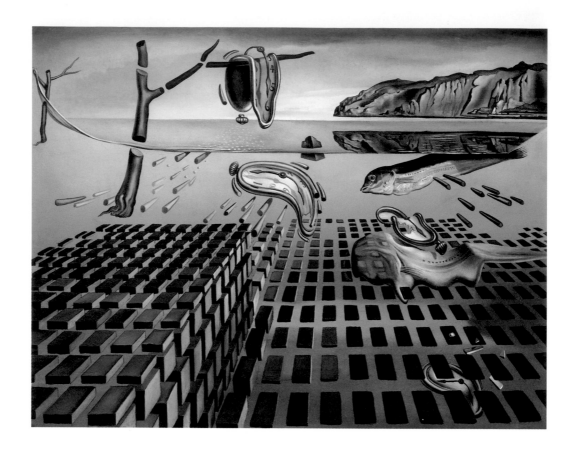

THE DISINTEGRATION OF PERSISTENCE OF MEMORY
1952-1954
Oil on canvas, 25.4 x 33 cm
Salvador Dalí Museum, St Petersburg (Florida)

EXPLODING RAPHAELESQUE HEAD
1951
Oil on canvas, 43.2 x 33.1 cm
Scottish National Gallery of Modern Art, Edinburgh

By the mid-1950s, Dalí suffered from that occupational hazard of successful painters: he had begun to repeat himself, although this work does mitigate that defect by recycling Dalí's most famous image in terms of his post-war interest in physics and metaphysics. Dalí said of the work:

After twenty years of total immobility, the soft watches disintegrate dynamically, while the highly coloured chromosomes of the fish's eye constitute the hereditary approach of my pre-natal atavisms.

The Dalínian 'soft' self-portrait seen in the earlier work is located immediately below the fish, whilst the sea is represented as a skin that can be lifted, a conceit that Dalí would employ frequently after 1954.

Dalí's sense that matter is discontinuous and fragmentary comes across most forcefully and inventively here. The great Italian painter Raphael (1483-1520) is buried in an ancient Roman temple converted into a church, the Pantheon, that still stands in Rome today. And that is what we see within the area denoted by Raphael's head. Light streams through the open oculus or top aperture of the Pantheon, to fall across an array of the building's decorative coffers. The sense of fragments spinning centrifugally as they explode is intensified by the halo drawn in pencil at the top, for the circle sets the entire image in motion. Ingeniously, the head and shoulders of Raphael are composed of many other things, including pieces of masonry, a razor blade, the very sexual rhinoceros horns regarded by Dalí as being chaste, and the ubiquitous wheelbarrows derived from Millet's *The Angelus*.

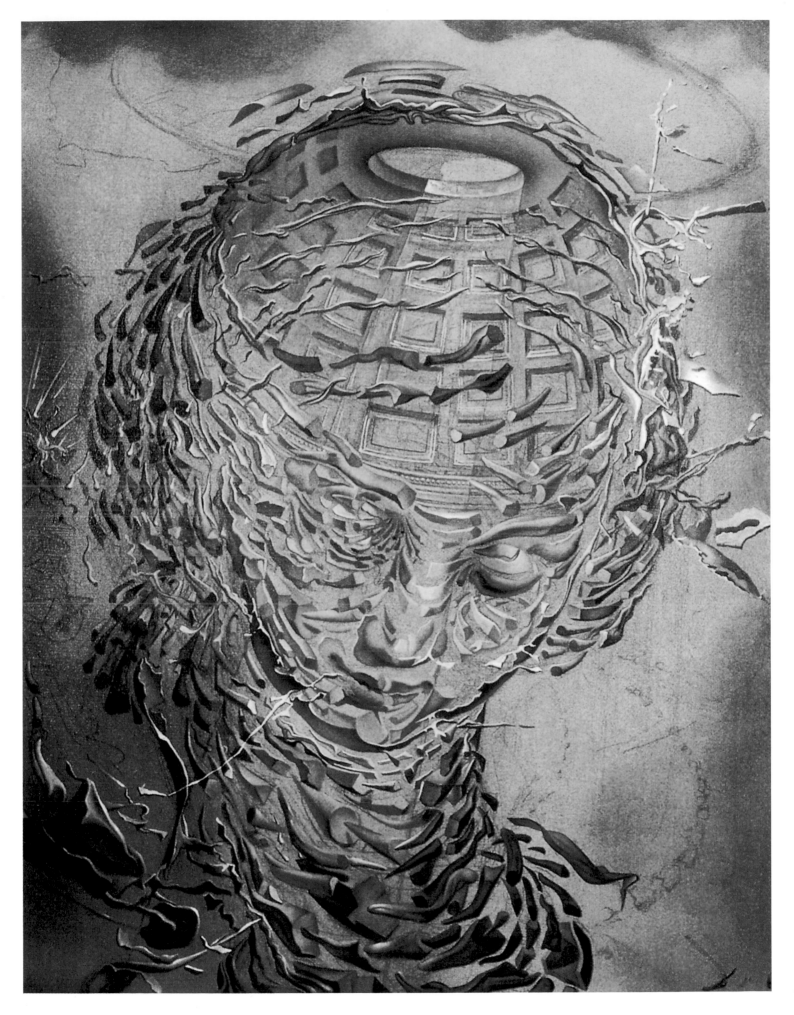

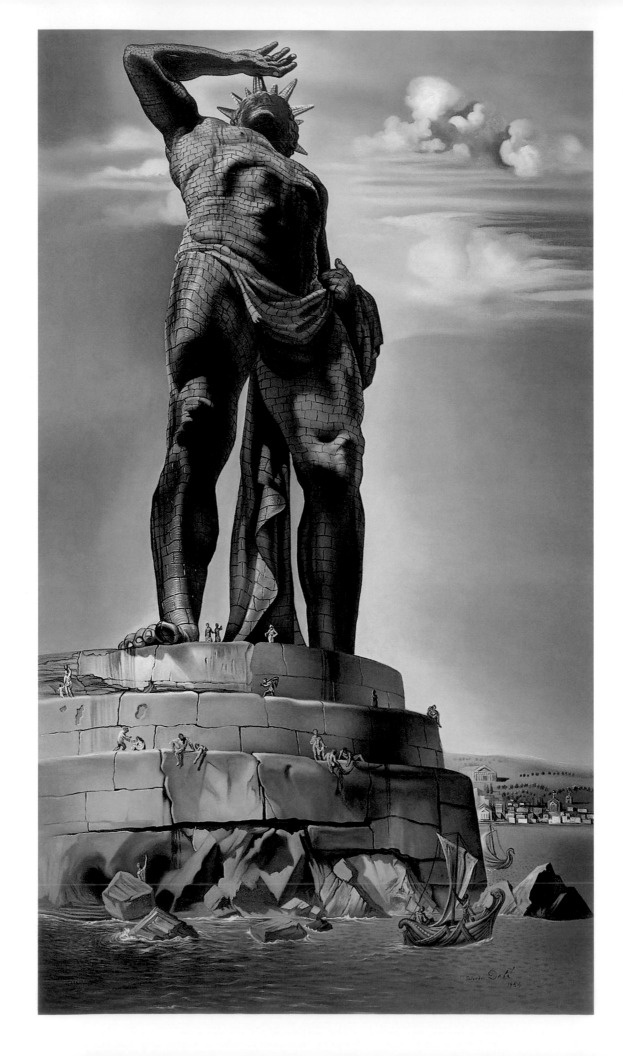

THE COLOSSUS OF RHODES

1954

Oil on canvas, 68.8 x 39 cm

Kunstmuseum Bern, Bern

From his earliest years Dalí was profoundly drawn to the works of 19th-century historical painters such as Meissonier. Usually such attraction merely affected the degrees of verisimilitude and detailing in his works and was thus easily reconciled with his Surrealism. However, from the 1950s onwards, and obviously because he had begun both to falter imaginatively and become more reactionary where art was concerned, Dalí frequently painted purely historical subjects that are barely modified by any Surrealist input whatsoever.

Nothing could better typify this development than the small canvas seen here. Naturally, the low viewpoint emphasises the towering height of the Colossus, whilst a vaguely Surrealist touch is afforded by the way that the giant statue of the sun-god Helios is itself shielding its eyes from the sun. Yet in all other respects the image does not differ very much from a Hollywood film poster. As always Dalí creates a convincing fictive space and employs his usual skills as a landscapist, albeit in a rather slick fashion.

YOUNG VIRGIN AUTOSODOMISED BY HER OWN CHASTITY

1954
Oil on canvas, 40.6 x 30.4 cm
Hugh Hefner Collection, Playboy Enterprises, Los Angeles

On 5 July 1952 Dalí received the very peculiar revelation that rhinoceros horns formed the building blocks of all his imagery. He then went on to see all kinds of physical and metaphysical connections in such objects. Moreover, because of the association of the rhinoceros with the legendary unicorn, and then the link of the latter with chaste young maidens in medieval folklore, on a conscious level at least the painter ignored the obvious phallic symbolism and sexual associations of rhino horns, preferring to see them as symbols of chastity. That is why we see a "Young Virgin" being "Autosodomised by her own Chastity" in the form of rhino horns here. Yet despite such theoretical and titular diversion, the image itself gives the lie to Dalí's assertion that the form of a rhino horn is not phallic, for the picture is quite evidently one of his most sexually charged creations. Obviously his masturbatory sexual predilections and anal fixations remained undimmed by 1954.

The "Young Virgin" leans over the rail of a sunlit balcony, apparently gazing longingly at an infinite expanse of ocean and perhaps dreaming of throwing off the shackles of her virginity by being penetrated from behind. Dalí developed her image from a photo in a late-1930s girlie magazine. Two large rhino horns intersect with her body to constitute her buttocks and upper thighs. The one on the left looks extremely phallic. Below, two more horns hover. One of them is shadowed by the girl even though she does not otherwise cast shadows except within her own body. The tip of this horn is tautly encircled by a section of rail, which furthers associations of penetration, entrapment and coverage by a condom. Above and around the virgin three more horns float. The girl rests her elbows on a barely-visible section of rail, broken fragments of which wind behind her after having been sundered by the two largest and most phallic horns. The associations of breakage are obviously linked to her virginity. The short section of rail on the right that casts its shadow on the wall approximates in size to a small penis and it looks very phallic in shape, even if it does dangle downwards. In doing so it may have echoed Dalí's frequent detumescences.

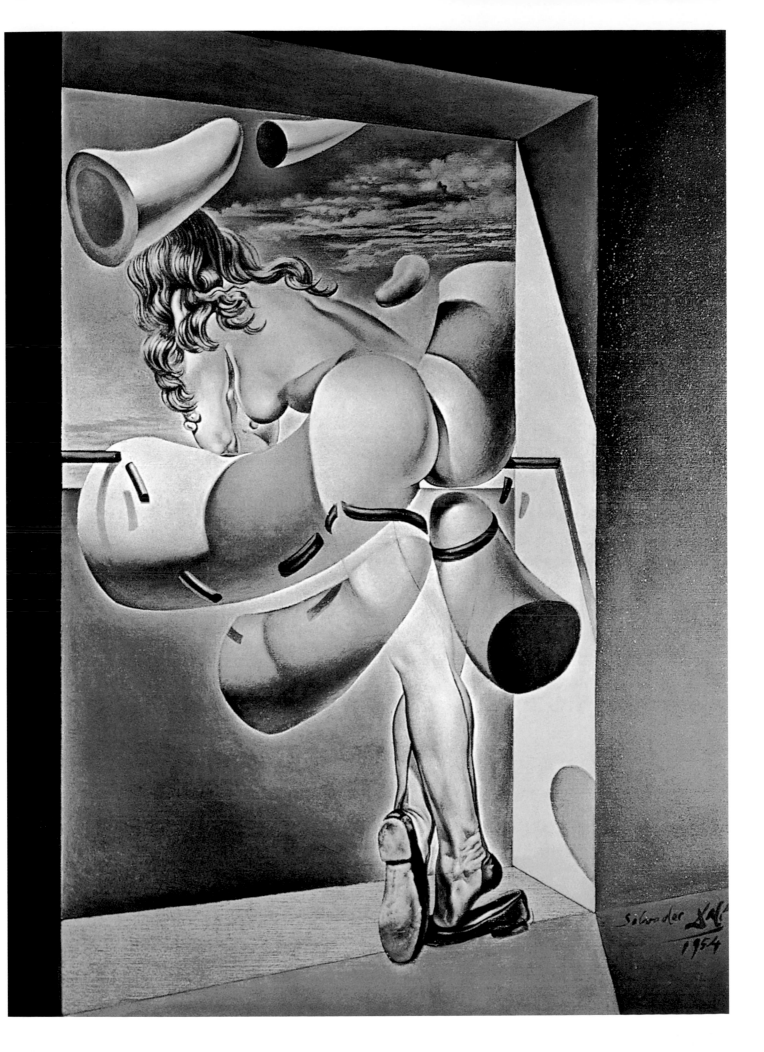

173

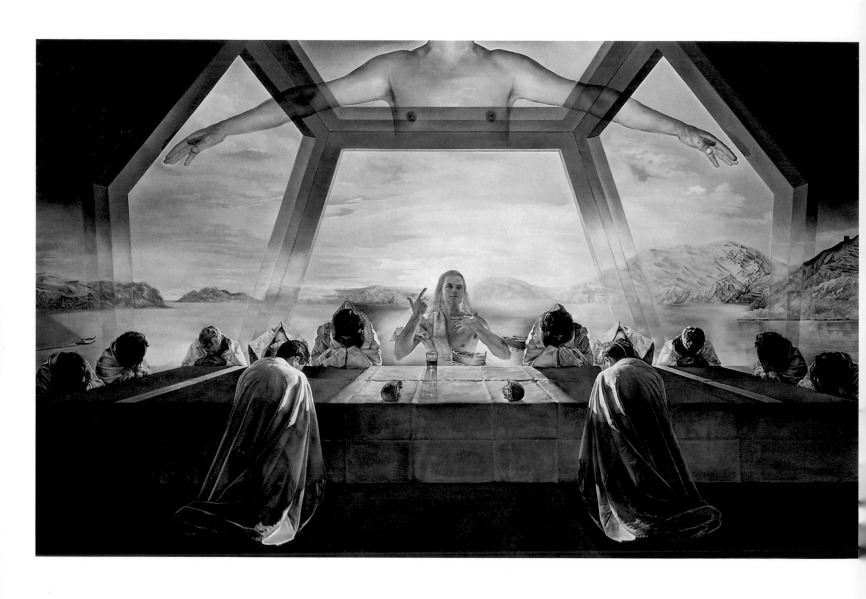

THE SACRAMENT OF THE LAST SUPPER

1955
Oil on canvas, 166.7 x 267 cm
National Gallery of Art, Washington, D.C.

For a criticism of the organisation and imagery of this work, see the Introduction above. It took Dalí about three months to paint this picture. For much of the time he employed photographs, stating later:

I almost always use photographic documents. It's traditional. Praxiteles made direct casts of arms, legs, and anything he was going to reproduce. For someone who draws as I do, a photograph is an extremely useful element.

Elsewhere he added that the painting embodies an:

Arithmetical and philosophical cosmogony, founded on the paranoiac sublimity of the number twelve – the twelve months of the year, the twelve signs of the Zodiac around the sun, the twelve apostles around the Christ, the twelve pentagons in the celestial dodecahedron, the pentagon containing the microcosmic man, Christ. (Thanks to Lorca who told me that the Apostles were as symmetrical as the wings of butterflies.)

The figure of Christ was modelled upon a handsome male model, which is why he looks like an all-American football player.

With its approachable symbolism, as well as its Hollywood sense of scale, this painting soon understandably became one of the most popular modern pictures in the National Gallery of Art, for which institution it was purchased by Chester Dale in 1959. However, its sentimentality bordering on kitsch also caused disgust in some religious quarters, and it is difficult to disagree with that judgment.

PORTRAIT OF SIR LAURENCE OLIVIER IN THE ROLE OF KING RICHARD III

1955
Oil on canvas, 73.7 x 63 cm
Captain Peter Moore Collection

This work was commissioned by Sir Alexander Korda, the director of the 1955 film of Shakespeare's *Richard III* in which Lawrence Olivier starred. Korda was an avid art collector who knew of Dalí's earlier portraits of Mae West (1934-1935), Harpo Marx (1937), and Shirley Temple (1939), as well as the painter's collaborations with Buñuel, Hitchcock, and Walt Disney. It must therefore have appeared logical to have commissioned a portrait of Olivier which could also be used as a poster for the film. However, the image was never employed for that purpose. This came about because the canvas was painted in Spain (England being "the most unpleasant place" known to Dalí). Consequently it was held up at Barcelona airport on its way to Great Britain because it was considered to be too important a work of art to be exported; as a result, it missed the printer's deadline, to Korda's extreme annoyance. The film director later gave the work to Olivier, and after the great actor's death in 1989 it was bought at auction by Dalí's old business manager, Captain Peter Moore. He had first met the painter when he worked for Korda.

In order to obtain the likeness, Dalí visited England in April 1955. He spent an hour sketching Olivier in costume at Shepperton Studios, and another short session at Claridge's Hotel the following day. At the same time, in a piece of typical nonsense whose pretentiousness was fully intended, the painter expressed to a London newspaper what he supposedly wished to convey in the work:

> I see rhinoceros in Sir Laurence so I shall probably paint it. He is two-faced, a split personality, an ideal subject to express the meteorology of the rhinoceros. But I am not altogether out of my lobster phase so they may intrude. I cannot say. I do not predict until I paint. No genius can. You see, the crayfish is in the ascendant and may not be ignored. He could arrive in one of Sir Laurence's many facets.

More relevant fauna are the ants; these may allude to Richard III's physical decay, being recurring signifiers of decay in Dalí's art. The boar on the brooch worn by Olivier reflects the fact that the animal was the heraldic emblem of Richard III. Beyond the actor/king are horsemen who might well allude to the Battle of Bosworth, at which Richard III was killed in 1485. Clearly these animals derived from the same Leonardo da Vinci source as the mounted horsemen in Dalí's *Spain* of 1938 (p. 137).

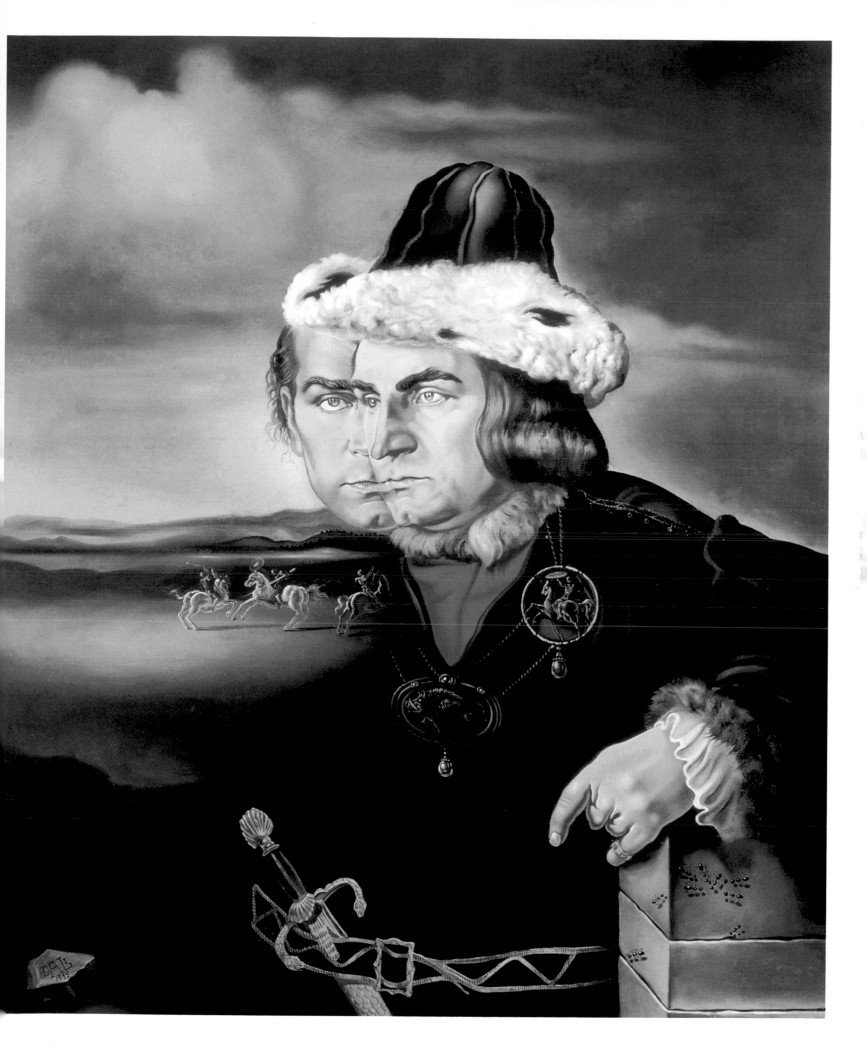

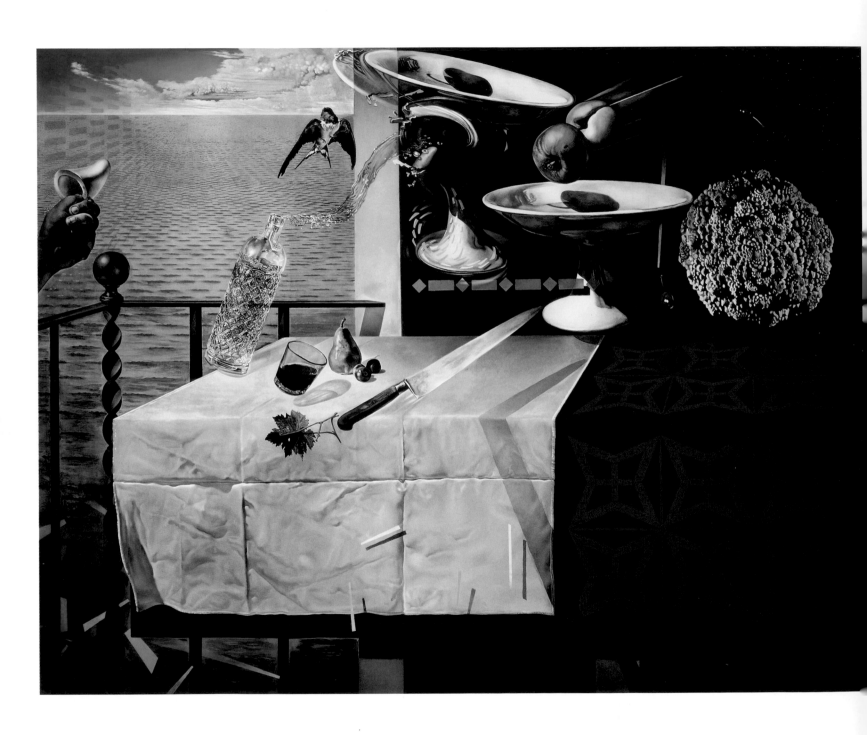

UNSTILL STILL LIFE

1956
Oil on canvas, 125 x 160 cm
Salvador Dalí Museum, St Petersburg (Florida)

This painting embodies Dalí's latterday quasi-mystical attitude to time and space, and its creator wrote of it in those terms in his *Secret Confessions*:

When in my 1956 *Nature morte vivante* (*Unstill Still Life*; or, literally: *Living Dead Nature*) I show the fruit bowl floating in space with the fan and fruits and a cauliflower and a bird and a glass and a bottle emptying itself and a knife, in front of a window through which there is an endless moire sea, while a hand holds a rhinoceros horn, I am defining and communicating a notion of time-space expressed through the vision of a levitation that shatters entropy. With the rhinoceros horn as maximum energy in minimum space, facing the infinite spaces of the sea, the picture becomes the privileged locus of a geometry that translates not only the loftiest scientific and philosophical speculations, but allows me, Dalí, existentially to know the truth of time-space and by that very fact a Dalínian truth of my person and my situation in the world.

Here again we see Dalí's old fashioned hyper-realism being validated as modernistic imagery through his unorthodox treatment of subject-matter, for if these objects were situated normally upon the table instead of flying around it, then the work would be little more than a conventional, almost photographic still life.

SANTIAGO EL GRANDE

1957
Oil on canvas, 396.2 x 289.6 cm
Beaverbrook Art Gallery, Fredericton (Canada)

Dalí related the genesis of this huge work in his *Unspeakable Confessions*:

The day I planned to do a painting to the glory of St James, I happened to bump into the Vicomtesse de Noailles, who had just bought a book on Santiago de Compostela and showed it to me. Opening it, I was immediately struck by the shell-shaped architectural vault that is the palm tree of the famous shrine, which I decided to reproduce. I also looked until I found a photograph of a horse bucking and traced it in the same way.

It is perhaps unsurprising, then, that the work looks very photographic. Beyond the bucking horse may be seen the base of an atomic mushroom cloud, whilst to the lower right Gala stands shrouded in the type of garb that was clearly intended to introduce Biblical, if not even virginal, associations.

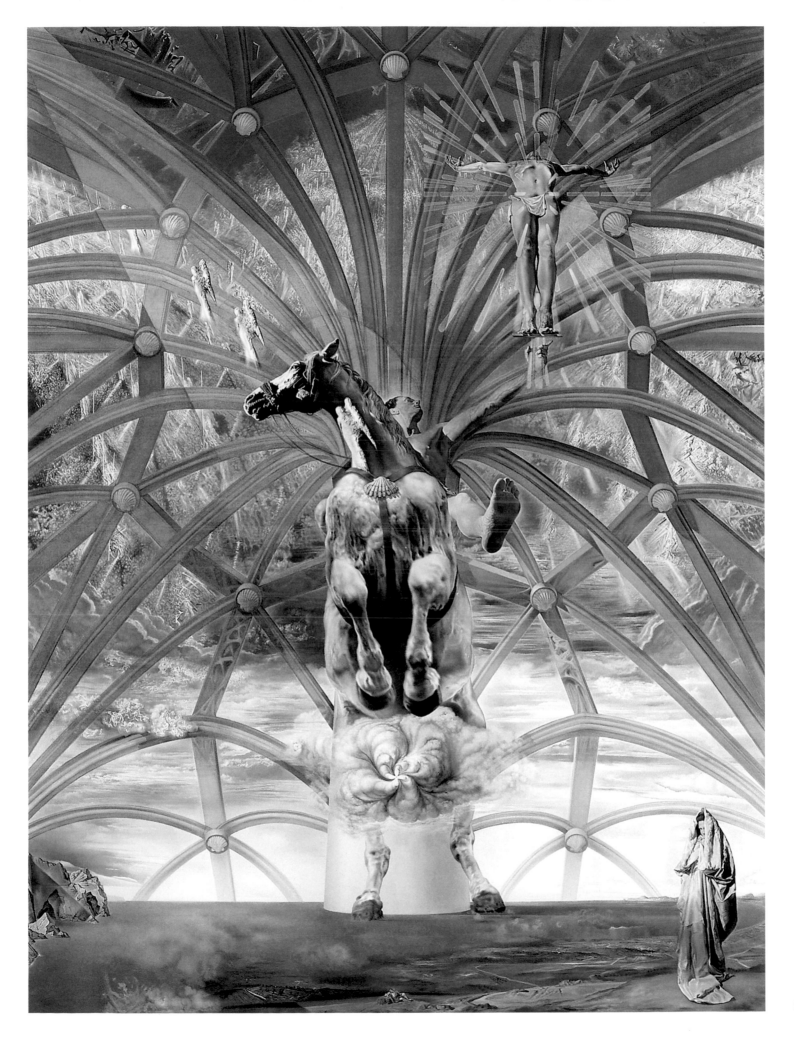

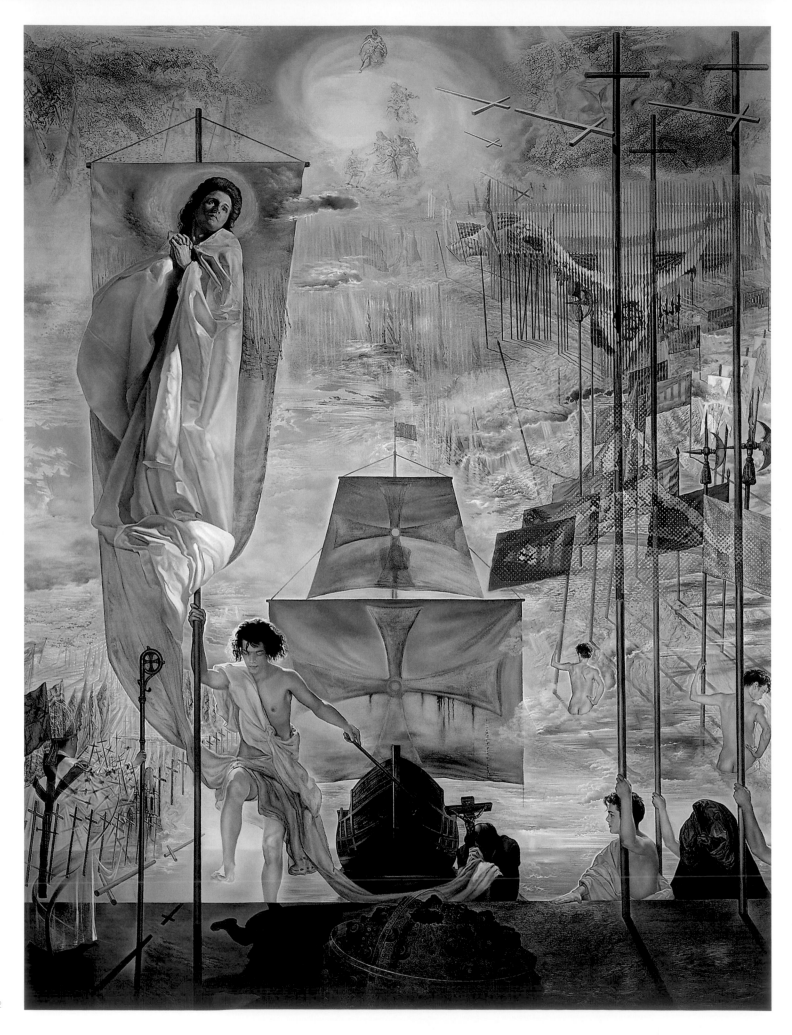

182

THE DISCOVERY OF AMERICA BY CHRISTOPHER COLUMBUS

1954
Oil on canvas, 410.2 x 310.2 cm
Salvador Dalí Museum, St Petersburg (Florida)

Dalí alternatively titled this painting *The Dream of Christopher Columbus*. He also tells us that the giant sea urchin in the foreground is surrounded "by the orbit of an artificial satellite" (in 1958-1959 the Russians and Americans were just putting their first unmanned space vehicles into orbit around the earth). By such symbolic means Dalí was obviously attempting to draw a parallel between the discovery of America by Cristoforo Colombo and more recent venturings into space. Gala emerges three-dimensionally from the banner on the left, whilst on the right Dalí has imitated the Benday dot breakdown of mechanised halftone reproduction in magazines and newspapers, just as the American Pop artist, Roy Lichtenstein, would begin to do far more fully just three or so years later. Again, the high degree of verisimilitude was obtained by the faithful copying of photographs.

PORTRAIT OF MY DEAD BROTHER

1963
Oil on canvas, 174.9 x 174.9 cm
Private collection

In *The Secret Life*, Dalí related of his dead elder brother, also named Salvador, saying:

> My brother and I resembled each other like two drops of water, but we had different reflections. Like myself he had the unmistakeable facial morphology of a genius. He gave signs of alarming precocity, but his glance was veiled by the melancholy characterising insurmountable intelligence.

However, as Dalí's brother died at the age of less than two years in 1903, some eight months before the birth of the painter, it is difficult to imagine how Dalí could have known of any resemblance with his deceased older sibling, let alone what the toddler would have looked like if he had survived to maturity. Obviously the portrait we see in this unusually large work is entirely fictive.

Here Dalí brought together a number of his current visual preoccupations. The "portrait" is created by means of the Benday dot breakdown of mechanised magazine and newspaper reproduction, many of the dots of which have joined up in emulation of areas of over-inking. On the right those dots assume the likeness of molecular-structured people, whilst at the bottom they metamorphose into ranks of soldiers. In the mid-distance on the left, people look on sadly as the peasants from Millet's *The Angelus* lift a corpse into their wheelbarrow; this, we may assume, is the body of Dalí's dead brother (in 1932 Dalí had had the Millet painting X-rayed and was excited to find that when underpainting the work, the French painter had put an oblong box where the wheelbarrow appears in the final canvas, thinking this might have been a coffin).

In overall terms the image seems rather banal, although the vagueness in the definition of the dead brother appears apt.

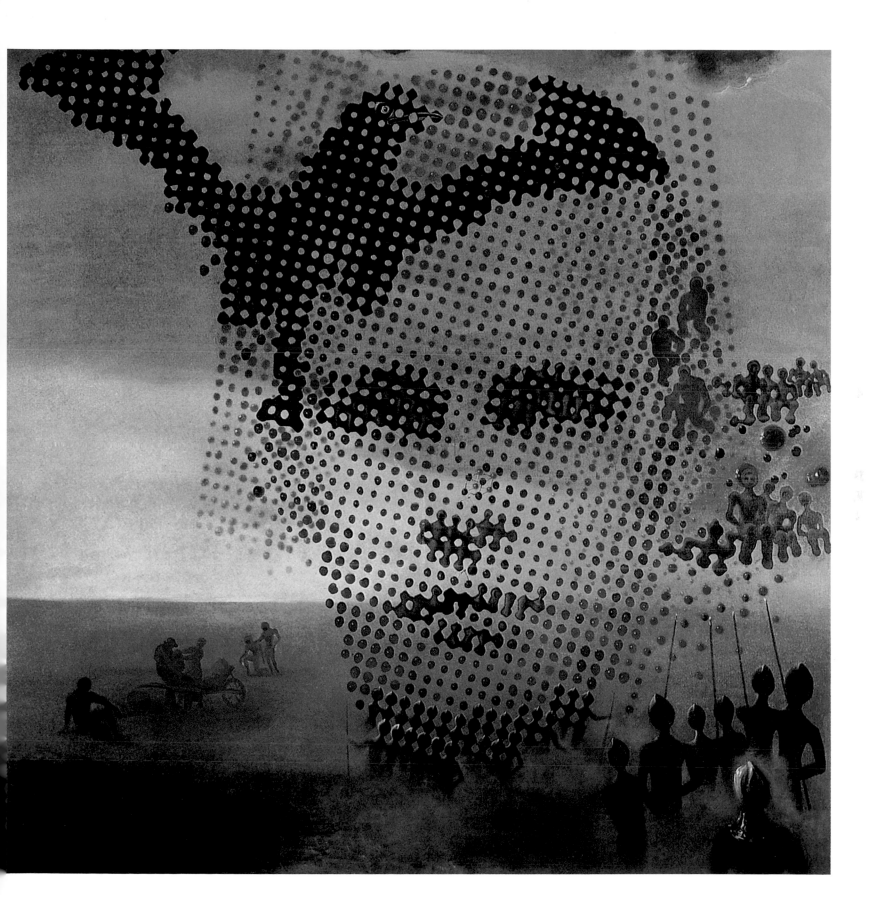

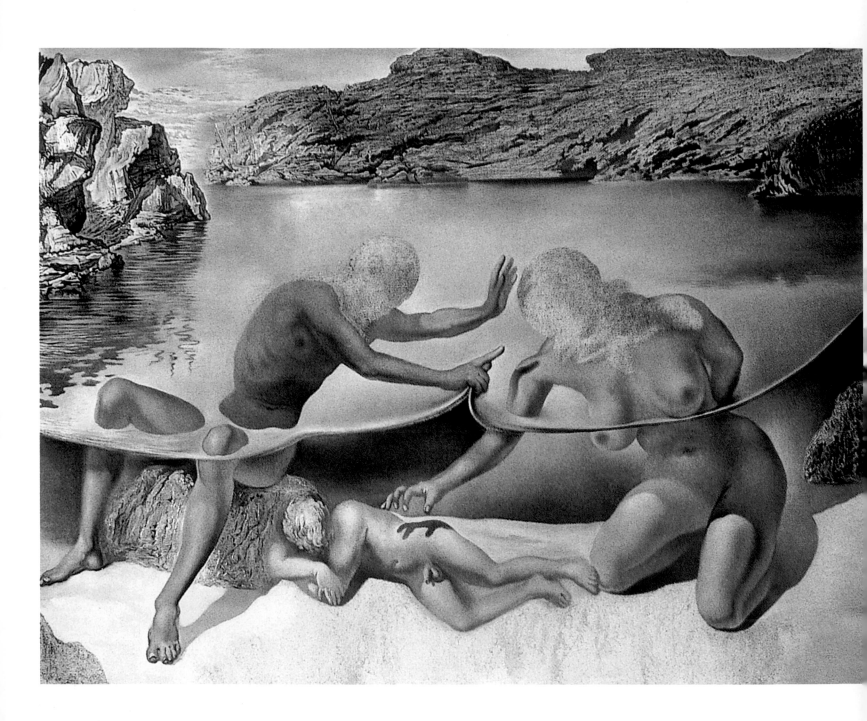

HERCULES LIFTS THE SKIN OF THE SEA AND STOPS VENUS FOR AN INSTANT FROM WAKING LOVE

1963

Oil on canvas, 41.9 x 55.8 cm

Niigata Prefectural Museum of Modern Art, Nagaoka

During the early 1960s Dalí occasionally painted neo-classical pictures, of which the present work is a representative example. (Of course, had one seen the painting in 1963 in a traditionalist artistic context, such as the Royal Academy Summer Exhibition, it would surely have resembled nothing more than old-fashioned academic kitsch, which only serves to demonstrate the importance of cultural context for our evaluations of a work of art). Yet paintings like this also directly prefigured the post-modernist neo-classicism of two decades later. And at the very least the work demonstrates how adroitly Dalí continued to represent the human figure.

The idea of showing the surface of the sea as a skin was one that the painter had been using for almost twenty years by 1963, and he probably obtained it from once viewing the sharp edge of a body of water in a glass-walled fish tank. The control of tone underneath the surface of the sea is very skilful. As always, the representation of the typical rock formations at Port Lligat demonstrates Dalí's mastery of landscape painting.

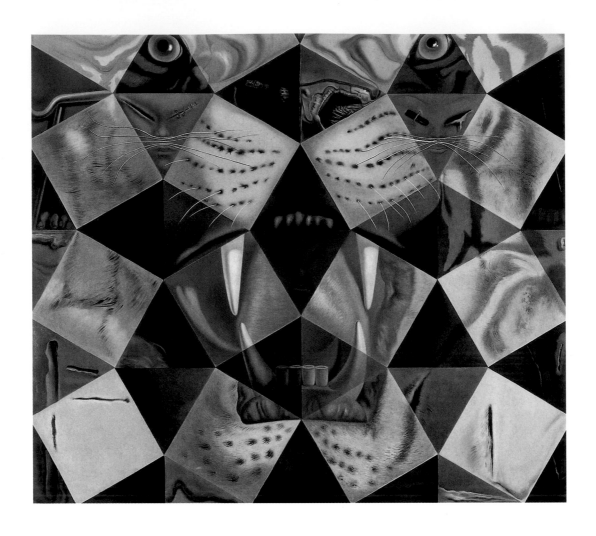

FIFTY ABSTRACT PAINTINGS WHICH AS SEEN FROM TWO YARDS CHANGE INTO THREE LENINS MASQUERADING AS CHINESE AND AS SEEN FROM SIX YARDS APPEAR AS THE HEAD OF A ROYAL BENGAL TIGER

1963
Oil on canvas, 200 x 229 cm
Teatre-Museu Dalí, Figueres

Dalí's title for this picture is so long and so informative that it must be wondered if the reader of this book needs any additional information to help analyse the image. The work certainly indicates Dalí's continuing interest in multiple and composite imaging, and how inventive he remained in that department well into his later years.

The likening of Lenin to a Chinese surely reflects the fact that by 1963 the most threatening and radical version of the Communism that Dalí had come to hate by then was being practiced by the Chinese (whose fanaticism, if anything, would intensify with the Cultural Revolution of the later 1960s). Yet it should be noted that the work's title tells us that the three Lenins "masquerade" as Chinese. Maybe by using that word Dalí was subtly alluding to the fact that Communism itself was a masquerade. Certainly the Royal Bengal tiger looks very dejected, possibly as a visual comment upon the failure of Communism worldwide.

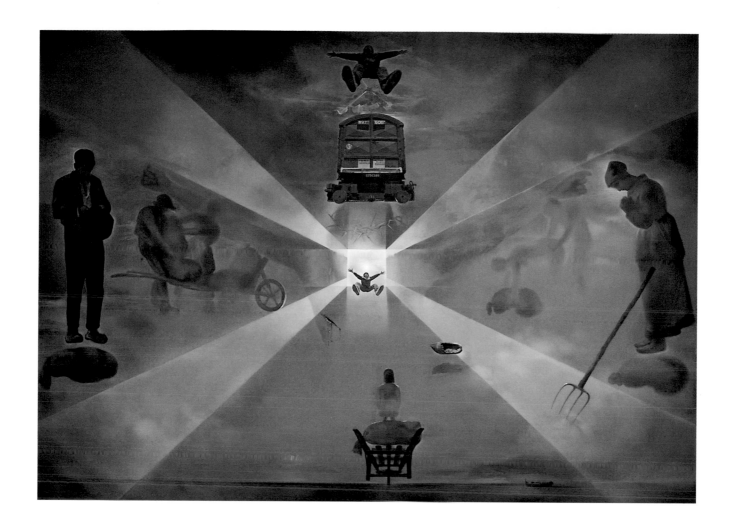

THE PERPIGNAN RAILWAY STATION

1965
Oil on canvas, 294.6 x 411.4 cm
Museum Ludwig, Cologne

In the third of his autobiographies, the *Diary of a Genius*, published in 1966, Dalí wrote of the genesis of this work:

On September 19, 1963, in the railway station at Perpignan, I had a much more powerful cosmogonic ecstasy than ever before. I had an exact vision of the constitution of the universe.

It is arguable whether this large work does project "the constitution of the universe" very successfully. Certainly it seems a mystical statement, for beyond the brilliant crux of a vast Maltese cross of light appears the head of the crucified Christ, whilst blood seeps from the incision in His side. The bodily wound is balanced by a similarly shaped peasant's clog to the right.

In front of Christ may be seen the familiar couple from Millet's *The Angelus*, both in their original poses and loading a sack onto the wheelbarrow, as well as making shadowy love on the right. At the bottom of the image is the Millet wheelbarrow viewed from the rear, with its handlebars raised up. This barrow supports perhaps the same sack that is being loaded by the peasants on the left, while just above it Gala gazes up at the small floating figure viewed doubly from below, as well as at a railroad truck. The central vertical arrangement of lights, figures and objects reinforces compositional symmetry, although the wheelbarrow at the bottom slightly offsets any monotony by being located just slightly off-centre.

THE HALLUCINOGENIC TOREADOR

1969-1970

Oil on canvas, 398.8 x 299.7 cm

Salvador Dalí Museum, St Petersburg (Florida)

The inclusion of the Venus de Milo in this unusually large painting was prompted by seeing a reproduction of the Greek sculpture on a Venus-brand pencil packet, in which image Dalí had simultaneously discerned the head of a toreador. Here that head can be made out in the shadows of the central Venus, shadows that are cast by the left side of her head, by her right-hand breast and by the folds across her midriff. Compositely these shadows respectively form the toreador's shaded left eye-socket, the underside of his nose, and his mouth and chin. The curve of the arena beyond the sculpture gives us the contour of the toreador's hat, the green shadowed side of a Venus's lower garment forms his necktie, and the brilliantly coloured or monochromatic molecules to the left of the sculptures contribute to his suit of lights. Beneath these molecules/lights, the shadowing of innumerable rock-forms creates an overall shape that was intended to represent the head of a dying bull, according to Dalí himself. And at the very bottom of the picture, in the centre, further discon-nected shapes suggest an advancing wild animal. To the left of and slightly above the line of sculptures, the shadowed contours of a further representation of the Venus de Milo act equally as a figure twisting as it holds aloft a tambourine or possibly a *muleta*.

The distant terraces, walls, and statues summon forth echoes of De Chirico's deserted architectural surroundings. From that setting, a regular formation of small, shadowed ellipses advances to evolve gradually into a host of winged objects. At the bottom-right, these finally turn into bluebottles. Such common house-flies are watched unconcernedly by a little boy wearing a sailor's costume whom we have previously encountered in Dalí's work, for it is exactly the same portrayal of the painter himself that appeared in *The Spectre of Sex Appeal* of 1932.

Elsewhere may be perceived a quasi-religious hallucinatory image of Gala at the top-left, Dalí's arch-enemy of the irrational, Voltaire, to the lower-right, and numerous heads or complete renderings of the Venus de Milo, including a head at the top-left that enjoys a polarised colouring. When Dalí made this painting in the late 1960s, similar polarisation was frequently encountered in popular graphics such as posters and the like, and it was commonly supposed to reflect the visual stimulus afforded by hallucinogenic drugs such as LSD. Here and elsewhere in this work, Dalí was clearly building upon that familiar type of imagery so as to inject his rather tired Surrealism with the hallucinatory stimulus of the new drug culture.

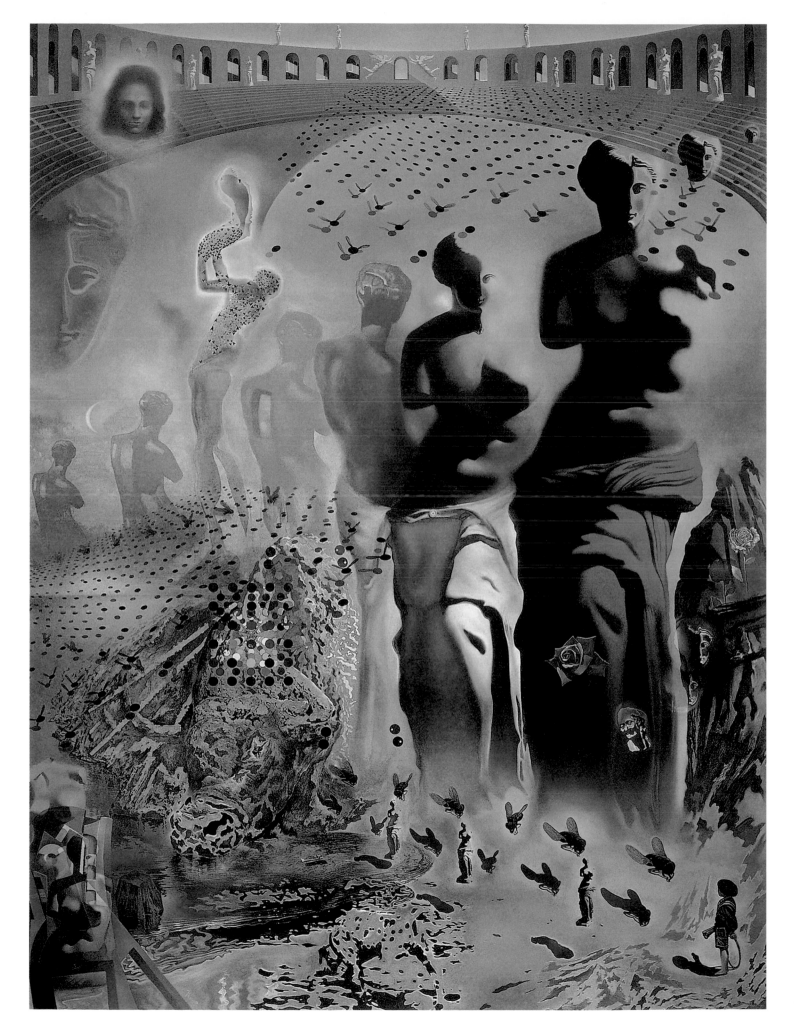

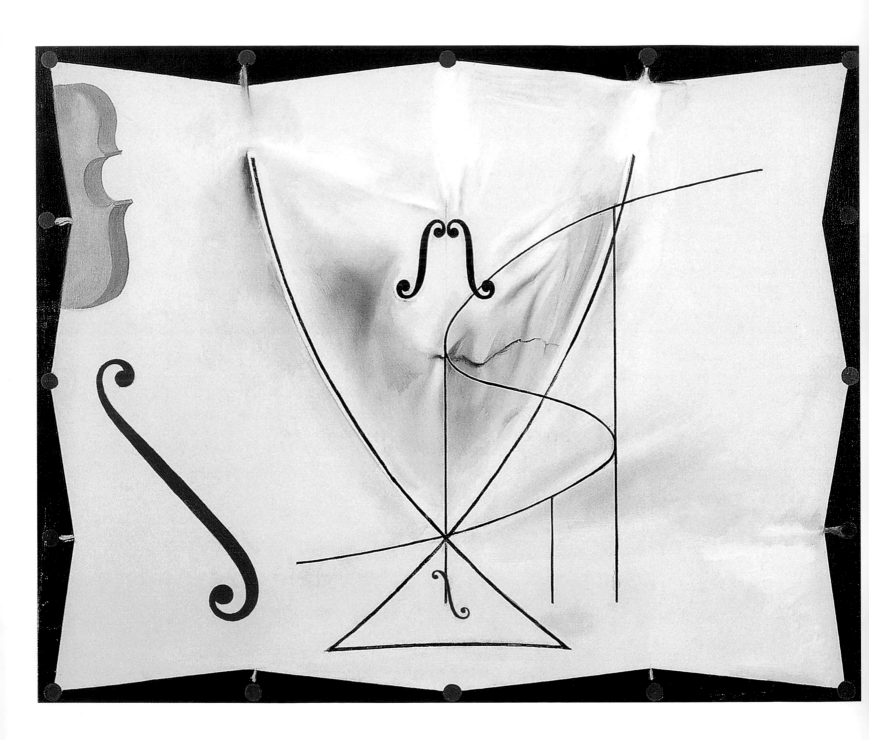

THE SWALLOW'S TAIL (SERIES ON CATASTROPHES)

1983
Oil on canvas, 73 x 92.2 cm
Teatre-Museu Dalí, Figueres

By 1983 Dalí was very aged and infirm indeed, with hands that were usually far too shaky to create fine lines and sharply-defined forms, as here. He therefore undoubtedly called upon the help of others in order to create this canvas, which was probably his very last work. As with a great many artists before him, such reliance upon others does not matter at all: it is the *concept* that is important, not exactly who put that idea into practise. In these terms *The Swallow's Tail* is undoubtedly a work wholly by Salvador Dalí.

The picture reflects the ageing artist's continuing interest in science and mathematics, in this case the ideas of the French mathematician René Thom (1923-2002). Both the shape of what Thom had labelled the swallow's tail – the extended X-form that is joined across its base – and the overlaid S-curve with vertical lines running down from parts of it, were taken from diagrams in Thom's 1972 book, *Structural Stability and Morphogenesis*. The shape of a cello may be seen towards the top-left, whilst the f-holes of wooden stringed instruments such as cellos were doctored by Dalí so that they would look even more like the mathematical symbol for an integral in calculus. We are a very long way from Surrealism and the workings of the subconscious here, but then Dali always had an extraordinary mind, even if its power to summon forth significant images had died a long, slow death by 1983.

Selected Bibliography

ADES, Dawn

Dada and Surrealism Reviewed, London, 1978.

Dalí, London and New York, 1982.

Dalí (editor), exhibition catalogue, Venice and Philadelphia, 2005.

BOSQUET, Alain

Conversations with Dalí, New York, 1969.

DALÍ, Salvador

Diary of a Genius, London, 1966.

The Secret Life of Salvador Dalí, 4th edition, London, 1973.

The Unspeakable Confessions of Salvador Dalí, London, 1976.

DESCHARNES, Robert

Dalí de Gala, Lausanne, 1962.

Salvador Dalí, The Work, The Man, New York, 1984.

The World of Salvador Dalí, London, 1962.

EXHIBITION CATALOGUE:

Salvador Dalí, Musée national d'Art .moderne, Centre Georges-Pompidou, Paris, 1979.

GERARD, Max

Dalí, New York, 1968.

GIBSON, Ian

The Shameful Life of Salvador Dalí, London, 1997.

LEVY, Julien

Memoirs of an Art Gallery, New York, 1977.

McGIRK, Tim

Wicked Lady: Salvador Dalí's Muse, London, 1989.

MORSE, Reynolds

Dalí, A Study of his Life and Work, New York, 1958.

ROGERSON, Mark

The Dalí Scandal, London, 1987.

SECREST, Meryle

Salvador Dalí, A Biography, New York, 1986.

SERNA, Ramon Gomez de la

Dalí, London and Sydney, 1977.

Chronology

1904
Birth of Salvador Domingo Felipe Jacinto Dalí i Domènech in Figueres, Catalonia, Spain, on 11 May.

1918
Shows first works publicly in local art exhibition held in the Municipal Theatre, Figueres.

1921
Mother dies.

1922
Gains admittance to the San Fernando Royal Academy of Fine Arts Special in Madrid and lives in the university hall of residence where he becomes friendly with Luis Buñuel and Federico García Lorca.

1923
Suspended by the San Fernando Royal Academy of Fine Arts for a year on account of supposedly subversive behaviour.

1925
Between 14 and 27 November holds first one-man show at the Dalmau Gallery in Barcelona.

1926
Makes first trip to Paris, where visits Picasso. Is permanently expelled from the San Fernando Royal Academy of Fine Arts. Holds second one-man exhibition at the Dalmau Gallery, Barcelona.

1927
Performs military service. Designs sets and costumes for Lorca's drama *Mariana Pineda* in Barcelona and writes for *L'Amic de les Arts*.

1928
Paints in Figueres. Contributes an attack on Catalan cultural provincialism and anti-modernism to the *Manifesto Groc* or *Yellow Manifesto*.

1929
Between March and June visits Paris again, and collaborates with Buñuel on film *Un Chien andalou*. In summer is visited in Cadaqués by Gala and Paul Éluard, as well as by René Magritte. Officially joins Surrealist movement. In November holds first one-man show in Paris at the Goemans Gallery. Begins living with Gala Éluard. Is barred from family home in Cadaqués on account of supposed insult to his mother and his relationship with Gala.

1930
With money provided by Vicomte de Noialles buys fisherman's cottage in Port Lligat, where spends summer. Works on scenario of *L'Age d'or* with Buñuel.

1931
Holds second Paris one-man show, at Pierre Colle Gallery, in June.

1932
Participates in Surrealist group shows in New York and Paris. Writes a further film scenario, *Babaouo* (never produced). Holds further show at Pierre Colle Gallery in Paris.

1933
Is promised a regular salary by a group of collectors and friends (The Zodiac group) in exchange for right to choose works on a rote basis. Participates in show of Surrealist objects at Pierre Colle Gallery, where also has further one-man show in June. First one-man exhibition in New York, at Julien Levy Gallery. Illustrates *Les Chants du Maldoror* for Swiss publisher, Albert Skira.

1934
30 January, marries Gala in Paris, with her ex-husband Paul Éluard as one of the witnesses. Holds six one-man shows (two in Paris, two in New York, one in Barcelona, and one in London). November, visits United States.

1935

Lectures on Surrealism at the Museum of Modern Art in New York. Publishes major essay "The Conquest of the Irrational". Concludes agreement with English collector, Edward James, to sell him his most important works (agreement continues until 1939).

1936

Visits London in June-July for International Surrealist Exhibition, giving lecture in diving suit in which he nearly suffocates. Visits Spain in summer but forced to leave by outbreak of Civil War. December, revisits America for exhibition at Julien Levy Gallery, appears on cover of *Time* magazine, 14 December.

1937

February, visits Harpo Marx in Hollywood, and collaborates on film scenario entitled *Giraffes on Horseback Salad*. April, returns to Europe, spending month in Austria and Switzerland, then stays in Italy with Edward James and Lord Berners. Begins designing dresses and hats for Elsa Schiaparelli.

1938

Takes part in International Exhibition of Surrealism at the Beaux-Arts Gallery in Paris, showing a mannequin inside a taxicab. Visits Freud in London in July. In autumn visits Coco Chanel in Monte Carlo where also designs ballet *Bacchanale*.

1939

January, returns to Paris. February revisits New York for show at Julien Levy Gallery and is engaged by Bonwit Teller, a Fifth Avenue department store, to design shop windows; attracts wide publicity after dispute over the arrangement. Contributes *Dream of Venus* to New York World's Fair. Returns to France in autumn and eventually settles at Arcachon after outbreak of World War II.

1940

After fall of France in June, flees to America via Spain and Portugal. Settles in Hampton, Virginia, at home of Caresse Crosby.

1941

Exhibits at Julien Levy Gallery in New York in April. Is attacked in print by Andre Breton who nicknames Dalí 'Avida Dollars' for propensity for making money. Designs ballet *Labyrinth*, with choreography by Massine. Writes autobiography, *The Secret Life of Salvador Dalí*. November, holds retrospective exhibition at the Museum of Modern Art, New York.

1942

Designs a calendar to benefit the Free French cause.

1943

Holds exhibition of portraits of American personalities at Knoedler Gallery, New York. Designs apartment for Helena Rubinstein.

1944

Publishes only novel, *Hidden Faces*. Designs three ballets, *Sentimental Colloquy*, *Mad Tristan*, and *El Cafe du Chinitas*.

1945

Holds exhibition at Bignou Gallery, New York, and publishes first issue of *Dalí News*. Creates dream sequence for Alfred Hitchcock's film *Spellbound*.

1946

Works in Hollywood with Walt Disney on unrealised project, *Destino*.

1947

Exhibits in Palm Beach, Cleveland, and New York, where produces second edition of *Dalí News* containing first chapter of book on technique, *Fifty Secrets of Magic Craftsmanship*.

1948

Returns to Europe in July, and thereafter regularly winters in New York, spending rest of year in Paris and Port Lligat. Designs Shakespeare production for Luchino Visconti, Richard Strauss opera for Peter Brook, and begins to paint religious subject matter. Terminates direct participation in Surrealist movement.

1949

Visits Pope Pius XII in Rome in November.

1951

With Gala attends Beistegui Ball in Venice in seven-metre-high costumes designed by Christian Dior.

1952

Lectures in United States on his "new cosmogony". Purchase of *Christ of St John of the Cross* by Glasgow Art Gallery for £8,200 causes public outcry in Scotland.

1954

Completes series of 102 watercolours illustrating Dante's *Divine Comedy*.

1955

Lectures at the Sorbonne in Paris on "The Phenomenological Aspects of the Paranoiac-Critical Method". Paints portrait of Laurence Olivier dressed as King Richard III.

1956

Dalí's painting *The Sacrament of the Last Supper* goes on view at the National Gallery of Art in Washington, D.C.

1957

Develops ideas for 'living' nightclub in Acapulco, and for film of *Don Quixote* with Walt Disney, who visits Dalí at Cadaqués, but both projects remain unrealised.

1958

Lectures at the Théâtre de l'Etoile in Paris with specially-baked loaf of bread almost forty feet long. Remarries Gala in religious ceremony in Spain.

1959

Produces *Ovicipede*, a plastic bubble projecting the "intra-uterine phantasm".

1960

Exhibits *The Discovery of America by Christopher Columbus* painted in 1958 for Huntingdon Hartford's Gallery of Modern Art in New York. Participation in Surrealist exhibition in New York leads to protests by fellow surrealists. Exhibits *Divine Comedy* watercolours in Paris.

1961

Designs sets and costumes, and writes story for ballet with choreography by Maurice Bejart, the *Ballet de Gala*.

1962

Exhibits *The Battle of Tetuan* in the Palacio del Tinell in Barcelona alongside painting of same subject by Mariano Fortuny that inspired it.

1963

Publishes *The Tragic Myth of Millet's "Angelus"*.

1964

Publishes *The Diary of a Genius*, third volume of autobiography. Awarded the Grand Cross of Isabel la Catolica by General Franco.

1965

Exhibits painting *The Perpignan Railway Station* at Knoedler Gallery in New York. Large exhibition of works held at the Gallery of Modern Art in New York.

1967

Shows painting of *Tuna Fishing* in Paris and contributes catalogue essay praising work of Meissonier and other 'Pompier' painters.

1970

Announces creation of Dalí Museum in Figueres.

1971

Dalí Museum of works from Morse Collection opens in Cleveland (Ohio) and is later transferred to St Petersburg (Florida).

1972

Exhibits holograms at Knoedler Gallery in New York.

1974

September, Teatre-Museu Dalí inaugurated in Figueres.

1978

Exhibits first stereoscopic painting at the Solomon R. Guggenheim Museum in New York. Elected a Foreign Associate Member of the Académie des Beaux-Arts of the Institut de France.

1979

December, large retrospective exhibition opens at the Centre Georges-Pompidou in Paris, later moves to London.

1982

March, presented with the Gold Medal by the Generalitat of Catalonia. Gala dies 10 June in Púbol. Created Marquis de Púbol by the King of Spain on 26 July.

1983

Retrospective exhibition held at the Museo Español de Arte Contemporaneo in Madrid.

1984

30 August, seriously injured by fire whilst asleep.

1989

Dies 23 January in Figueres.

List of Illustrations